Only a Promise of Happiness

Only a Promise of Happiness

The Place of Beauty in a World of Art

Alexander Nehamas

Princeton University Press

Princeton and Oxford

Copyright © 2007 by Princeton University Press

Published by Princeton University Press,
41 William Street, Princeton, New Jersey 08540

In the United Kindgom:
Princeton University Press,
3 Market Place, Woodstock, Oxfordshire OX20 1SY

Library of Congress Cataloging-in-Publication Data
Nehamas, Alexander, date
 Only a promise of happiness : the place of beauty in a world
of art / Alexander Nehamas.
 p. cm.
 Includes bibliographical references and index.
 ISBN-13: 978-0-691-09521-9 (hardcover : alk. paper)
 ISBN-10: 0-691-09521-3 (hardcover : alk. paper)
 1. Aesthetics. 2. Art—Philosophy. I. Title.
 BH39.N378 2007
 111'.85—dc22
 2006021360

Publication of this book has been aided by grants from the
Princeton University Fund for Research in the Humanities and
the Social Sciences and from the Andrew W. Mellon Foundation

British Library Cataologueing in Publication Data is available

This book has been composed in Adobe Garamond
with Trade Gothic display and GFS Porson Greek.

Printed on acid-free paper. ∞

pup.princeton.edu

Printed in Canada

10 9 8 7 6 5 4 3 2 1

For Arthur Szathmary

ο]ἰ μὲν ἰππήων στρότον οἰ δὲ πέσδων
οἰ δὲ νάων φαῖσ' ἐπ[ὶ] γᾶν μέλαι[ν]αν
ἔ]μμεναι κάλλιστον, ἔγω δὲ κῆν' ὄτ-
τω τις ἔραται.

Some say a marshaling of horsemen, others, soldiers on the march,
and others still say that a fleet of ships is the most beautiful thing
on the dark earth. I say
it is what you love.

 —Sappho, Fragment 16

Que tu viennes du ciel ou de l'enfer, qu'importe,
O Beauté! monstre énorme, effrayant, ingénu!
Si ton oeil, ton souris, ton pied, m'ouvrent la porte
D'un Infini que j'aime et n'ai jamais connu?

De Satan ou de Dieu, qu'importe? Ange ou Sirène,
Qu'importe, si tu rends,—fée aux yeux de velours,
Rythme, parfum, lueur, ô mon unique reine!—
L'univers moins hideux et les instants moins lourds?

Who cares if you come from paradise or hell,
appalling Beauty, artless and monstrous scourge,
if only your eyes, your smile or your foot reveal
the Infinite I love and have never known?

Come from Satan, come from God—who cares,
Angel or Siren, rhythm, fragrance, light,
provided you transform—O my one queen!
this hideous universe, this heavy hour?

 —Charles Baudelaire, "Hymne à la
 Beauté," from *Les Fleurs du mal*
 (English translation by Richard Howard)

Contents

Acknowledgments

For the third time in my life, an invitation to the University of California at Berkeley has resulted in a book. This one began as the Townsend Lectures in 2000, when I had the immense benefit of several discussions with Donald Davidson. Considerably expanded, the text served as the core of the Tanner Lectures I delivered at Yale University in 2001 at the invitation of Peter Brooks, then director of the Whitney Humanities Center—a happy occasion made even better by the productive disagreement of Richard Rorty and Elaine Scarry. Material from these lectures is reprinted here with the permission of the Tanner Lectures on Human Values and the University of Utah Press.

Over the next four years, many students, colleagues and friends, particularly Lanier Anderson, Denis Donoghue, and Joshua Landy, gave me both their time and their attention—two of them, Thomas Laqueur and Paul Guyer, more than I had any reason to expect. Nor did I have any reason to expect the startling generosity of the Mellon Foundation; I hope I have put it to good use.

Arthur Danto, with whose approach to the philosophy of art this book engages at length, has been on my mind throughout its writing. So has Bernard Williams, whose approach to philosophy more generally may be implicit but not, for that reason, any less important. Finally, I hope that Arthur Szathmary, who was my teacher in the philosophy of art when I was a graduate student at Princeton many years ago, will accept this short book as a grateful acknowledgment of his generous and spirited friendship, personal and intellectual.

Only a Promise of Happiness

I

Plato or Schopenhauer?

All beautiful things, the Greek philosopher Plotinus wrote in the third century A.D., produce "awe and a shock of delight, passionate longing, love and a shudder of rapture." *All* beautiful things: natural objects and works of art, bodies and souls, ways of life, knowledge, virtue, and much else besides. Our time, by contrast, has confined such feelings to everyday life. It has drawn a heavy curtain between them and the true pleasures of art, which ordinary people, as Ortega y Gasset charged in 1925, are incapable of experiencing: "To the majority of people aesthetic pleasure means a state of mind which is essentially indistinguishable from their ordinary behavior. As they have never practiced any other attitude but the practical one in which a man's feelings are aroused and he is emotionally involved, a work that does not invite sentimental intervention leaves them without a cue"; ordinary people wallow in emotions not only different "from true artistic pleasure, but . . . incompatible with aesthetic enjoyment proper."

Philosophy, too, has abandoned Plotinus's broad vision. Suspicious of passion, it limited itself to a kind of beauty to which desire seemed inappropriate—the beauty in great art and the wonders of nature, concentrated in museums and national parks. And so the beauty that mattered to philosophy, to criticism, and often to the arts themselves, if it mattered at all, was separated from the beauty that mattered to the rest of the world, to whom it seemed irrelevant and empty: the higher and more refined its pleasures, the less like pleasures they seemed.

How did that happen? Is it purification or impoverishment? And what, if anything, are we—philosophers, critics, historians, the "educated" public that looks down on the "masses," and the masses themselves, who, when they bother to think about any of this, make fun of the educated—to do about it?

Plotinus's words were a conscious echo of Plato's description of a man who sees a beautiful boy for the first time. Such a man, Plato writes in the *Phaedrus*, first

> shudders in cold fear . . . and gazes at the boy with reverence, as if he were a god. . . . But gradually his trembling gives way to a strange feverish sweat, stoked by the stream of beauty pouring into him through his eyes and feeding the growth of his soul's wings. . . . He cares for nothing else. Mother, brothers or friends mean nothing to him. He gladly neglects everything else that concerns him; losing it all would make no difference to him if only it were for the boy's sake.

Plato and the ancients were not afraid of the risky language of passion because they thought that beauty, even the beauty of lowly objects, can gradually inspire a longing for goodness and truth. In the *Symposium*, Plato describes a long process that leads from the love of a single individual to a life governed by the love of all the beauty of the world, which is for him the life of philosophy itself. Passion in pursuing that life, its wisdom and virtue, and everything that leads to them, is just what the ancients encouraged and valued, and the pleasures they promised in return were vivid and intense.

The fiery reaction to beauty Plato and Plotinus describe was still comprehensible to lovers of beauty and art like John Ruskin, Walter Pater, and Oscar Wilde in the nineteenth century, but beauty had long ago ceased to go hand in hand with wisdom and goodness; it had eventually come to be, as it is to most of the world today, largely irrelevant and often opposed to them. Even Ruskin, the most moralizing of modern aestheticians, had to acknowledge the breach between beauty and morality, and his advice to painters reveals the conflict he faced: "Does a man die at your feet—your business is not to help him, but to note the colour of his lips. . . . Not a specially religious or spiritual business this, it might appear."

And so it did. Mistrustful of passion, the twentieth century gradually came to doubt beauty itself. The contrast between helping the suffering and painting them, between fighting for them and writing about them, became starker and deeper. Wary of the ability of art to transmute the greatest horrors into objects of beauty, philosophy disavowed it and relegated the beauty of human beings and ordinary things, inseparable as it is from yearning and from the body, to biology and psychology, to fashion, advertising, and marketing. It preserved the beauty of art and its equivocal satisfactions as its rightful subjects only by means of thinking of them as "aesthetic," a category that obliterated the vision that had once kindled Plato's imagination.

The aesthetic made it possible to isolate the beautiful from all the sensual, practical, and ethical issues that were the center of Plato's concern. The concept itself is part of the legacy of Immanuel Kant, who established the modern field of Aesthetics in the late eighteenth century. In an enigmatic formulation whose influence nevertheless permeates our attitude toward the arts and, as we shall see, countless aspects of everyday life, Kant disavowed the ancients. Beauty, he claimed, is manifested only through a contemplation of nature or art that produces "a satisfaction without any interest." The pleasure ("satisfaction") we find in beautiful things is completely independent of their relations to the rest of the world—of their uses and effects. We have no interest in possessing them or in their consequences for ourselves or others. It is a pleasure bereft of desire.

The beautiful is according to Kant different from both the "agreeable" and the good. The agreeable is anything that we like and enjoy in the most everyday sense of the word—strawberry ice cream, the smell of jasmine, silk, a large house or a good meal and perhaps canary wine (Kant's own example) to go with it. The pleasure such things give spurs the desire to possess them; we want them to continue to be, along with other things like them, available to us. That is, Kant says, to have a serious interest "in their existence." It is an attitude we also have toward good things—things that are either useful or morally valuable. Useful things are those that lead to an agreeable end—an ice-cream maker, for instance, if I like ice cream—and I have an interest in their existence, since I desire to possess the ends to which they are the means. Morally valuable things, finally, are valuable in themselves, things we want to be the case for their own sake—which is also to have an interest in their existence. But no such interest enters when we are concerned with the beauty of something: "If the question," Kant writes, "is whether something is beautiful, one does not want to know whether there is anything that is or that could be at stake, for us or for someone else, in the existence of the thing, but rather how we judge it in mere contemplation." Is such a thing pleasant to have? Is it good for us to have it? Is it good that it exists? Does it exist in the first place or is it a figment of my imagination? None of that matters. A palace can be beautiful despite being ostentatious, useless, and the product of oppression. If I want to own a painting because I find it beautiful or praise a novel because of its moral point of view, my judgement is undermined:

> Everyone must admit that a judgment about beauty in which there is mixed the least interest is very partial and not a pure judgment of taste. One must not be in the least biased in favor of the existence of the thing, but must be entirely indifferent in this respect in order to play the judge in matters of taste.

Aesthetic pleasure is a pleasure we take in things just as they stand before us, without regard to their effects on our sensual, practical,

or moral concerns. Moreover, beauty is not a feature of things themselves: the judgment of taste—"This is beautiful"—does not so much describe its object as it reports the feeling of pleasure we are experiencing. The judgment of taste, he writes, is made only on the basis of "the feeling of pleasure and displeasure, by means of which nothing at all in the object is designated, but in which the subject feels itself as it is affected by the representation."

Kant's views on the nature of beauty and art and their relationship to the rest of life are immensely complex. Although he dissociated beauty from desire, he did not himself limit it to the arts; the tradition that followed him, though, emphasized not only what has come to be known as the "disinterestedness" of beauty but, even more, the "autonomy" of art. Neither beauty nor art bears (or should bear) any relation to the everyday world of desires, and both move us (or should move us) as nothing else in that world does. Long before Modernism taught us to prize the difficult, the discomforting, and the edifying instead of the lovely or the attractive, the beauty that was important to philosophy had already been transformed from the spark of desire to the surest means of its quenching. For Arthur Schopenhauer in the mid-nineteenth century, desire can never be fully satisfied; no matter what we accomplish, we want more, our ultimate goal always hovering, like Tantalus's fruit, just beyond our reach. Desire is for him unending torture, from which only the contemplation of art can deliver us. But when the beauty of art lifts us above the everyday,

all at once the peace, always sought but always escaping us on the former path of the desires, comes to us of its own accord, and it is well with us. It is the painless state Epicurus prized as the highest good and as the state of the gods; we are for the moment set free from the miserable striving of the will; we keep the Sabbath of the penal servitude of willing; the wheel of Ixion stands still.

Schopenhauer values art because he thinks of beauty as a liberation from the disturbing travails and the distracting details of ordinary life. He believes that art reveals to us the real nature of things, the

"persistent form" of their species. By focusing on the universal features that things have in common, we are removed from the vicissitudes of the specific and particular; we leave active participation behind and enter the realm of pure contemplation, where pain is absent: "Happiness and unhappiness have vanished; we are no longer the individual; that is forgotten; we are only the pure subject of knowledge. We are only that *one* eye of the world which looks out from all knowing creatures."

Nothing could be farther from Plato's celebration of desire in the *Symposium* than Schopenhauer's hymn to its cessation. For Plato, the only reaction appropriate to beauty is *erōs*—love, the desire to possess it. Moreover, all beautiful things draw us beyond themselves, leading us to recognize and love other, more precious beauties, culminating in the love of the beauty of virtue itself and the happy life of philosophy. Plato agrees that beauty provides knowledge—love and understanding go hand in hand—but he also sees that it gives more: the philosopher is actively involved in the world, moved to act on it by love and able to act well through understanding. He also never leaves the body behind. He describes a long and difficult "ascent" that ends in the knowledge and love of the very Form of Beauty—the essential nature of beauty that is manifested in every beautiful thing in the world and explains why it is beautiful. But the first steps of that philosophic ascent are firmly rooted in the world of the senses—in sexual, paederastic desire. The whole process begins with a man falling in love with a beautiful boy—a common phenomenon in Classical Athens whose dimensions were not only sexual but also social and ethical. In return for the boy's affection, the older man was expected to provide him with the motivation and knowledge necessary for success and distinction in life—what the Greeks called *aretē* and we often misleadingly understand as moral virtue.

In the phenomenon of paederasty, Plato saw an opportunity not only for the boy but for the man as well, at least if he was philosophically inclined. Such a man would want to understand what made the boy beautiful and sparked his desire. Desire for the boy, then, leads

to a desire for understanding, and that desire leads to the beauty of the human body in general—the features all beautiful bodies share with one another and which, according to Plato's way of looking at things, make each beautiful individual beautiful. But since the reaction appropriate to beauty is love, a more philosophical man would now want to understand what makes the human body in general beautiful and inspires him to love it and what in turn accounts for the beauty of that, and would go on asking until he reached a full and final answer. Every new step reveals another beauty, and the man's desire to possess the boy is gradually amplified to a desire for more, and more abstract, things: not just the beauty of the human body but also that of the soul, which is for Plato responsible for bodily beauty; the beauty of the cultures whose laws and institutions produce people with beautiful souls; the beauty of the knowledge and understanding needed to establish such laws and institutions; and, at the end, the single and immutable essence of beauty, its "Form," which animates the beauty of everything that leads a lover to it—that is, of everything in the world. And though these "higher" beauties are abstract and seemingly impersonal, they never cease to provoke action and inspire desire and longing. Even the very last stage, when the philosopher understands through reason alone what beauty really is, is not a moment of pure contemplation: his understanding is inseparable from the truly successful and happy life he is now able to lead; his desire has not been sublimated into some sort of higher, disembodied phenomenon. Tellingly, the philosopher wants from the Form just what ordinary men who know no better want of beautiful boys: intercourse (*sunousia*)—without a second thought, Plato applies to the highest point of this philosophic ascent the very same word he uses for its lowest. In that way, he reminds us that beauty cannot be sundered from understanding or desire. The most abstract and intellectual beauty provokes the urge to possess it no less than the most sensual inspires the passion to come to know it better. Any satisfactory account of beauty must acknowledge that fundamental fact. No easy distinction between body and spirit, inner and outer, superficial and deep can accommodate its complexity.

That complexity is just what Schopenhauer refuses to accommodate. He wants to exclude passion and desire from the serious, contemplative aspects of life, and worst of all is sexual desire, which lurks behind every manifestation of love:

> All amorousness is rooted in the sexual impulse alone, is in fact absolutely only a more closely determined, specialized, and indeed, in the strictest sense, individualized sexual impulse, however ethereally it may deport itself. . . . It is the ultimate goal of almost all human effort; it has an unfavorable influence on the most important affairs, interrupts every hour the most serious occupations, and sometimes perplexes for a while even the greatest minds. . . . It appears on the whole as a malevolent demon, striving to pervert, to confuse, and to overthrow everything.

Although, unlike many other philosophers, Schopenhauer pays serious attention to sexuality, he does so only to denounce it with an almost desperate determination. He builds a great wall between beauty and what we might call attractiveness or sensual appeal (another form of the distinction between the inner and the outer) and insists that even the body's beauty cannot be discerned unless we divorce perception from desire. As long as we find someone's body attractive we are failing to see it aesthetically, by which he means contemplating it as if it were a landscape or a work of art—disinterestedly, without any regard for its effects on us or anything else in the world. He admits that it is hard to appreciate the human form in that way. "Amorousness" is a constant danger and so is the body itself, even when it is merely being represented. He rejects nude figures "calculated to excite lustful feelings in the beholder" because they demolish aesthetic contemplation and defeat the purpose of painting or sculpture. He even finds still life painting that depicts "edible objects, [which] necessarily excite the appetite" distasteful: "This is just a stimulation of the will which puts an end to any aesthetic contemplation of an object" (fruit, however, turns out to be acceptable: in art, he believes, we see it only as an organic development of the flower, not as food!). The will "springs from lack, from deficiency, and thus from suffering" and gives only ephemeral

satisfaction, "like the alms thrown to a beggar, which reprieve him today so that his misery may be prolonged until tomorrow." To want is to lack and is a source of unrelieved misery. Wherever desire is present, there is also pain. Pain can be avoided only when desire has been left behind, in the pure contemplation of beauty, which shields us, if only for a moment, from the will's incessant demands.

It is hard to imagine a starker opposition. Schopenhauer is appalled by the fact that as long as desire persists, something always remains beyond its reach. In that sense, desire can never be satisfied; desire fulfilled is desire killed, and destroying it altogether is the only way of escaping its insatiable demands. Plato celebrates it. He personifies *erōs* as the child of two gods, Resource and Poverty, whose features he combines: "Now he springs to life when he gets his way; now he dies—all in the same day. Because he is his father's son, he keeps coming back to life but [because of his mother] anything he gets close to slips away, and so he is never completely without means nor is he ever rich." It is exactly that combination that makes *erōs* as wily in the pursuit of beauty and wisdom as he is unable to possess them fully: both lover and philosopher. Where Schopenhauer sees the pain of deficiency, Plato finds the hope of fulfillment. So long as we find anything beautiful, we feel that we have not yet exhausted what it has to offer, and that forward-looking element is, as we shall see, inseparable from the judgment of beauty.

For Plato and the long tradition that came after him beauty is the object of love, the quarry of *erōs*. But beauty can be deceptive, and love has its dark side: who knows what beauty will bring eventually to light? who knows what we find beautiful and why we love as we do? Plato and his followers tried to answer such questions and escape the dangers they indicate by means of a vast philosophical picture, eventually appropriated by a current within Christian thought, according to which beauty, when it is properly pursued, provides a path to moral perfection and is aligned with goodness and virtue. But the sense that a higher authority—reason or God—secured that alignment was gradually lost and the picture gradually faded, only the dangers of beauty remaining in the traces it left behind. The desires beauty sparks and the

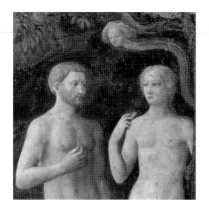

Figure 1
Masolino de Panicale, *The Original Sin*, c. 1427, S. Maria del Carmine, Florence, Italy

pleasures it promises began to seem dubious. Beauty itself was often taken to be the seductive face of evil, a delightful appearance masking the horrid skull beneath the skin. And even if it was not always the face of *evil*, once its connection with goodness was severed, beauty was still always a *face* (fig. 1), capable of promising one thing and delivering another: a mere surface and for that reason alone morally questionable. It became a feature and, if there can be virtues in appearance, a virtue of appearance and no longer a subject worthy of philosophy. Although the word continued to be used, beauty itself was replaced by the aesthetic, which, completely isolated as it is from all relationships with the rest of the world, promises nothing that is not already present in it, is incapable of deception, and provokes no desire.

Everyone knows, of course, that works of art actually can elicit the most extraordinary reactions. Pliny tells us that Praxiteles' statue of the Cnidian Aphrodite caused such lust in one man that the stains that marked the consummation of his passion were still visible in the marble hundreds of years later. Titian's *Venus of Urbino* (fig. 2) is "the foulest, the vilest, the obscenest picture the world possesses," Mark Twain

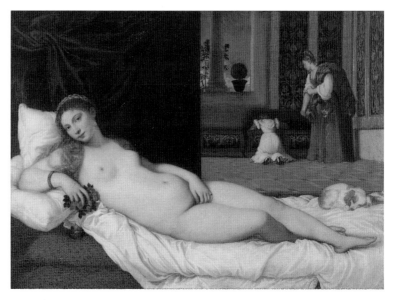

Figure 2
Titian (Tiziano Vecellio), *Venus of Urbino*, c. 1538, Uffizi, Florence, Italy

complains: "It isn't that she is naked and stretched out on a bed—no, it is the attitude of one of her arms and hand. If I ventured to describe that attitude there would be a fine howl—but there the Venus lies for anybody to gloat over that wants to—and there she has a right to lie, for she is a work of art, and art has its privileges." But although there are innumerable such cases, it has always seemed easier to believe that desire is less ardent when it comes to paintings or books than when real bodies are involved. For that reason, although the erotic elements that have always been part of our love for the arts have not always disqualified the works that provoke them, it is now the conventional wisdom that they are always irrelevant to aesthetic appreciation.

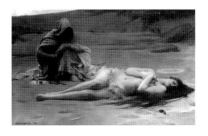

Figure 3
Arthur Hacker, *Pelagia and Philammon*, 1887, Walker Art Gallery, National Museums, Liverpool, UK

If beauty inspires the desire to possess and own its object or to use it for some further purpose, especially if it involves sex, it might seem reasonable to believe that those who value art for its beauty are either philistines or perverts. Philistines attracted to the beauty of a painting would be treating it no better than a carpet or a sofa—an expensive piece of private or corporate decoration—or else a trophy—a yacht or a private jet or, for some men, a wife. Perverts attracted to the beauty of its subject would be treating it pornographically. Pliny's young man knew very well what he was doing with Aphrodite's statue. Others may be less knowing. The men who admired the sprawling, naked, and vulnerable women in many nineteenth-century paintings (fig. 3) did not have to be aware that "fed in their youth with fantasies of woman as the all-suffering household nun and constrained in their own sexual development by images created by their fathers, [they] were now seeking relief in daydreams of invited violence, of an abandonment to aggression for which they could not be held personally responsible." Or one could be a little of both philistine and pervert, trying to claim possession of both painting and subject, as Charles II may have done by means of the portrait of Nell Gwynne painted for him by Sir Peter Lely (fig. 4).

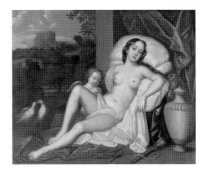

Figure 4
Sir Peter Lely. *Portrait of Nell Gwynne* [1650–87] *as Venus, with her son, Charles Beauclerk* [1670–1726] *as Cupid* (oil on canvas), Army and Navy Club, London, UK

Writing early in the twentieth century, Clive Bell extended Schopenhauer's radical version of Kant's idea of disinterestedness even further when he declared that representation is altogether immaterial to art: "To appreciate a work of art we need bring with us nothing from life, no

knowledge of its ideas and affairs, no familiarity with its emotions . . .
we need bring with us nothing but a sense of form and colour and a
knowledge of three-dimensional space." Bell was not moved by Scho-
penhauer's metaphysical anxieties. His purpose was to defend and
justify what his British contemporaries considered as deformations
of nature in the painting of Cezanne, Matisse, and Gauguin, and
he urged them not to pay attention to what these works were about
but to respond to their formal characteristics—what he called "sig-
nificant form"—instead. But since representational content—bodies,
objects, recognizable situations more generally—is where the desires
prompted by works of art are focused, his rejection of representa-
tion resulted in an even stronger barrier between the aesthetic and
the beautiful. Bell was quite explicit about it. Significant form is the
only cause of that "peculiar emotion provoked by works of art" that
is characteristic of a correct aesthetic response. "'Beautiful,'" by con-
trast, "is more often than not synonymous with 'desirable,'" and for
that reason "the word does not necessarily connote any aesthetic reac-
tion whatever." And since most people "are apt to apply the epithet
'beautiful' to objects that do not provoke that peculiar [aesthetic]
emotion produced by works of art . . . it would be misleading to call
by the same name the quality that does."

Unlike Kant and like Schopenhauer, Bell confined beauty—"real"
beauty, the beauty that matters, anyway—to the arts. Even more radi-
cally, he thought that significant form can distinguish works of art
from everything else in the world because it is a *feature* that belongs
only to the former and never to the latter. Things either do or don't
have significant form, and the judgment of taste does not simply dis-
tinguish things that elicit a particular feeling from those that don't, as
Kant had thought, but also things that are works of art from things
that aren't—one kind of thing, that is, from every other: the judgment
of taste has now become equivalent to saying, "This is a work of art."

However inadequate Bell's formalism is as a general theory of art,
his way of handling beauty was not a single critic's isolated gesture.
It was made in tandem with Roger Fry's extraordinarily influential,
less polemical and more sophisticated, privileging of "design" over

content, and it was repeated, for example, by the philosopher R. G. Collingwood, who, precisely because he agreed with Plato that beauty is the object of love, insisted that "the words 'beauty', 'beautiful', as actually used, have no aesthetic implication. . . . The word 'beauty', wherever and however it is used, connotes that in things in virtue of which we love them, admire them, or desire them . . . aesthetic theory is not the theory of beauty but of art."

With that, Schopenhauer's version of beauty, which extended radically Kant's idea of the aesthetic and opened an unbridgeable chasm between beauty and the will, gained absolute dominion over art. Beauty as Plato had described it and most of us experience it, beauty that inspires passion and desire, the source of the keenest pleasure and the deepest pain, was exiled to the everyday. In 1948, during the glory years of Abstract Expressionism in New York, Barnett Newman said it all in one famous sentence: "The impulse of modern art was to destroy beauty."

A Feature of Appearance?

It was an impulse common to the arts, to criticism, and to philosophy. It made its way from slogans and programmatic statements to everyday practice. It affected the look and feel, the sound and structure of what artists produced, the goals and standards of each individual art, the role of the arts in the economy of life and their relationship to their audience. It also marked the complete victory of a particular conception of the nature and role of criticism—a conception that had been gaining power in step with the rise of criticism itself as an institution since the middle of the eighteenth century, when both artists and audiences began to grow at an unprecedented pace.

At that time, both the Académie Royale de Peinture et de Sculpture in Paris, which had been founded in 1648, and the newly established Royal Academy of Art in London began to take an active role in making art available to a wide public whose tastes they were eager to shape. Attendance at various exhibitions, most notably the Paris

Salon, which was faced with so many submissions that it established a jury system in 1748, increased year by year. The new public, which was mostly drawn from the emerging middle classes, was much less familiar with the arts than the much smaller group of rich patrons and connoisseurs of the past. Much of what they knew came from newspapers or magazines like the *Review*, *The Tatler*, and *The Spectator* in London or *Journal de Paris* and *Mercure de France* in Paris. Critics, among whom Samuel Johnson and Denis Diderot are probably the best known, became the prime mediators between this new public and the arts that were increasingly absorbing its attention.

The elements of the model that came to dominate the understanding of criticism were already in place in the educational system of Rome at the time of Cicero, perhaps the earliest effort at a humanistic education, which was designed to prepare cultured and eloquent men suited for civic life. Once they had completed their primary education, the sons of wealthy families (and a few gifted daughters, who, however, could not continue past that stage) came under the supervision of a teacher called the *grammaticus*. They mostly studied Greek and Latin poetry and they became familiar with the works assigned them in four consecutive (though not always clearly distinct) stages. They began with *lectio*—elementary reading, distinguishing individual words (manuscripts at the time did not include spaces), inserting the proper marks of punctuation, and memorizing. *Lectio* was followed by *emendatio*, the effort to establish the authentic parts of each text and correct various errors according to principles they were taught concurrently. Once the text was established, *enarratio* produced interpretative commentaries on various words, lines, and extended passages. And once interpretation was complete, it was followed by *judicium*, a considered judgment on a work's value that came at the very end of this process.

And there, more or less, it has remained. Isn't the purpose of criticism, after all, to use the interpretation of a work of art in order to reach a judgment of its value, and doesn't criticism then arrive at its conclusion? Why do we argue with one another about the arts? Isn't it in order to decide the quality of a work, an exhibition, or an artist? Criticism enables an audience to confront its object with confidence,

understand it, and, finally, determine its value. Although most of it is interpretation, its result is a verdict, a little bit like a civil or criminal trial that places the critic in the position of a judge.

All that seems very far from the issues regarding beauty with which we began, and, in any case, next to the artistic upheavals of the last two hundred years, nothing that happened to criticism can seem nearly as important. In fact, though, criticism has not only followed, it has actually cleared the way for the changing role of beauty in art. The *Critique of the Power of Judgment* begins with the words, "In order to *decide* whether or not something is beautiful . . ." and that decision is exactly what judgment—the judgment of taste—expresses. Despite the nuances and complications of Kant's own position, it is now almost an article of faith that the end of our interaction with the arts comes when we are in a position to make a judgment of value. Arnold Isenberg, the most important American aesthetician of the mid-twentieth century, endorsed that idea and claimed that the purpose of criticism "is the evaluation of the immediate experience"; Monroe Beardsley took it for granted in his influential introduction to aesthetics: critics, he wrote, "are interested in describing and interpreting works of art because they want to evaluate them." This Kantian view is the starting point of many philosophical theories of aesthetic value, and finds a clear expression in Alan Goldman's book on that issue: "The purpose of interpretation itself [is] to guide perception toward maximal appreciation and therefore fair evaluation of a work." It has connived, as we will see, in purging beauty both from the arts and from aesthetics; but even Mary Mothersill, in her ambitious and spirited defense of beauty, agrees that criticism aims at "removing obstacles to appreciation and to present a particular text, performance, or object perspicuously, that is to say, in such a way as to enable its audience to arrive at a fair estimation of its merits."

The position of judgment in criticism is in real conflict with the place of beauty in art. We can only judge a work after we have given it an adequate interpretation: "An evaluation can only be argued for by means of a detailed description and interpretation of a work." Even Isenberg's "immediate experience" is not a first reaction but something

that comes later, when we arrive at an interpretation we can accept and "with a sense of illumination we say, 'Yes, that's it exactly,' . . . giving expression to the *change* which has taken place in our aesthetic apprehension." But it takes time to develop an interpretation—sometimes a very long time indeed. And so the value that interpretation reveals, whatever it is, can't possibly be what Joseph Addison had in mind when he observed how easy it is to experience the pleasures of the imagination: "It is but opening the Eye, and the Scene enters. . . . We are struck, we know not how, with the Symmetry of any thing we see, and immediately assent to the beauty of an Object without enquiring into the particular Causes and Occasions of it." If the beauty of things strikes us as soon as we are exposed to them, beauty can't be the same as the value that criticism is supposed to determine through the interpretations it offers. Johann Joachim Winckelmann was in love with the beauty of ancient Greek sculpture, but in his *History of Ancient Art* (1764), the founding work of art history, he introduced it in terms that contrasted with its traditional conception and foreshadowed Kant's understanding of the aesthetic: "The first view of beautiful statues is . . . like the first glance over the open sea; we gaze on it bewildered, and with undistinguishing eyes, but after we have contemplated it repeatedly the soul becomes more tranquil and the eye more quiet, and capable of separating the whole into its particulars."

Both experience and a long philosophical tradition stand behind the idea that the effect of beauty is immediate. For Plato, who stands at that tradition's origins, beauty is the most arresting and "lovable" of the ideal Forms because unlike the others, which are grasped only through reason, it alone is perceived through the eyes: we see it, "sparkling, through the clearest of our senses." But the very immediacy that makes beauty the first step to the rest of the Forms and the good life for Plato makes it irrelevant to art for Arthur Danto, one of the tradition's most recent exponents. Beauty as we ordinarily think of it is perceived through the senses; it is "really as obvious as blue: one does not have to work at seeing it when it is there." But the beauty that is important to art is only disclosed gradually and "requires discernment and critical intelligence." That wrenches beauty away from aesthetic

value. Since ordinary beauty and the beauty of art are so different, Danto follows the lead of Collingwood and Bell: "Why use the word beauty at all in the latter case?"

As a matter of fact, we don't—we certainly use it less often than we might believe, as Wittgenstein remarked: "It is remarkable that in real life, when aesthetic judgements are made, aesthetic adjectives such as 'beautiful,' 'fine,' etc., play hardly any role at all. . . . The words you use are more akin to 'right' and 'correct' (as these words are used in ordinary speech) than to 'beautiful' and 'lovely'." Although Wittgenstein's point has been often repeated, along with J. L. Austin's advice to pay more attention to "the dainty and the dumpy" than to the beautiful, we will see that not using the *word* for beauty and not being affected by beauty *itself* are two very different things. Still, it is not difficult to understand why using the word might seem dangerous. That was the danger Addison had in mind when he warned his readers to limit themselves to the genuine pleasures of the imagination, "find in them such a satisfaction as a wise man would not blush to take," and avoid the sensual delights that "suffer the mind to sink into . . . negligence and remissness."

The problem Addison faced is that if "but opening the Eye" is enough for beauty to strike, everyone whose eyes are working will perceive every kind of beauty—simple or complex, high or low, vulgar or refined—and its rewards at the same time. But that makes it impossible to separate the subtle appeal of the "serious" arts from the crude attraction of the "popular," or, for that matter, the satisfactions of the arts generally from the seductions of the everyday. Imagine, for example, that Thomas Kinkade's *Dogwood Chapel* seems to me as beautiful as Van Gogh's *Church at Auvers-sur-Oise* (fig. 5, *Plate 1*) seems to you and that both of us experience the pleasure these works produce in the same amount of time. How can we now distinguish between the upper regions and the lower depths? How does the thrill I get from Kinkade differ from your admiration of Van Gogh? You may try to explain the difference by contrasting the harsh and emphatic brushwork of *Church at Auvers-sur-Oise*, which contributes to the sense of anguish that haunts Van Gogh's late works, to the hazy

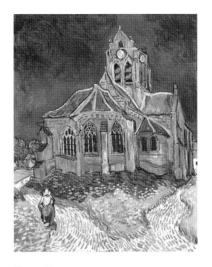

Figure 5
Vincent van Gogh, *Church at Auvers-sur-Oise*, 1890, Musée d'Orsay, Paris, France

Unfortunately, Thomas Kinkade has refused to give his permission to print an illustration of *Dogwood Chapel*. Interested readers may want to consult one of the following web sites for a version of the painting: http://www.kinkadecapitola.com/dogwood_chapel.htm or http://www.christcenteredmall.com/stores/art/kinkade/dogwood_chapel.htm

Figure 6

Balthasar Klossowski de Rola (Balthus),
Therese Dreaming, 1938, The
Metropolitan Museum of Art, New York

smoothness that seems almost designed to rob *Dogwood Chapel* of any hint of individuality. Its shifting, snake-like outline makes Van Gogh's church seem unstable and sinuous and gives it an air both threatened and threatening, while Kinkade's chapel, nesting comfortably within a postcard-like scene of stream, bridge, forest, and distant peaks, is what every tourist might expect to see in some country that doesn't exist during a trip that is never taken. Lit brightly from above, Kinkade's sky may remind the cultured viewer in you of Tiepolo or Luca di Giordano, but its only effect is to reinforce the picture's mawkish sense of comfort (God is in His heaven and all's well with the world), while the gradual darkening of the upper sky in *Church at Auvers-sur-Oise* announces an impending doom, perhaps Van Gogh's suicide barely a month after completing the picture. All that is fine. But is it more than just talk, unrelated to the original experience? If the experience of beauty is already complete, no sophisticated analysis can affect it, and the aesthete's urbane appreciation begins to look like a deceitful version of the lowbrow's sentimental bliss.

Imagine now that both of us are looking at *Therese Dreaming* (fig. 6), which, like all of Balthus's paintings of young girls, hovers near the pornographic, and that we are both attracted to the picture at the same time. I can see how it affects you by your sly smile, and that makes me uncomfortable. I want to show—to you and to me both—that it appeals to me in a different way, subtle and refined. I may admit that the picture is charged with eroticism (but what does "eroticism" mean in this context? I am tempted to say that it provides a way of claiming that *others*—not I—will find it exciting and that my awareness of its power should raise some questions about my sincerity). I may also cite a critic who admires it because "the clear white of the girl's skirts and undergarments surrounds her legs like a paper cornucopia wrapped around a romantic bouquet of flowers [while] echoes of Morandi and Cézanne are sounded in the simple vases" in the background. But, once again, it won't be easy to convince you (or, I suspect, myself) that the pleasure we both felt was in my case discerning enjoyment while you were in the grip of vulgar lust.

What strikes us first about things in the world is their appearance. If beauty, then, strikes as swiftly as Addison believed, it is a feature of appearance. Let's leave aside for now the question whether that, as many people believe, makes beauty "subjective" and closer to the "agreeable" than Kant would ever have wanted. Let's turn instead to the problem that appearance, according to yet another tradition that goes back to Plato, is the foremost object of desire, especially desire of the most questionable kind, rooted in sense and sensuality. The desires elicited by how things look, and not by what they really are, aim at pleasures that Plato says are neither "true" nor "pure." It is the philosophers, who know the nature of things, who experience the "truest" pleasures and enjoy them without becoming their slaves. Like illusionist paintings, the pleasures of appearance mislead their pursuers about nature and value. If beauty is confined to appearance (that, by the way, is not at all Plato's view), it can't be a reliable guide to the nature of things. If it is limited to the equivocal desires appearance elicits, it can't be an authentic mark of their value. It is not only superficial but also seductive.

Not everyone, of course, sees the harm of that. Many defenders of beauty agree with its opponents that it belongs to appearance, and for that reason see appearance in a positive light. In the fact that design has now become essential to every aspect of everyday life, Virginia Postrel, for example, sees a victory for aesthetics, which she takes to be "the way we communicate through the senses . . . the art of creating reactions without words, through the look and feel of people, places, and things." She considers it a great achievement of contemporary culture to have finally realized that "surfaces matter, in and of themselves." For her, design provides a way of differentiating between different objects that perform the same function equally well, and she values it because she believes that it furnishes their owners with a means for expressing their individual character through their possessions. In what is surely the best known part of her book she declares that "the toilet brush is an unusually pure example of aesthetic demands. . . . A brush hidden in the corner of the bathroom, a bathroom your neighbor will quite likely never see, is surely just a brush, an object acquired for its own sake. . . . The look and feel of your toilet brush are just that—sensory

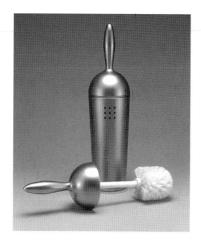

Figure 7
Michael Graves, *Toilet Brush*

pleasures, expressions of what you find appealing" (fig. 7). Although it is central to the argument I will be making in this book that we need to understand both beauty and aesthetics as generously as possible, this seems to me more like profligacy—not because toilet brushes are incapable of expressing a personality but because ownership is not by itself enough for that purpose. Aesthetic preferences are essential to the expression of character—that is one of their most important functions—but to do so they must fit into a coherent whole. My toilet brush—or, for that matter, my Tuomo Manninen photograph—may tell you something about my social class or my financial resources, but neither one manifests anything more specific about me. Character is manifested only through a pattern of choices, and not everything that is part of my household is also part of a pattern.

We will have to look at that question carefully later on. For the moment, I want to point out that not everyone agrees that aesthetics has won the day. The critic Dave Hickey, for example, locates beauty squarely within appearance but is far less optimistic about the fate of surfaces and the place of beauty in contemporary art. On the contrary, he believes that the most powerful figures in the art world are people who "distrust the very idea of appearance and distrust most of all the appearance of images that, in virtue of the pleasure they give, are efficacious in their own right." Hickey, who lacks Postrel's wide-eyed enthusiasm for the ethical benefits of beauty, values it simply for the pleasure it gives. That does not mean that he thinks it serves no other function. On the contrary, Hickey attributes to beauty a crucial role: it is, he claims, visual rhetoric, intended to offer pleasure to a picture's beholders in order to capture their attention and dispose them positively toward the message the picture communicates. But rhetoric can be deceptive, and the content of the image may be anything but benign. Beauty encourages the audience to "valorize" the content of the image, but if that content is indeed "in need of valorization" the value of beauty cannot lie in what it serves to communicate. It consists, Hickey argues, only in the pleasure it provides and that makes it valuable in itself, whatever its consequences.

But that is just what beauty cannot be for those who value messengers only if they welcome their messages. Some—like Dada, which

against the background of the Great War declared that "Goethe and Schiller and Beauty added up to killing and bloodshed and murder" or some strands of feminism faced with the glorification of glamor—take the radical view that it is *bad* to be beautiful. Others, more moderately, simply refuse to believe that being beautiful is always *good*. They do not regard beauty as a virtue in its own right, its mere presence enough to make its bearer more valuable than it would be without it. Arthur Danto, for instance, locates beauty wholly on the surface of things, and finds many great works of art beautiful but does not believe that they are ever great *because* they are beautiful. That is for him the great lesson of Modernism: "The discovery that something can be good art without being beautiful [is] one of the great conceptual clarifications of twentieth-century philosophy of art, though it was made exclusively by artists."

On such an understanding, beauty—what we might call "good looks"—can sometimes be a definite fault. It is exactly because their beauty seems inappropriate to their content that Sebastião Salgado's photographs of the displaced (fig. 8), Mapplethorpe's depictions of sadomasochism (fig. 9), Bouguereau's fantasies of naked women

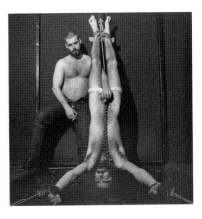

Figure 9
Robert Mapplethorpe, *Elliot and Dominick, 1979*

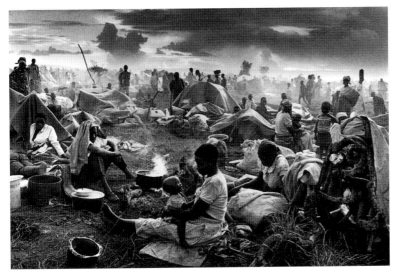

Figure 8
Sebastião Salgado, *Rwandan refuge camp of Benako, Tanzania, 1994.*
© Sebastião Salgado / Amazonas / nbpictures

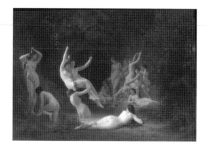

Figure 10
William-Adolphe Bouguereau,
The Nymphaeum, 1878, The Haggin
Museum, Stockton, CA

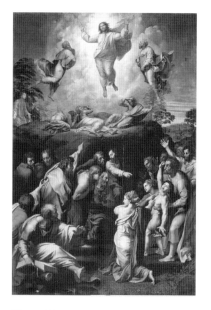

Figure 11
Raffaello di Sanzio (Raphael), *The
Transfiguration*, 1518–20, Pinacoteca,
Vatican Museums, Vatican State

(fig. 10) or even Raphael's visionary *Transfiguration* (fig. 11) are objectionable to people with particular moral, political, and religious sensibilities.

The view that the beauty of art is all on the surface mirrors some common sentiments about the beauty of people: We are attracted to beautiful people; we often admire them; we sometimes fall in love with them. But looks can be misleading and in the long run they always fade away. Unless our lovers are intelligent, spirited, kind, or understanding, unless their "inner" character is attractive, love is bound to fade away as well. Beauty alone cannot sustain it, although it may sometimes give love its spark. But most of the unattractive people in the world, which is to say most of the people in the world, have been loved without it. In the end, beauty is as irrelevant to the genuine worth of human beings as it is alien to the real value of the arts.

None of these common sentiments is true. Beauty and love are much more intimately connected, as Plato knew, but before we try to say how, we must follow this line of thought to its conclusion. Once it is agreed that the most ravishing picture is not a good picture, if it is good, because it is ravishing, and that the ravishing is all done by its surface, it is natural to take a further step. If the value of a work of art does not lie in its appearance, it must depend on features that lie more deeply within it. It is therefore difficult both to discern and to appreciate, and it is revealed only through the laborious efforts of criticism. That step leads directly into the heart of a certain understanding of the various arts of Modernism.

Modernist Voices

One of the central characteristics of Modernism, both critics and admirers agree, was an effort—largely successful—to detach the value of art from its appearance. Some of the most representative modernist works illustrate, among other things, a sense that neither the appearance of the world nor the surface of a painting is where their value lies. Various movements and individuals converged on that idea from many independent directions. Kasimir Malevich, for example,

thought that figurative painting was "doubly" dead because "first it depicts culture in decay and, second, it kills reality in the very act of depicting it." His *Black Square* (fig. 12) was much more complex than it seemed: "The world as feeling . . . the ideas—that is in essence the content of art. A square is not a picture, just as a switch or a plug is not electricity. Anyone who . . . saw the icon as . . . a picture was mistaken. For he mistook the switch, the plug, for a picture of electricity." Wassily Kandinsky was equally explicit. "Color makes a momentary and superficial impression on a soul whose sensibility is slightly developed. . . . But to a more sensitive soul the effect of colors is deeper and intensely moving. . . . They produce a correspondent spiritual vibration, and it is only as a step towards this spiritual vibration that the physical impression is of importance."

That kind of disregard for the obvious and the physical is not limited to abstraction. Arthur Danto refuses to see any connection with beauty—artistic beauty, that is—even in the phantasmagoric colors of Matisse. He doesn't think that Matisse's bold early work, *Blue Nude* (fig. 13, *Plate 2*), could possibly be considered beautiful:

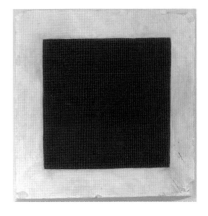

Figure 12
Kazimir Malevich, *Black Square*, c. 1923–30, Musée National d'Art Moderne, Centre Georges Pompidou, Paris, France

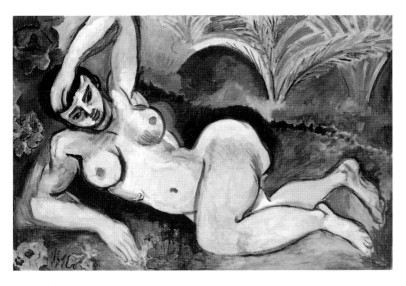

Figure 13
Henri Matisse, *Blue Nude*, 1907, The Baltimore Museum of Art: The Cone Collection, Baltimore, MD

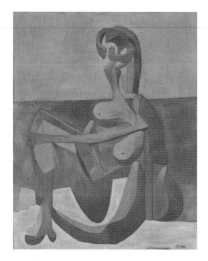

Figure 14
Pablo Picasso, *Seated Bather* [*La Baigneuse*], 1930. Oil on canvas, 64 ¼ × 51". Mrs. Simon Guggenheim Fund. (82.1950) The Museum of Modern Art, New York, NY, USA. Reproduced by permission from Art Resource, NY. Pablo Picasso (1881– 1973) © ARS, NY. Photo credit: Digital Image © The Museum of Modern Art / Licensed by SCALA / Art Resource

When one says that *Blue Nude* is beautiful, one is merely expressing admiration for its strength and power, for Matisse's decision to present us with a powerful painting rather than a pleasant one, to draw our attention to the painting rather than to the woman. . . . One has . . . to work at seeing a painting as good despite its not being beautiful, when one had been supposing that beauty was the way artistic goodness was to be understood.

Matisse, I think, would not have agreed. When he said that in *Blue Nude* "it was no longer the woman that was beautiful, but the picture," he didn't mean that the picture was merely strong and powerful, but he also didn't have to mean simply that his picture was good-looking. William Carlos Williams, too, seems to have found beauty in the painting: "In the french sun, on the french grass in a room on Fifth Ave. [he saw *Blue Nude* in New York], a french girl lies and smiles at the sun without seeing us." Beauty is not identical with an attractive appearance, although it is not nearly as independent of it as our easy dichotomies between "inner" and "outer," "sensual" and "moral," "physical" and "spiritual," or "ordinary" and "artistic" make it comfortable to believe. Their relationship is much more vexed and complex: beauty is always manifested in appearance without ever being limited to it, and I will have more to say about that later in this book.

In the meantime, though, I want to turn to Danto's reasons for thinking that *Blue Nude* can't be beautiful. He gives two: one is that Matisse painted as blue what in reality was pink; the other, that he painted as hideous what in reality might have been beautiful (but what if it wasn't?). The first assumes that in order to be beautiful a representation must be faithful to the appearance of its subject (else why question the color of the woman's body in the painting?), the second, that the perception of beauty—unlike, say, the perception of power—is always accompanied by pleasure (else why say that Matisse created a powerful picture "rather than" a pleasant one?). Both seem puzzling to me: the first, because it is often necessary to falsify appearances in order to produce a beautiful representation; the second, because beauty elicits reactions that are much too complex to be

thought of simply as pleasure. Still, since everyone who has thought about beauty seems to agree that its connection with pleasure is obvious, it would be fair to say that if, like Danto, you believe that Modernism pushed beauty aside but, unlike him, you find no comparable satisfaction in power, you will understand why Dave Hickey laments "the continuing persistence of dated modernist conventions concerning . . . the inconsequence of 'beauty' in twentieth-century images" and the loss of figuration and illusionistic space that has left us "content to slither through [the] flatland of Baudelairian modernity."

Take away Danto's exuberance and Hickey's melancholy (not to mention Matisse's doubts), and it does seem hard to deny that there is some truth in such accounts of Modernism. Already in 1907, before Roger Fry and Clive Bell forced a large international audience to question the importance of beauty and Dada tried to produce art out of ugliness, Picasso had begun his lifelong game of hide-and-seek with beauty in *Les Demoiselles d'Avignon*. It was a game he sometimes played by recreating famous works by other painters—*Las Meñinas*, *Déjeuner sur l'herbe*, *The Rape of the Sabines*—in his own vocabulary. Leo Steinberg has shown that a technical problem—how to depict a body simultaneously both from the front and the back—was at the heart of Picasso's many versions of Delacroix's *Femmes d'Alger*, but, whatever else they are about, all his great works in this genre are also about eliminating the traditional figures of beauty from their models. Nowhere is that more obvious than in his *Seated Bather* (fig. 14, *Plate 3*), which must surely be a version of Bouguereau's own version of the same popular subject (fig. 15, *Plate 4*).

The open picture plane and spatial recession of Bouguereau's picture issue an invitation to the viewer and encourage him—this is primarily a painting for men—to enjoy the radiant sensuality of the young woman's flesh, soft and bright against the dark craggy background. Exuding innocence and guile in equal parts, she seems aware of being watched, and her look is both somewhat embarrassed and also a bit gratified. Her legs are drawn close to her body, perhaps in an attempt to cover her nakedness, but her pose is too carefully arranged and her face is too composed to convince that she doesn't realize that her right breast,

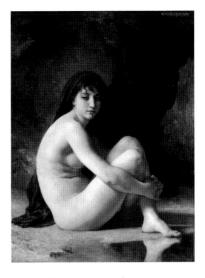

Figure 15
William-Adolphe Bouguereau, *Seated Bather*, 1884, the Sterling and Francine Clark Art Institute, Williamstown, Massachusetts, USA

to which the eye is drawn by her midriff, creased by the effort to clasp her arms together over her legs, is partially and invitingly exposed. Her shoulders, which are slightly hunched, and her pensive expression give her an air of vulnerability—although, if you look carefully, you may notice the barest shadow of a knowing smile on her face.

Bouguereau himself may have been thinking of another painter here: his bather is a tame, domesticated version of Victorine Meurend in Manet's *Déjeuner sur l'herbe* (fig. 16). Her semi-abstracted look is

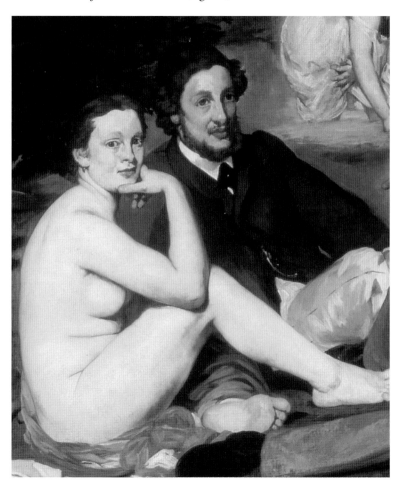

Figure 16
Edouard Manet, *Le Déjeuner sur l'herbe (Luncheon on the grass)*, 1863, Musée d'Orsay, Paris, France

worlds away from Victorine's unyieldingly self-conscious stare. Her body displays the same slight flaws as Victorine's, but their effect is altogether different. Manet, like Courbet, had used the wrinkles and pouches that seldom mar the academic nude as insults—insults to his audience and the type of painting they were familiar with. Victorine's imperfections (imperfections, that is, relative only to the academy's archetypes) were designed to jolt the audience, especially the men among them, into acknowledging that what they were enjoying was not a painted canvas or an idealized figure with an edifying message but a naked woman of their own place and time: their pleasure was nowhere near as innocent as they would have liked to think. But Bouguereau's picture, like his bather, is fully at his viewer's service. Instead of thrusting her into the harsh light of the everyday, the folds in her midriff are a sign of her innocence and delicacy and the response they ask for is not prurient but tender. The painting aims to provoke in its audience a desire to possess the girl at the same time that it encourages in them the urge to protect her. If we leave aside what might be a disturbing allusion to the blue veil characteristic of the iconography of the Madonna, it is clear that the picture is contrived to give pleasure without troubling its male viewers (or the women who would also inevitably see it). Its purpose is to make things easy, to stir a sensual desire but let it emerge as a generous, compassionate impulse.

Picasso inverts all that, beginning with the pose of his bather, which is a mirror image of Bouguereau's, accurate down to the high arch of her forward foot. Bouguereau painted his *Seated Bather for* his audience; Picasso, we could say, *against* them. Moving his figure forward, Picasso closes the picture plane, and the painting no longer invites its viewer to enter and look; on the contrary, it is now the predatory, threatening figure, almost protruding from the canvas, that is doing the watching. Bouguereau's soft, light-colored flesh has become a collection of stone-like limbs darker than the background against which they are placed—the darkness from which the girl might have to be saved has been transformed into a peaceful view of sea and sky marred by a menacing presence. Picasso has rotated the body of his figure toward the front of the composition, with legs spread apart,

and lets her expose everything Bouguereau had primly concealed. But because her face (if her saw-like teeth and her blank eyes add up to a face) can't possibly express anything, it is impossible to tell if she sits in plain view because, like an insect, she lives in a world to which human observers are altogether irrelevant or because—as the aggressive forward thrust of her right leg may suggest—she is daring the viewer to draw near as he would have approached the gentle girl of which she is the sinister transformation. This picture makes nothing easy. A casual viewer wouldn't think to ask himself why he should rest his eyes on Bouguereau's bather (at least if he had no moral objections to nudes or aesthetic ones to academic painting), but Picasso's makes you ask why you should look at her at all. If this *Seated Bather* is worth looking at, it can't be because of its beauty.

The modernist arts and the rhetoric that surrounds them made much of the idea that artistic value, even when they called it "beauty" and connected it with pleasure, is independent of beauty and pleasure as we usually think of them. The confusion of terms made it even more difficult to give this obscure idea precise expression, forcing Guillaume Apollinaire, one of the first apologists of Modernism, to resort to the manner of negative theology:

> Modern art rejects all the means of pleasing that were employed by the greatest artists of the past: the perfect representation of the human figure, voluptuous nudes, carefully finished details, etc. . . . Today's art is austere. . . . If the aim of painting has remained what it always was—namely, to give pleasure to the eye—the works of the new painters require the viewer to find in them a different kind of pleasure from the one he can just as easily find in the spectacle of nature.

A picture like Botticelli's *Birth of Venus* appeals easily to large groups of anonymous viewers from many backgrounds, either because that is exactly what beauty, as visual rhetoric, does or else because, having become available to a large public for various other reasons, it gradually became part of the standards of what counts as a beautiful painting. In either case, beauty goes hand in hand with drawing power, which

is one reason why Modernism, which exploited the popular arts but was never itself intended for a popular audience, looked at it with disdain. It was not out of respect for the public that Stéphane Mallarmé, whose views on art and literature established what counted as advanced art in France in the late nineteenth century, urged concern for the audience:

> Every work of art, apart from its inner treasure, should provide some sort of outward—or even indifferent—meaning through its words. A certain deference should be shown the people: for, after all, they *are* lending out their language, and the work is going to turn it to some unexpected account.

Often self-consciously difficult, the modernist arts shifted the burden of communication from the work of art to its audience. It was no longer the work that had to attract its audience and bring it around, but the audience itself that became responsible for taking the initiative and making an effort to understand it and establish its value—a value that, since the work was seldom immediately appealing, must for a certain length of time be taken for granted. Genuine value is not obvious pleasure: the obvious is common. It is no better than decoration, and decoration, the Viennese architect Adolph Loos sneered in his famous essay of 1908, is fit only for the low, the primitive, and the deprived:

> I can accept the African's ornament, the Persian's, the Slovak peasant woman's, my shoemaker's, for it provides the high point of their existence, which they have no other means of achieving. *We* have the art that has superseded ornament. After all the toil and tribulations of the day, we can go to hear Beethoven or *Tristan*. My shoemaker cannot. I must not take his religion away from him, for I have nothing to put in its place. But anyone who goes to the *Ninth* and then sits down to design a wallpaper pattern is either a fraud or a degenerate.

As long as we continue to identify beauty with attractiveness and attractiveness with a power of pleasing quickly and without much

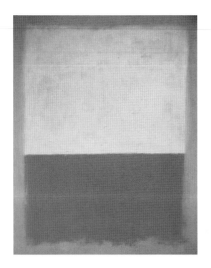

Figure 17
Mark Rothko, *Untitled*, 1998

thought or effort, we can't even begin to think of many of the twentieth century's great works as beautiful. Even when they are, their value must be sought elsewhere. And so, following in Kandinsky's footsteps, we go looking for the deep spiritual meaning of Mark Rothko's late works (fig. 17), hoping to find in them "a harmony, an equilibrium, a wholeness in the Jungian sense, that enabled him to express universal truths in his breakthrough works, fusing the conscious and the unconscious, the finite and the infinite, the equivocal and the unequivocal, the sensual and the spiritual." He uses colors as signs, and the murals in the Rothko chapel in Houston evoke "his belief in the passion of life, the finality of death, the reality of the spirit. Red, so often the principal carrier of Rothko's emotions and ideas, is now accompanied by black, which symbolizes his state of mind and the character of his existence in the latter part of his life." No wonder that, approached with such ideas in mind, Rothko's work is surrounded by the most vacant and bewildered faces you are likely to see in a museum.

Modernist Appropriations

Apollinaire's rhetoric of radical difference became less appropriate once Modernism gradually established itself and needed to consolidate its success by showing that it was continuous with the great art of the past: the establishment has respect for itself. To make that connection, modernist theory looked for the separation of beauty from aesthetic value, which had so far been limited to twentieth-century artists, in their worthy predecessors as well. Clement Greenberg, the major voice in American art criticism and theory in the mid-century, and T. S. Eliot, whose magisterial tone set the course of literary practice and criticism over much of the same period, led the way.

A select group of nineteenth-century artists, Greenberg argued in his very first published essay, having absorbed the "scientific revolutionary thought" of their time, detached themselves from capitalist society and created a completely new phenomenon: avant-garde culture. At the same time, industrialization brought huge masses of

workers from the country into the cities, where, deprived of their genuine "folk" traditions, they required a totally new form of distraction and entertainment: "ersatz culture, kitsch." The gap between avant-garde art and kitsch is absolutely unbridgeable. The avant-garde art wants nothing to do with the decadence that surrounds it: "The avant-garde poet or artist tries in effect to imitate God by creating something valid solely on its own terms, in the way nature itself is valid." The avant-garde renounces representation and, in the end unable to imitate God, it turns to the imitation of "the disciplines and processes of art and literature itself." It takes its own medium as its proper subject matter and as source of its inspiration. Purged of representation, it seems austere, barren, and mysterious to the vast, uncultivated majority of the public and forces them to turn to the quick and crude satisfactions of kitsch, which demand nothing from them "except their money—not even their time." While kitsch takes everything for granted and is easy for everyone to assimilate, having no purpose other than diversion, avant-garde art questions the world as we know it and requires hard work and a special public, because its aim is, literally, to create a new culture:

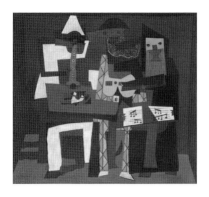

Figure 18
Pablo Picasso (1881–1973), *Three Musicians*, 1921. Oil on canvas, 6'7" × 7'3 ¾". Mrs. Simon Guggenheim Fund. (55.1949), The Museum of Modern Art, New York. Reproduced by permission from Art Resource, NY. Photo credit: © The Museum of Modern Art / Licensed by SCALA / Art Resource, NY

> The ultimate values which the cultivated spectator derives from Picasso [the avant-garde, fig.18], are derived at a second remove, as the result of reflection upon the immediate impression left by the plastic values. . . . Where Picasso paints *cause*, [Ilya] Repin [kitsch, fig. 19], paints *effect*. Repin predigests art for the spectator and spares him effort, provides him with a short cut to the pleasure of art that detours what is necessarily difficult in genuine art. Repin, or kitsch, is synthetic art.

Between them, uneasily, stands the *New Yorker*: "high-class kitsch for the luxury trade" (fig. 20).

Greenberg has only contempt for kitsch, which relies essentially on representation, narration, and drama—features central to the traditional arts—but that doesn't prevent him from admiring Giotto, Michelangelo and Raphael, Shakespeare, and Rembrandt—even the medieval artist who worked under the Church's direction: "Precisely

Figure 19
Ilya Repin, *St. Nicholas Delivers Three Unjustly Condemned Men from Death*, 1888, State Russian Museum, St. Petersburg, Russia

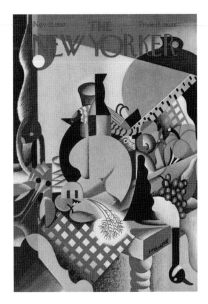

Figure 20
Theodore G. Haupt, *New Yorker*.
Reproduced by permission from
Condé Nast Publications. Copyright ©
1930 *The New Yorker* / Condé Nast
Publications. Reprinted by permission.
All rights reserved

because his content was determined in advance, the artist was free to concentrate on his medium. . . . For him the medium became, privately, professionally, the content of his art, even as his medium is today the public content of the abstract painter's art." On the contrary, Greenberg wants to vindicate the judgment of "the cultivated of mankind" over the ages, and he attributes their agreement on what is good and bad art to "a fairly constant distinction . . . between those values only to be found in art and the values which can be found elsewhere." What that means is that great art has always been concerned with its own medium and devoted to "formal" problems and that its best audience has always appreciated it for that reason. Modernism just made explicit what had been up to then unknowing and unselfconscious. It showed that content that is easy to understand, telling a story, "sunset, exploding shells, running and falling men"—whatever a coarse peasant might find attractive—lies outside the proper content of art, the investigation of what painting or poetry, *as* painting or poetry, can legitimately accomplish. Aesthetic value has never resided in what goes by the name of beauty, although it took the austerity of Modernism to show that only kitsch holds proper dominion over its facile pleasures.

Greenberg eventually transformed this idea into a sweeping, metaphysical account of the essence of art. Like Kant, who investigated rationally how far reason can go without lapsing into the irrational, modernist artists used their medium in order to establish the limits beyond which it is no longer pure and uncontaminated by features that belong to different arts. Each art, in Kantian terms, sought to establish the conditions of its own possibility. Painting, in particular, tried to isolate the features of a painting that make it just painting and not, say, sculpture or theater, and so it discovered "the ineluctable flatness of the support." Neither three-dimensional space nor stories that require it but only flatness, two-dimensionality, is the condition painting shares with no other art. Turning away from sculptural and theatrical elements, painting abandoned "the representation of the kind of space that recognizable, three-dimensional objects can inhabit" and rested content with flatness, the norm that has governed the making of pictures "since pictures first began to be made." Modernism didn't

change the practice of painting; it "never meant a break with the past [and] left most of our value judgments intact." It only made plain what was always and necessarily true of painting, vindicating the great masters while showing that "though the past did appreciate masters like these justly, it often gave wrong or irrelevant reasons for doing so." Beauty, or what we ordinarily take beauty to be, was first among these wrong or irrelevant reasons, and has nothing to do with the value of art. Greenberg, who had no difficulty with the word, could write that "what is thought to be Pollock's bad taste is in reality simply his willingness to be ugly in terms of contemporary taste. In the course of time this ugliness will become a new standard of beauty." But what he understood by it was something that did not even belong to art as a whole: it was the exclusive feature of high art. He saw Modernism as "a kind of bias or tropism: towards esthetic value, esthetic value as such and as an ultimate," a response to "a growing relaxation of esthetic standards at the top of Western society" in the mid-nineteenth century that aimed at maintaining or restoring "a most essential continuity: continuity with the highest esthetic standards of the past." Modernism's success was the victory of those standards over the debased principles by which the arts had been in danger of being judged—a victory of the pure passion of the few over the maculate velleity of the many: the modernist arts succeeded in "demonstrating that the kind of experience they provided was valuable in its own right and not to be obtained from any other kind of activity."

Greenberg's attitude toward the art of the past seems moderate and conciliatory compared to T. S. Eliot's wholesale rejection of the poetry which, as he saw it, separated him from his real predecessors—Donne, Chapman, Marvell, Herbert, and the other "metaphysical" poets of the late Elizabethan era. "A direct sensuous apprehension of thought, or a recreation of thought into feeling," a true harmony between reason and emotion, lifts their poetry above everything that intervenes because the harmony was lost in the seventeenth century, and under the influence of Milton and Dryden "a dissociation of sensibility set in, from which we have never recovered." As the language of poetry became ever more urbane and sophisticated while

the feelings it communicated were constantly getting more common and crude, a later generation of poets rejected reason and description as the enemies of deep and refined emotion and fell into an exaggerated sentimentalism. The lowest point of that downward trend is the poetry Eliot's public had been brought up on: of Tennyson's or Browning's sensibility, it is better to "say nothing"; of their intellect, the best is that they "ruminate."

Eliot was willing to dismiss two centuries of English poetry as both intellectually overrefined and emotionally coarse because his purpose was to argue that Modernism had rediscovered the essential virtues of poetry (he mentioned Baudelaire, Laforgue, and Corbière, and was coyly silent about himself). Metaphysical poetry was distinguished from everything that followed it by the very same harmony of feeling and thought that distinguished Modernism from everything that preceded it and made them both equally incomprehensible to a public that had been brought up on neoclassical dryness and romantic excess. Nothing written during that time could possibly accomplish, and none of those who took pleasure in it could ever appreciate, the serious, complex task both modernists and metaphysicals had set themselves:

> It appears likely that poets in our civilization, as it exists at present, must be *difficult*. Our civilization comprehends great variety and complexity, and this variety and complexity, playing upon a refined sensibility, must produce various and complex results. The poet must become more and more comprehensive, more allusive, more indirect, in order to force, to dislocate if necessary, language into his meaning.

Despite his historical vocabulary, Eliot didn't believe that the task of poetry changes with the times. The value of the metaphysical poets is "something permanently valuable, which subsequently disappeared, but ought not to have disappeared." Nothing comparable can ever be found in poets who, however accomplished, "do not feel their thought as immediately as the odour of a rose," and the most obvious mark of their poetry is—these are *his* words—that it is not various or complex,

comprehensive, allusive or indirect, able to force or dislocate language; in short, that it is *easy*. Deprived of the paradoxical conjunction of feeling and thought that is the soul of poetry, it offers distraction without edification, pleasure without insight. That is what Tennyson's and Browning's admirers think of as beauty and (for good reason) cannot find in Donne, Laforgue, or Eliot himself: *their* poetry has nothing to do with the easy satisfactions of those for whom poets "look into our hearts and write." But such poets are too simple and "not deep enough; Racine or Donne looked into a good deal more than the heart. One must look into the cerebral cortex, the nervous system, and the digestive tracts." Beauty, if we still want to use the word at all, does not even belong to high art as a whole but only to a small subdivision within it.

For Greenberg, what most people take beauty to be is mostly irrelevant to the value of art. With Eliot, it turned out to be serious art's frivolous but deadly enemy. While Modernism held sway and the dependence of art on beauty, with its connections to the rest of the world, kept diminishing, the rule of the aesthetic expanded until, as Modernism began to lose ground and continued to do so, it too came under attack, especially during the 1980s. In the introduction to *The Anti-Aesthetic*, an influential anthology that both expressed and determined that period's attitudes, Hal Foster wrote that

> the very notion of the aesthetic, its network of ideas, is in question here: the idea that aesthetic experience exists apart, without "purpose," all but beyond history, or that art can now effect a world at once (inter)subjective, concrete and universal—a symbolic totality. Like "postmodernism," then, "anti-aesthetic" marks a cultural position on the present: are categories afforded by the aesthetic still valid?

My own answer to all these questions is "No." But to the extent that they raise problems for the aesthetic, they leave beauty untouched, for beauty, the rest of this book will try to show, is part of the everyday world of purpose and desire, history and contingency, subjectivity and incompleteness. That is the only world there is, and nothing, not even the highest of the high arts, can move beyond it.

II

Criticism and Value

One of the most famous scandals in the history of art broke out when Edouard Manet's *Olympia* (fig. 21, *Plate 5*) was first exhibited in the Salon of 1865 along with his *Jesus Mocked by the Soldiers*. It made the crowds that flocked to see it so violently indignant that the exhibition's officials decided to move both pictures to a back gallery and place them so high that they were nearly invisible: "You scarcely knew whether you were looking at a parcel of nude flesh or a bundle of laundry," one critic remarked; "*Olympia* looks like a huge spider on the ceiling," said another.

The picture provided the cartoonists with an incomparable target. The critics were devastating—sarcastic, dismissive, and every bit as indignant as the general public (fig. 22). They hated everything about the painting, but they were especially galled by two things, to which they returned again and again: the work appeared unfinished and it was totally incomprehensible. Some of their complaints were stock

Figure 21
Edouard Manet, *Olympia*, 1863, Musée d'Orsay, Paris, France

Figure 22
Bertall, *The Cat's Tail or the Charcoal-seller of Batignoles*, 1865

Figure 23
Alfred Stieglitz, *Fountain*, Tate Gallery, London, UK, photograph of sculpture by Marcel Duchamp, 1917

critical figures or exaggerations, but the consistent use of words like "unformed," "indecipherable," or "unspeakable" suggests not simply that they didn't like the picture but that they just didn't know how to react to it—that they couldn't tell whether Manet had made a genuine work of art *at all*; one confessed, "I . . . do not know if the dictionary of French aesthetics contains expressions to characterize her."

Some people express extreme confusion as righteous indignation and violent denunciation; others dread having to make any response, fearing that only a dupe or a hypocrite would claim to admire, and only a philistine would dare to reject, a work no one understands. Confusion of that type has been one of the most characteristic effects of the modernist arts and their many successors (figs. 23, 24, 25). One school replaced another almost as fast as fashions were changing, left the public profoundly uncomfortable, and made it hard to imagine a time when the experience of art did not include the nagging suspicion that what was on offer was not the real thing at all.

I am thinking of a specific feeling of blankness that takes over when I am faced with something completely incomprehensible but

Figure 24
Andy Warhol, *Brillo Box*, 1965, The Museum of Modern Art, New York

Figure 25
Stelarc, *Spin Suspension*, 1997

still presumed to be a work of art—a blankness that makes me avoid the eyes of anyone asking whether I like it and smile evasively in the hope of forestalling any further questions. It is a mental silence broken only by the stirring of a question that makes me very uncomfortable (for it is not only the philosopher's question, it is also the philistine's)—*Why* is this a work of art?—and eventually leads to another that is even more disturbing because I know I can't give it an answer—*What* is art? These questions had never been urgent as long as the arts were taken for granted; they were raised only when the radical innovations of the nineteenth century began to erode the public's confidence in traditional certainties. The first work to address them systematically, Leo Tolstoy's *What Is Art?*, did not appear until 1896, but the question of the definition of art has gradually become the starting point of every textbook on aesthetics, and it can be raised about anything whatever—ancient Greek oil jars, French suits of armor, Maori feeding funnels (fig. 26), even the *Mona Lisa*. Is there a line that separates everything that is a work of art from everything that isn't? If we define art generously enough to include hanging yourself from the ceiling by hooks piercing your nipples as a work of art, then it might seem that *anything* can count as art, which may seem incompatible with the value we attribute to the arts and their role in society. If, on the other hand, we define it narrowly enough to exclude Stelarc's performance (because, we might say controversially, self-mutilation is unacceptable), it may prove impossible to include things that many are perfectly willing to treat as serious works of art—Orlan's series of surgical self-transformations (fig. 27), for instance, or *Self*, Mark Quinn's effigy of his head in his own frozen blood, or tattooing.

These are important issues that deserve careful consideration—but not here: our interest is not quite that theoretical. Imagine that you are watching *L'Empereur de la perte*, a monologue by Jean Fable described by *Le Monde* as "a totally vacuous and vain text . . . an imposture bloated by its own importance and of abysmal tedium." Although questions concerning the definition of art will be hovering in the background, your first question is whether to stay or leave and

the second, whether the business on the stage has a *point*. In order to answer that question, you will have to try to *interpret* the spectacle, to see whether the events on the stage occur as they do for a reason and are more than a meaningless assemblage of words and movements.

A meaningless assemblage, a disparate collection of unrelated elements that serve no common purpose—that is exactly what its original public thought of the *Olympia*. Théophile Gautier complained that the picture "does not explain itself from any point of view"; he couldn't understand why Olympia was so ugly, for what purpose a black maid was standing beside her with a bouquet of flowers wrapped in newspaper (why newspaper?) in her arms, what role the cat at Olympia's feet could possibly play. Even when they acknowledged Manet's technical skill, his critics couldn't say what the painting was about or give it a coherent description; the best they could do was to provide a list of various parts that failed to add up to a whole:

Figure 26
Feeding funnel (koropata), Maori peoples, Aotearoam, New Zealand, nineteenth century. Wood, 16.5 cm (6 ½ in.). Gift of William E. and Bertha L. Teel, 1991.1071. Reproduced by permission from the Museum of Fine Arts, Boston. Photo credit: © 2006 Museum of Fine Arts, Boston, MA

> This Olympia, a sort of female gorilla, a grotesque in India rubber outlined in black, apes on a bed, in a state of complete nudity, the horizontal attitude of Titian's *Venus*; the right [i.e., her left] arm rests on the body in the same fashion, except for the hand, which is flexed in a sort of shameless contraction. On the other side of the bed, a negress, "a gentle black messenger," brings to her, as she awakens, the spring in the form of a bouquet of flowers that gives no indication that it would please one's sense of smell. Who knows what a wretched skinny cat, of a beastly black color, is doing there, since it is miserably stretching its spine at the foot of "the august young girl in which the fire burns."

Again and again, failing to develop a unified account of the painting, the critics had to remain content with variations of such a list. The question one of them asked best expresses their collective frustration: "*Que signifie cette peinture?*" What does this picture signify? What is the point?

Manet's contemporaries were so indignant because it was clear that the *Olympia* was an attempt at a deliberate insult to academic painting and especially the academic nude—a prostitute for Venus, a

Figure 27
Orlan, *Self-hybridations precolombiennes no. 1*, 1999. Cibachrome collé sur aluminium, cadre : boite américaine, cornières et plexiglas Aide technique au traitement numérique des images : Pierre Zovilé

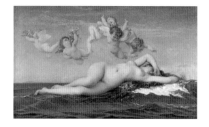

Figure 28
Alexandre Cabanel, *The Birth of Venus*, 1863, Musée d'Orsay, Paris, France

"Negress" instead of Nereids or Cupids, a cat where dolphins might be, a messy bed in place of delicate waves, no modeling, no soft hues, no plump and rounded figures. But unless the picture could demonstrate that new and better art could be made of its different technique, its new type of subject and the radical ideas it incorporated it could be nothing more than an *attempt* at an insult—no better than trying to abuse someone's family by screaming names of other families at random: it is difficult to insult someone else if you end up making a fool of yourself, and Fyodor Karamazov, who made a habit of it, is an uncommon character.

No theoretical proof of possibility will do: the only way to show that new and better art is possible is to create a work that some, at least, among its audience will at some time accept as new and better art. But that can happen only if they learn from its lessons and can interpret it so that what seems haphazard at first turns out to be there for a reason and helps make its point. In such a situation, not only critics but artists as well can function as the work's interpreters, if, that is, they can see its point and make something of it after adapting it to their own methods and purposes. Now when a work hurls an insult as deep as the *Olympia* did at the conventions of its time (figs. 28, 29), it will vindicate its arrogance and justify the time and effort needed to fathom its significance only if its point constitutes a genuine achievement. That mode of expression, though, is misleading, for it suggests that the insult and the point, the challenge and the achievement, are distinct, as if we can establish the challenge of the *Olympia* and then try to determine the magnitude of its accomplishment. In fact, we cannot recognize an insult (as opposed to an attempt to insult) unless it is to some extent successful and makes a minimum amount of sense. How deep it will be depends completely on the extent and the importance of what it puts down, and it is impossible, as we have seen, to put something down without envisaging a better alternative, which is, then, part of its point and accomplishment. The two go hand in hand, and what we call them reflects whose side we are taking. And so Émile Zola, Manet's earliest champion, found in the work a fundamental shift in the priorities

of painting, content becoming for the first time subordinate to form and showing up the outdated principles of the academy:

> Tell them aloud, *cher maître*, that a painting is for you a mere pretext for analysis. You needed a nude woman, and you chose Olympia, the first to come along; you needed clear and luminous tones, and you introduced a bouquet; you needed black tones, and you placed in a corner a Negress and a cat. . . . [Manet,] a child of our times . . . an analytical painter . . . has never committed the folly, as did so many others, of wishing to put ideas into his painting.

And that was only the beginning, as we will see when we return to the *Olympia* in a later chapter: the picture has been also credited with bringing the working class into the drawing rooms of the rich, showing new ways the painting of the past could serve the aims of the present, with forming part of a lifelong quest to blur gender distinctions and the line between the viewer and the viewed and with much else besides. The more it is seen to accomplish, the more it is seen to deny.

Most works, of course, aren't nearly as momentous. Still, I think it is impossible to treat an object as a work of art unless we see a point of some significance to it, however modest, unless it makes a difference, however slight. But everything significant is, to that extent, valuable as well. The moment interpretation begins and gives the first hint that different elements may be parts of a whole, an evaluation has already been made: "Her look has the sourness of someone prematurely aged, her face the disturbing perfume of a *fleur du mal*; her body fatigued, corrupted, but painted under a single, transparent light, the shadows light and fine, the bed and pillows put down in a velvet, modulated grey." The first critic to have something positive to say about the *Olympia* saw a connection between its form and content that calls for explanation and makes the picture worth another look: the search for significance cannot be separated from a judgment of value.

That is not to say that all critical judgments are positive, since critics are much more likely to describe a novel as "a long day's journey into tedium" or a video-art show as "just artsy pay-per-view TV" than

Figure 29
Jean Auguste Dominique Ingres, *Vénus Anadyomene*, 1848, Musée Condé, Chantilly, France

to say of a film that "it sets out to do something that is both noble and intricate, and wholly succeeds in doing it." Still, every artist knows that bad publicity is better than none, and Bishop Berkeley's definition of being, "To be is to be perceived," is actually true when it comes to the arts. To pay attention to something, if only to revile it, is already to have set it apart from an immense throng of undifferentiated, and indifferent, objects. The real opposition is not between the works of art one admires and those one detests, but between those that stand out enough to be noticed at all and those that just pass by, unable to attract a second look (although, I admit, I find it difficult to point to an example of things that have *failed* to capture my attention). Of the more than 3,000 works exhibited at the Salon of 1865, only a very few came up either for praise or blame. The *Olympia* provoked by far the strongest reaction among them; but, far from having caused it harm, the ferocity of its critics suggests that on some level they knew they were confronting something importantly different from the paintings to which they were accustomed. Harm was done only to the thousands that went, and have remained, unnoticed, outside the history of art.

If that is right, evaluation enters the moment criticism begins, inextricably tangled with interpretation and evident even in the choice of one work over another. Aesthetic value comes into criticism as early as we have been supposing beauty is perceived, and, as we shall see, the opposite is also true: beauty can enter the picture as late as we have thought aesthetic value emerges. The lines that seemed to keep them apart are already beginning to blur and will collapse when we see, as we will, that, as with aesthetic value, love clashes less with hate than with indifference and beauty is less opposed to ugliness than to the nondescript.

Immersed in evaluation, criticism doesn't aspire even to the degree of objectivity that some have claimed for art or literary history, and it is exactly for that reason that verdicts are neither its purpose nor its end. I would imagine that even a critic like Harold Bloom, who isn't shy about stating his preferences, doesn't take the declaration that "the plays remain the outward limit of human achievement: aesthetically, cognitively, in certain ways morally, even spiritually" to mark the

conclusion of his Shakespeare criticism. He doesn't write in order to determine how good the plays are or, for that matter, to convince his readers that they are as good as that (how good is that, anyway?). He writes in order to establish, for instance, Shylock as a comic villain, a truly anti-Semitic invention, or Othello (not Iago, whom contemporary criticism has often placed in that role), as the hero of his own tragedy—he writes in order to communicate his vision of the plays. If you happen to find his reading of Shakespeare convincing and manage to see—as Bloom believes everyone should—a bit of yourself in both Hamlet and Falstaff yet still, for some reason, hear more about the human condition in Bach's music than you can see on the Shakespearean stage, would you have a real argument with him? I can't believe that you would say that you had been misled, that Bloom's "judgment" of Shakespeare was wrong. We don't read the critics of *Hamlet*, or *Hamlet* itself, in order to determine how good the play is but in order to grasp what it has to offer us, which requires us to understand what is says; what it says may turn out to be truly magnificent, but making *that* judgment is never the purpose of reading.

If we can't wrest them apart, there is no good reason for thinking that critical evaluation is the end for which interpretation is the means; it could as easily be the other way around, a positive evaluation giving a reason for proceeding to interpret further—merit as means, in Nelson Goodman's words. Yet we have seen, in the previous chapter, the sway of the view that criticism tries to establish plausible interpretations of art on the basis of which it can then determine its value. According to that account, we read, we look and listen attentively because without an interpretation of a work, without understanding it, we can't make a confident judgment of its worth. The view comes in many variations, but on the general picture common sense, art theory, and the philosophy of art all seem to see eye to eye. Since the process of interpretation takes time, it seems that beauty must be different from aesthetic value because, depending as it does on how things look, it is among their manifest characteristics and does not need interpretation, while their aesthetic value can't become apparent without knowledge, sensitivity, and effort. Criticism may

or may not begin with beauty, but it certainly ends with a judgment on the value of its object. There is little agreement on the details of getting there, but an understanding of the route overall is solidly in place: criticism begins with (nonaesthetic) descriptions like "There is a red patch in the corner," goes on to aesthetic judgments of the sort "The color is vibrant," and concludes with overall aesthetic verdicts: "The work is brilliant, magnificent, pathetic."

I am thinking here of criticism in broad terms, including what is found in newspapers, magazines, books, radio, television, or the internet, and ranging from the casual conversations that begin by asking "Well, how did you like it?" after a film or a play, a concert, an exhibition or, for that matter, a TV show, to some of the most sophisticated art-historical and theoretical investigations. It is an essential part of all efforts to interact with and come to terms with the arts. But the idea that "having found out about all the components of the work, we put everything together and give a verdict" depends on, and encourages, a deep misunderstanding of both beauty and aesthetic value. It also has little to do with what critics do in real life, as the case of the *Olympia* may have suggested. Why, then, do we continue to think that the main aim of criticism is to determine the value of artworks and that criticism ends when it has done so?

The Role of Reviewing

The reason is that one segment of critical practice does seem to aim quite explicitly at judgments of value and end when it has issued them—reviewing. Reviewing has been most important to philosophy because it is teeming with "aesthetic" vocabulary. Words like "powerful," "swift," "fluid," "deep," "solid," "sharp," "eloquent," or "delicate" are thought to specify the features on which aesthetic value depends (or with which, as with words like "garish" or "clunky," it clashes).

The list of words above is not haphazard: they are examples of aesthetic terms that Arthur Danto, wishing to reflect actual critical practice, plucked not out of thin air but from a review of André Racz's

drawings, and reviews, as I will try to explain, are where aesthetic terms naturally belong. There is nothing unusual about Danto's choice. Here is another group of slightly more complicated expressions, which I haven taken from a review of Richard Tuttle's retrospective show at the Whitney Museum of American Art in 2005: "whispering details," "rapturous brand of intimism," "the ecstasies of paying close attention to the world's infinitude of tender incidents," "intense deliberation," "exquisiteness . . . akin to jewelry," " [works that] substituted handmade delicacy and lightness for industrial weight," "heavenly doodles," "Rube Goldbergian confections, brightly painted, divinely balanced," "refined respect for plain material facts and a fascination with immaterial ones like light, which verges on the spiritual." Like Danto's examples, these are all value-laden expressions, and it is not surprising that they are part of an enthusiastic account. When, on the other hand, a review of the final installment of *Star Wars* opens with the words, "Sith. What kind of a word is that? Sith. It sounds to me like the noise that emerges when you block one nostril and blow through the other, but to George Lucas it is a name that trumpets evil," you know that you are headed in a different direction. Carried along by expressions like "a terrible puritan dream" and "flawless and irredeemable vulgarity," you are ready for the closing comment: "I keep thinking of the rueful Obi-Wan Kenobi, as he surveys the holographic evidence of Anakin's betrayal. 'I can't watch anymore,' he says. Wise words, Obi-Wan, and I shall carry them in my heart."

And that seems to be as as it should. Reviews are meant to help us decide whether or not to visit an exhibition, read a book, or attend a performance. They are, in a sense, advertisements, although, since they are as likely as not negative, they are nowhere near as blatant and compromised as the catalogue essays that lend prestige, for a fee, to every gallery exhibition. A verdict, positive or negative, is exactly what we expect, and what we get, from them. But, once again, appearances are deceiving.

The fact is that reviewing, which is easy to find and easy to read, is for philosophy its main point of contact with criticism as a whole (as it is for most of the rest of the world). Most people with an

Figure 30
Jake and Dinos Chapman, *Zygotic acceleration, Biogenetic de-sublimated libidinal model (enlarged × 1000)*, 1995. Mixed Media, 58 13/16 × 70 9/16 × 54 14/16 in. (150 × 180 × 140 cm). © the artists. Reproduced by permission from Jay Jopling / White Cube, London, UK. Photo credit: Diane Bertrand

Figure 31
Robert Morris, *Untitled (Ring with Light)*, 1965–66, Cologne, Munich, Germany

interest in the arts, like most philosophers, take criticism to be a form of reviewing, and that assumption, I believe, gives this "juridical" interpretation of criticism its air of unquestionable authority. What can be questioned, though, is, first, whether reviewing as we have understood it so far is really representative of criticism and, second, whether that understanding of reviewing is correct in the first place.

On their own, a reviewer's words are neither easy to interpret nor enough to convince. If you don't know that Michael Kimmelman is Tuttle's reviewer, you won't be able to make anything of the piece. And if you are not familiar with Kimmelman's criticism, you will have trouble understanding what he takes the "whispering details" of Tuttle's work to be and why he thinks of them as a positive feature—after all, whispering details may be a defect in another work, clashing with its monumental sweep and robbing it of coherence. Only if you go to the show will you begin to recognize how Kimmelman uses his terms and, depending on how you react to Tuttle, whether he is a critic you might trust. But you will also need to read more of Kimmelman's criticism because it is only gradually that you will come to see what he tends to like and what to expect on the basis of his judgment. That doesn't mean that you will always agree with him: you may simply find that engaging with his way of seeing helps you to reach a different but satisfying view of the art; you may even find his taste and preferences inferior and, just on the strength of his praise, give Tuttle a miss. In that respect, critics and artists are the same: we cannot understand an individual piece in isolation from their other work, without an understanding of their manner, their purposes, and style.

But that isn't all. The same terms, like "whispering details," can sometimes pay a compliment and sometimes highlight a fault. Some words, of course, are less flexible than others. Of those on our original list, "powerful" is unlikely to work well as a put-down. But delicacy makes Salgado's photographs (fig. 8) distasteful; Jake and Dinos Chapman's demented figures (fig. 30) are repellent partly because they flow so fluidly into one another; and hollowness gives Robert Morris's *Untitled (Ring with Light)* (fig. 31) its magnetic attraction. Soutine's

manner of applying paint to a surface is "vehement, almost brutal," according to Clement Greenberg: a tribute or a swipe (fig. 32)?

It is difficult to know, but even if we manage it, it is impossible to tell whether we will agree with Greenberg until we look at Soutine for ourselves; nothing a critic ever says about a work can show how it will affect me when I am exposed to it directly. Aesthetic evaluation, as Kant saw, obeys no principles, and none of their features explains or is a reason why some things produce aesthetic delight while others do not: there are, in that sense, no standards of taste of the sort David Hume once hoped to establish. That is not simply because we disagree with one another so often: I can't even find such reasons for myself. Reasons are general. If a feature explains why something attracts me in one instance, it should do so in all—at least in my own case. Yet I know that the obsessive observation of social detail that gives such power to *In Search of Lost Time* is simply boring in the diaries of the Goncourts; that the long-lasting sexual tension between Niles and Daphne in the TV serial *Frasier* is the subject of some of the series' best episodes, while the sexual tension between Billy and Ally in *Ally McBeal* was dead from the very beginning. But if social detail or sexual tension explains why I like Proust or *Frasier*, how can it also explain why I hate the Goncourts and *Ally McBeal*?

One of Kant's most telling observations about beauty is that it "pleases universally without a concept," which is to say that "there can . . . be no rule in accordance with which someone could be compelled to acknowledge something as beautiful." That means that no account of why something is beautiful can ever be enough to prove that others should agree with me. As Arnold Isenberg put it, "There is not in all the world's criticism a single purely descriptive statement concerning which one is prepared to say beforehand, 'If it is true, I shall like that work so much the better.'" I can specify the particular shades of red whose combination and contrast I so admire in Botticelli's Uffizi *Annunciation* (fig. 33) as finely as I want, but what I tell you can't possibly convince you that you should judge it the same way: only looking for yourself will move you one way or another. But it is not only descriptions that can't support conclusions about aesthetic

Figure 32
Chaim Soutine, *Portrait of Man (Emile Lejeune)*, c. 1922–23

Figure 33
Sandro Botticelli, *Annunciation*, c. 1489, Galleria degli Uffizi, Florence, Italy

Figure 34
Sandro Botticelli, *La Primavera*,
c. 1478, Galleria degli Uffizi,
Florence, Italy

value: statements full of aesthetic terms won't do any better. Nothing I tell you about the dramatic tension of posture and facial expression, the diagonal that joins the two figures even as the disposition of their hands and bodies divides them, the echo of the *Primavera* Venus's pagan hand in the Christian Virgin's gesture (fig. 34), the mixture of sacred and profane in a pose that may have been derived from the dance called *Cupido*, which undermines as it animates the first of the five traditional "Laudable Conditions" (*Conturbatio*) in which Mary was depicted in paintings of the Annunciation—nothing I tell you will allow you to say, "If that is true, I shall like the work so much the better," because although you may find yourself agreeing with my account once you see the picture, you may also find—and that is more important—that you reject my taste. Kant was right that no "rule" can compel us to find something beautiful: a rule that leads to contrary outcomes in the same situation is no rule at all.

Aesthetic terms are double-edged but, more important, they play only a minor role in critical writing. For one thing, they are not very useful. Knowing that Racz's drawings are powerful and swift, fluid, deep, sharp, and eloquent tells you very little about the drawings, and what it tells you is intolerably vague—perhaps that, especially since they are of flowers, they are unlikely to remind you of Goya's *Caprichos*. You don't even know whether their swiftness will count for or against them when you finally see them. For another, aesthetic terms don't occur nearly as often as the philosophical preoccupation with them might indicate.

For over half a century, philosophers of art have been trying to distinguish aesthetic terms from their descriptive counterparts. Very roughly, descriptive terms, like "blue," "square," or "weighs twenty pounds," which generate little or no disagreement—they apply on the basis of public criteria everyone accepts—are supposed to be irrelevant to aesthetic value. Aesthetic terms, like "elegant," "delicate," or "garish," which are considered relevant to judgments of value, generate disagreements that may be impossible to resolve: we can't determine delicacy in the way we establish age or size, and what you consider delicate I may well find just drab. Aesthetic terms are not

governed by shared criteria, because taste, which some philosophers believe is a mental faculty required to recognize them, is something only some people possess to an appropriate degree. And although no one has been able to offer a satisfactory account of the distinction between aesthetic and nonaesthetic terms, the idea that a specific group of words, and that group only, indicates the features that determine the aesthetic value of things is now an institutional commonplace. The entry "Qualities, Aesthetic" in the *Encyclopedia of Aesthetics*, for example, raises several problems with their definition but remains characteristically confident: "To say that a particular painting has a blue spot in the upper right corner is not to say or suggest anything about the value of the painting; such a statement is clearly not relevant as grounds for aesthetic praise or blame of that painting," while aesthetic features are always "value-relevant."

Is that true of what we actually say about the arts? In the Mannheim version of *The Execution of Emperor Maximilian* (fig. 35, *Plate 6*), Manet painted over the squad's commander, who is clearly visible in two other versions of the work and whose sword appears in the earlier version now in the National Gallery in London (fig. 36). All that is left of the officer is a streak of red (fig. 37, *Plate 7*) between the legs of the third soldier from the right and a small patch of red behind his black cap—part of the officer's trousers and his red kepi. Why, if he wanted to erase the officer, did Manet leave his traces in the picture? In *Manet's Modernism*, Michael Fried, after rejecting several other interpretations, has this to say:

> On close inspection the streak of paint is merely that and nothing more: it absolutely resists being assimilated to the work of representation, by which I also mean that it escapes the categories of finish and nonfinish that indefatigably structured contemporary responses to Manet's work. . . . Perhaps it too is best thought of as a *remainder* . . . something left over after the task of representation was done and which stands for everything in Manet's art which adamantly resisted closure, which was irremediably disparate, which pursued a strikingness that could not be kept within the bounds even of the excessive, which repeatedly interpellated the beholder

Figure 35
Edouard Manet, *Execution of Emperor Maximilian of Mexico*, 1867, Staedtische Kunsthalle, Mannheim, Germany

Figure 36
Edouard Manet, *Execution of Emperor Maximilian of Mexico*, 1867–68. Reproduced by permission from National Gallery, London, UK. © The National Gallery, London, UK

Figure 37
Edouard Manet, *Execution of Emperor Maximilian of Mexico* (detail), 1867, Staedtische Kunsthalle, Mannheim, Germany

Figure 38
Sol LeWitt, *Schematic Drawing for Incomplete Open Cubes*, 1974, the Wadsworth Athenaeum Museum of Art, Hartford, CT

in ways the latter could only find offensive and incomprehensible, and which in fact continues to defeat our best efforts to make reassuring sense of his paintings by inserting them in a historical context, no matter how that context is defined.

We don't have to accept Fried's interpretation of the picture as an allegory of Manet's own work in order to realize how flexible and complex the language that expresses our reactions to the arts can be. If a streak of red paint can make such a difference to the interpretation, and the value, of a painting, how can we possibly think that critical evaluation depends only a particular group of individual words, which are seldom more than boring and vague? That is not how Rosalind Krauss writes about Sol LeWitt's repetitive structures (fig. 38):

> LeWitt's outpouring of example, his piling up of instance, is riddled with system, shot through with order. There is, in *Variations of Incomplete Open Cubes*, as they say, a method in this madness. For what we find is the "system" of compulsion, of the obsessional's unwavering ritual, with its precision, its neatness, its finicky exactitude, covering over an abyss of irrationality. . . . To get inside the systems of this work . . . is precisely to enter a world without a center, a world of substitutions and transpositions nowhere legitimated by the revelations of a transcendental subject.

None of these words would appear in a list of aesthetic vocabulary, but, like the rest of the essay, they express an admiration so clear that it makes the sentence that follows, "This is the strength of this work, its seriousness, and its claim to modernity," seem purely conventional. Krauss's evaluation of LeWitt is in the close, loving accounts of his work that precede it. This sentence is merely the conclusion of her essay, not of her argument.

Instead of a special class of aesthetic terms or qualities, we should be thinking of an aesthetic use to which every part of our language can be put. "Elegant" and "garish," perhaps, may always be relevant to the aesthetic value of things; most words and expressions, including "forceful" and "fluid," are not, but can be. It is difficult to think

of any word that cannot ever play a role in an aesthetic context—not even "blue."

The mantle in *St. Francis Giving His Cloak to a Poor Soldier* (fig. 39) is blue neither by accident nor out of Sassetta's concern for the look of the altarpiece but because ultramarine, expensive and difficult to work with, stands for the saint's generosity and duplicates it on a pictorial plane. The color is as directly involved in the interpretation and the value of the work as International Klein Blue, his patented shade, is part of the value of the art of Yves Klein (fig. 40, *Plate 8*). William Gass has written a whole book on blue, turning it at once into object and tool of aesthetic interest:

> *Blue*, the word and the condition, the color and the act, contrive to contain one another, as if the bottle of the genie were its belly, the lamp's breath the smoke of the wraith. There is that lead-like look. There is the lead itself, and all those blue hunters, thieves, those pigeon flyers who relieve roofs of the metal, and steal the pipes too. There's the blue pill that is the bullet's end, the nose, the plum, the blue whistler, and there are all the bluish hues of death.

And there is also, in what seems like a cosmic joke on philosophy and the *Encyclopedia of Aesthetics*, the "blue spot on the upper right hand corner" of Damien Hirst's *Alantolactone* (fig. 41, *Plate 9*)!

The term "aesthetic" applies whenever language is used to say something relevant to the interpretation and so to the aesthetic value of things, not only when a special group of words occurs. Nothing is in principle excluded: the size of Courbet's *A Burial at Ornans* gives an everyday contemporary event the authority of a history painting; the date David's "hastily composed" *Death of Marat* was first shown to the public is central to T. J. Clark's interpretation of the picture. Aesthetic terms are everywhere because everyone uses language aesthetically all the time; it is part of the texture of our lives. The difference is not between us and the others who can't detect delicacy or balance because they lack taste, perceptiveness, or sensitivity but between us and the others who don't find them where *we* usually search

Figure 39
Stefano di Giovanni (Sassetta),
St. Francis Giving His Cloak to a Poor Soldier, 1437–44, the National Gallery, London, UK

Figure 40
Yves Klein, *Vénus bleue* (*Blue Venus*),
S 41, 1962, Yves Klein Archives, Paris,
France

Figure 41
Damien Hirst, *Alantolactone*, 1965, Jay
Jopling, White Cube, London, UK

for them. The difference is just that—a difference in taste. Taste is not a faculty, but simply the ability to address *some* things aesthetically, and no one is without it; the question, as we shall see in detail later, is whether it is a good or bad taste.

Reviews characteristically end in verdicts, but these are peculiarly thin. They tell us little, and descriptions like "powerful," "fluid," "whispering details," or even "fantastic" serve less to express a reasoned and informative judgment, a final word, than to provoke curiosity, to excite interest, to issue an invitation to look (or read or listen) for ourselves. They are not conclusions but spurs. A favorable review is a promise—which may or may not come true—that time with some work of art will be well spent. If I accept the invitation and read the book, visit the exhibition, go to the opera or watch the TV show, will I be trying to reach a similar verdict on its value? That's what our theory says. But although I *will* probably reach a verdict of some sort, that will certainly be neither my goal nor, if it is positive, in any way the end of my involvement.

This is the time to stop thinking of the arts in isolation, as I have done so far in this discussion, and realize that reviewers have a very ordinary counterpart in the rest of life: friends who want me to get acquainted with someone they believe I will appreciate. Nothing they tell me about such a person can be very specific or very informative; their terms are bound to be generic: they'll tell me you are attractive, intelligent, interesting, unusual, kind, sensitive, sophisticated, generous to your friends, from an exotic background, and so on. If I agree to meet you on such grounds, I will be taking a chance, and I will go to our meeting *hoping* to do so but not *in order to* enjoy it and certainly not in order to *decide* whether it is worth enjoying. Of course, I will *want* to enjoy it, but that won't be my goal, which is only to get to know someone who may add to my life. If everything turns out as all of us had hoped and, once we've met, I find you and your company enjoyable, then, far from resting on that "verdict," I shall want to get to know you better. The "verdict" is not at all the end of the matter: it expresses my sense that you have more to offer me—that we have more to offer each other—and my desire to make

you, to some extent or another, a part of my life so that I can find out what it is. Instead of signifying the end of our interaction, the "verdict" indicates that far from thinking it's over, I want it to continue. In other words, it isn't a verdict.

That is exactly how reviews work. They praise, in terms necessarily vague but enticing, art their authors believe their audience would (or should) like. If I trust a reviewer and find the praise tempting enough, I will look at the work for myself, hoping to like it but not in order to do so. If I like it, I will want to see more of it in order to see more of what it intimates it has to offer and, on the basis of that intimation, try to make it, to some extent or another, a part of my life. Evaluation settles nothing. It is a commitment to the future.

Beauty, Love, Friendship

The pleasure of making a new acquaintance may seem an anemic parallel to the fervid power of art. Imagine yourself, then, on a street, in a restaurant or a gallery, at a party, during a lecture, a concert, or a game. You cast your eyes around, recognizing perhaps some people you know, stopping for a moment to glance at an outfit or two, lingering when you notice people talking to one another, distinguishing, so to speak, foreground from background, those you are explicitly aware of from others who mean nothing to you. And then, all of a sudden, everything becomes background—everything but a pair of eyes, a face, a body, pushing the rest out of your field of vision and giving you a moment of awe and a shock of delight, perhaps even passionate longing. For a moment, at least, you are looking at beauty.

And then? I know that when that happens to me, my first inclination, almost impossible to resist, is to keep looking. But that urge, which is also an effort to learn what can be known about you from a distance, soon gives way to the desire to draw near, to look and talk and get to know you better from up close. That desire is not irresistible: I won't always act on it, perhaps out of shyness or fear of rejection, perhaps out of concern for the feelings of others or even out

of uncertainty about the consequences of doing so for myself—but sometimes I will.

And now suppose I do. Immediately, I find myself, both in that imagined situation and as I am trying to write about it now, in a delicate situation, as difficult to engage with as it is to describe without seeming either too crude or much too unearthly. I am attracted, impelled to move forward and approach, come close to you, so to speak, geographically, which is in almost every case a precondition for every other kind of contact. That impulse springs from a sense that it would be good to do so, that—to put it a little dramatically—my life would be better if you were to become part of it. Not "better" in a moral sense: the word, like my sense of what to expect, is vague and lacks specific content; it ranges from immediate pleasure and satisfaction to the overall quality of my life over the long term—during these early stages of attraction, I have no way of knowing what to expect from our interaction.

Sometimes, half-knowingly, I may allow myself to expect more than I should. I persuade myself to think that you are more intelligent, engaging, serious, or sensitive than I have reason to believe—either because I am unwilling to acknowledge the sexual elements in my attraction or, more generously, because I hope that in time I will discover such features in you. But at no point is my attraction, however sexual, a "merely" physical phenomenon: just as "the degree and kind of one's sexuality reach up into the ultimate pinnacles of one's spirit," so spirit reaches down into the deepest recesses of sex. Even the "merely" sexual is already removed from the physical, and a merely sexual relationship is one that discloses (or, more likely, disclosed) little to attract me to you for a longer time, or, if it did last longer, was only intermittent—it's an affair that, perhaps against my own wishes, couldn't sustain itself. Sometimes, again, I may knowingly disregard a fault in your character because I choose pleasure over involvement and complexity. Here too there is no contrast between the physical and the spiritual but only between different psychological benefits (and dangers), and it is always possible for other features to reveal themselves and give new, unexpected life to our

relationship. Mistakes are possible in both directions: we can exaggerate the importance of sex as well as repress it. And sometimes, finally, you may really strike me as an intelligent, engaging, serious, or sensitive person.

But in every one of these cases, what sparks my desire is nothing but beauty itself—neither "inner" nor "physical" beauty, neither the beauty of "appearance" nor the beauty of "soul"; not even, perhaps, "a pair of eyes, a face, a body"; rather, a glance, a cast, or a bearing, features both bodily and mental. Think of them as isolated lines of verse, fragments of a large work, promising much but saying little and sometimes (as many who have tried to reconstruct some lost original from a few fragments have learned) pitilessly deceptive: "The reinterpretation of a facial expression," Wittgenstein once wrote, "can be compared to the reinterpretation of a chord in music, when we hear it as a modulation first into this, then into that key." And in none of these cases does my judgment that you are beautiful, which is identical with the spark of desire, constitute anything like a verdict. It does not look back at what I have learned and experienced so far, but at what—without knowing exactly what it is—I hope to learn and experience in the future. It is the expression of my need to become actively engaged—sexually, psychologically, ethically—with another person, a need that can't be satisfied by contemplation unless there are strong reasons (among them, perhaps, your own unwillingness) *not* to get further involved: contemplation is the counsel of despair.

Our reaction to beautiful things is the urge to make them our own, which is why Plato called *erōs* the desire to possess beauty—a sour note to contemporary ears, to which it sounds as if he is condoning a wish to dominate, exploit, and manipulate that we have learned officially to disparage. The desire to possess seems to be the mark of the consumer rather than the lover: to want to own something is to be prepared to use it as a means to one's own ends—even if only to prevent others from using it—while love, which values its objects for themselves, must find such a willingness unthinkable.

In the first volume of *In Search of Lost Time*, Proust describes how Swann, when he learns that his mistress was seen one evening in an

outfit he never knew she had, is shattered by the thought that she "had a life which did not belong entirely to him." Such things occur often enough: Swann and Odette know very well how to exploit each other. But, if they knew nothing else, it would be difficult to think that either one of them was ever in love with the other. But they did. During the first stages of their affair, each had been eager to learn to love what the other loved. Odette, however vulgar and ignorant, wanted to share Swann's interest in Vermeer: "'I've never heard of him; is he still alive? Can I see any of his things in Paris, so that I can imagine what it is that you like?'"; she was ready to put his wishes ahead of her own:

> "Me! I never have anything to do! I'm always free, I will always be free for you. At any hour of the day or night that might be convenient for you to see me, send for me and I'll only be too happy to come immediately. Will you do it?"

Swann, indifferent at first, gradually surrendered and gave himself over to her:

> Now that he loved Odette, to feel what she felt, to try to have but a single soul for the two of them, was so sweet to him that he tried to enjoy the things she liked, and his pleasure, not only in imitating her habits, but in adopting her opinions, was all the more profound.

He enjoyed performances he would never had attended before "for the sweetness of being initiated into all of Odette's ideas, of feeling he was sharing equally in all her tastes." He even refused to acknowledge the vulgarity of the Verdurins, masters of Odette's social circle, and because their invitations offered him "the inestimable gift [of Odette], he was happier among the 'little clan' than anywhere else, and sought to attribute real merits to it, for by so doing he could imagine that, out of preference, he would associate with it all his life."

Swann and Odette, totally unsuited to each other in any case, were hardly ever in love at the same time. Swann was at first unmoved by her feelings and fell in love with her only when he realized that

she was beginning to lose interest in him, plunging into an insane jealousy that subsided only as they settled into an indifferent marriage. But for a few genuine moments—brought back to Swann by a little phrase in a sonata that had once been "the national anthem" of their misbegotten affair—they had both been willing to let the other's desires give shape to their own. Those moments are enough to show that possession and ownership are two different things, since, not only in love but also in friendship, my desire to possess you is sometimes inseparable from the desire to be possessed by you. At such moments, I don't approach you with a settled sense of myself, taking my plans and my wishes for granted and counting on your assistance with them. Instead, I expect them—I want them—to change once I expose them to you. I hope that you will make me wish for what I have never wished before and give me what I now can't even imagine. You are no longer merely a means to my own ends, which are already established without reference to you, but someone whose own ends can become mine—an end in yourself. I then act on a sense—vague but intense—that there is more to you than I can now see and that it would be better for me to learn what I suspect you can offer. I willingly give you power over myself emotionally, ethically, and intellectually, trusting you not to exploit it. By becoming vulnerable in that way, I put my identity at serious risk because I have no way of telling how our relationship will ultimately affect me and whether it will be for good or bad—and neither do you: if your feelings for me are the same, so are the risks that you will have to take; but then, as the ancient proverb says, friends have all things in common.

Aristotle, who made much of that proverb, believed that only the virtuous can love one another for their own sake and therefore that only the virtuous can be friends. Although he used the same term, *philia*, to describe relationships formed in the expectation of profit or pleasure as well, he limited genuine friendship to those who love each other on account of the virtues they actually possess, since only our virtues, according to his theory, are essential to who we are and so only those who love their friends for their virtues love them for themselves. But since very few people are virtuous, Aristotle's theory makes

friendship intolerably rare, besides flying in the face of experience—most of us, though far from virtuous, are not without friends, and, after all, not every captured criminal turns state's evidence, leaving his friends in the lurch. Still, Aristotle's view contains an important idea, which emerges if we turn his picture around: people of little, perhaps of no virtue can be friends, provided they love each other at least in part because of features they *consider* to be virtues, rather than merely pleasant or profitable. If I approach you with profit or pleasure in mind, I generally know what I want to obtain from you: our relationship will satisfy desires I already have. Anything I consider a virtue, though, will be able to manifest itself in unexpected ways and, more important, the fact that I think of it as a virtue, even if I am wrong, shows that I believe that it can show me that other desires, which I don't now have, may be worth having as well. My friends are people from whom—no matter how familiar their character, their quirks, or their weakness—I don't yet know exactly what I want to get, because I trust them enough to let them influence what I believe and what I desire in ways I would not be able to do, or even to imagine, on my own. To love my friends for themselves does not prevent me from loving them for my own sake as well, expecting that they will help me with plans I have already formed. It does, however, require that I give them a part in determining *what* my sake actually is, what sort of person I shall turn out to be as a result of our friendship. I am quite sure that it is exactly because our friends, like our lovers, are people from whom we don't know what to expect that we can only give the most tepid and colorless reasons for loving them: "Because he's kind," "Because she understands me," "Because he's funny," "Because of your yellow hair"—how can we possibly describe what we can't even imagine? But that is also why our trust, as Swann found out, may always turn out to have been a mistake; nothing ensures I will put my faith in the right person. That is the danger of beauty—and beauty, I now want to claim, is not unconnected to the love friends have for each other.

On the face of it, this seems preposterous. Beauty is at best irrelevant to friendship, since even the ugliest people have friends.

At worst, it excludes it: to want your friendship on account of your beauty is effectively *not* to want your friendship but the sort of advantage beautiful people confer on those who surround them.

Still, beauty is not without a role in friendship, however unlikely that sounds. It is impossible for us to find our friends ugly: we are always able to find something in them attractive—their eyes, their smile, the way they carry themselves. David Lynch's *The Elephant Man* (1980) provides a brilliant illustration. The film tells the story of John Merrick, a nineteenth-century Englishman horribly disfigured by neurofibromatosis (fig. 42), and Frederick Treves, the physician who gives him asylum in his hospital. Treves, whose original interest may have been only in the disease, gradually realizes that Merrick's grotesque face is not a sign of a psychological wasteland but belongs to an intelligent, kind, and sensitive man. And as Treves comes to like and respect him, Merrick's face seems no longer grotesque to him and his appearance is no longer an issue. Throughout that process, Lynch identifies the physical point of view of the camera with the fictional point of view of Treves, and as Treves lets his eyes linger on Merrick, the viewer actually watches his transformation; what is more, since that is also the viewers' own point of view, we too undergo the same transformation. At the beginning of the film, our glimpses of Merrick are as short as the camera's, and probably shorter—it is difficult even to parse his face—but his looks are no longer in question by the time we have come to know him better, not because we have become aware of his inner qualities but because his personality—his soul—is manifest in his appearance, which alters when it finds an alteration in us.

Nicholas Ray's *Rebel without a Cause* (1955) makes the same point in negative terms. Desperate about her father's moral disapproval, Judy, Natalie Wood's character, understands exactly how he feels:

Judy: He hates me.
Ray: What makes you think he hates you, Judy?
Judy: I don't think, I know. He looks at me like I was the ugliest thing
 in the world.

Figure 42
Photograph of John Merrick.
Reproduced by permission from
St. Bartholomew's Hospital Archives
and Royal London Hospital Archives.
Copyright © St. Bartholomew's Hospital
Archives and © Royal London Hospital
Archives. Courtesy of St. Bartholomew's
Hospital Archives and Royal London
Hospital Archives

Another version of the story is in Isabel Allende's memoir, *Paula*:

> The first time I saw my Tío Ramón, I thought my mother was playing a joke. *That* was the prince she had been sighing over? I had never seen such an ugly man. . . . [T]en years later . . . I was at last able to accept him. He took charge of us children, just as he had promised. . . . He raised us with a firm hand and unfailing good humor; he set limits and sent clear messages, without sentimental demonstrations, without compromise. I recognize now that he put up with my contrariness without trying to buy my esteem or ceding an inch of his authority, until he won me over totally. He is the only father I have known, and now I think he is really handsome!

The inner and the outer go hand in hand, and how things look to us depends on what we take them to be. Love, as Plato said, is beauty's attendant and constant companion and has no place for ugliness:

> Even little facial blemishes on other women, such as a smallpox scar, touch the heart of a man in love and inspire a deep reverie; imagine the effect when they are on his mistress's face. The fact is, that pockmark means a thousand things to him, mostly delightful and all extremely interesting. He is forcibly reminded of all these things by the sight of a scar, even on another woman's face. Thus *ugliness* even begins to be loved and given preference, because in this case it has become beauty.

When the pockmark begins to seem merely a pockmark, when a lover's beauty begins to wilt, love is also beginning to fade, and as it withdraws it is replaced by indifference or even aversion to what once was magnetic. That's how it was with Emma Bovary, who was already sick of her husband, when she convinced herself that he was about to perform an operation that would make him famous and give them the life of her dreams and suddenly noticed, "with some surprise, that his teeth were not at all unsightly." But when, inevitably, Charles botched the operation, the attraction disappeared and Emma found once again that "everything about him exasperated her . . . his face, his clothes, what he did not say, his entire being, his very existence."

In Shakespeare's "Dark Lady" sonnets a man declares his love for a woman whose ugliness he finds one of her most striking features. I know of no other case, and this one is pathological—"My love is as a fever, longing still / For that which longer nurseth the disease" (Sonnet 147)—and so uncannily strange that Shakespeare's best readers have had to shy away from it. Helen Vendler, for example, has given a brilliant dissection of the sequence's paradoxical voice. But when she comes to the final sonnet,

> In loving thee thou know'st I am forsworn,
> .
> And to enlighten thee gave eyes to blindness,
> Or made them swear against the thing they see:
>> For I have sworn thee fair: more perjured eye,
>> To swear against the truth so foul a lie.
>
> (Sonnet 152)

she backs away from describing what the speaker avows as love, and feels compelled to place scare quotes around the word *love* in her commentary, implying that some other state is involved: The speaker's "own complicity is what shocks him, as he discovers that it is precisely her *unworthiness* that raises 'love' in him." Love is transformed into sexual passion: "greater self-knowledge . . . provokes a bitterly shaming acknowledgment of one's own least acceptable sexual proclivities," while "the reader admires the clarity of mind that can so anatomize sexual obsession while still in its grip."

I doubt that shifting to sex avoids the paradox created by love for the ugly. It's true that finding someone both sexually attractive and morally repulsive, the state some readers believe the poem displays, is not at all paradoxical, but neither is love for such a person. But if, as Vendler says, "love" is raised by unworthiness, lust is excited by sexual repulsiveness—and that is every bit as paradoxical as love that attaches itself to ugliness. Love survives dislike, disapproval, disgust, contempt, and hate, but ugliness immediately destroys it: *erōs*, as Plato writes in the *Symposium*, "was born to follow and serve Aphrodite."

Nevertheless, the *Symposium* presents what at first sight seems the most convincing demonstration that "inner" and "outer" beauty are distinct and that it is perfectly possible to love someone who is physically repulsive but psychologically or morally magnetic. It comes when the drunk Alcibiades confesses his love for Socrates, whose ugliness was as notorious as Alcibiades' beauty was famous. Alcibiades likens Socrates to those hollow statues of Silenus, Dionysus's grotesque companion, which contained tiny idols of various gods within them: "I don't know," he tells his fellow revelers,

> if any of you have seen him when he's really serious. But I once caught him when he was open like Silenus' statues, and I had a glimpse of the figures he keeps hidden within: they were so godlike—so bright and beautiful, so utterly amazing—that I no longer had a choice—I just had to do whatever he told me.

The image of Socrates as Silenus is so well known that we seem to have forgotten that it is an image. It is not literally true that the character of Socrates is sealed within him like the idols in Silenus's statues—and in any case, Alcibiades, who says that he *saw* how beautiful they were, does not describe a new way of becoming aware of beauty: it is still an aspect of appearance. And it is Socrates' *appearance*, as he marches in battle just as he rambles in the city, "with swagg'ring gait and roving eye," that "even from a great distance [made it] obvious that this was a very brave man, who would put up a terrific fight if anyone approached him." One of Nietzsche's most vicious attacks on Socrates is based on the idea, "monstrous in appearance, monstrous in soul"; Plato seems to have had the same thought, in the opposite direction: "wondrous in soul, wondrous in appearance."

The question is not whether I can love someone who is *in fact* ugly—for better or worse, most people do—but whether I can love someone I *find* ugly, and I believe that's impossible. But to the extent that I find you beautiful—which is always, in one degree or another, a matter of love—life will seem better to me with than without you. That forward-looking element and the risks that attend it are essential

to beauty, which withers when it can promise nothing it has not given already, and signals the fading of love. For love, as Proust wrote (although he was tormented by a thought I find exhilarating), "is born, it lives, only for so long as there is something left to conquer. We love only that which we do not wholly possess."

Beauty points to the future, and we pursue it without knowing what it will yield, and that makes it is as difficult to say why we love someone as it is to say why someone else is our friend. My reasons for finding you beautiful include characteristics I feel you have not yet disclosed, features that may take me in directions I can't now foresee. Beauty inspires desires without letting me know what they are for, and a readiness to refashion what I already desire without telling me what will replace it. When I say, as we all do sometimes, that what I want is *you*, not anything *from* you, I am putting myself in your hands, assuring us both that I will be happy no matter what happens to me, if it is due to you. It is an overwhelming feeling, that sweeping sense that all will be well—and it is often wrong. Stendhal was right: beauty is only a promise of happiness.

Attractiveness, Beauty, Evolution

What, in a person or an object, issues that promise? The obvious answer is: its appearance. And it is true that beauty is never detached from appearance—visual features, as we have seen, are informed by psychological characteristics. But it is also never exhausted by it.

That is so even if we think of "appearance," generously, not only as the *purely* visual aspects of something (whatever those would be) but as every one of its features, physical or psychological, of which we are aware by looking. To say that I like you for your looks is to say that my desires are relatively clear. I have a pretty good idea of what draws me to you and what I want you to give me, whether it's pleasure—not necessarily sexual—or some sort of advantage. And although these are not the complex, open-ended desires beauty provokes, nothing is wrong with them in themselves, especially if our

feelings are mutual, both of us willing to confer benefits as well as receive them and enjoying ourselves in the process. The difference between the clear desires of attraction and the complex desires of love is not a moral one: horrible harm has come to people through love, and Aristotle, remember, thought that both pleasure and profit are sound grounds for *philia*. The difference is that in one case desire grows mostly out of what one already knows, which includes what one wants, while in the other it is also a yearning for features still undisclosed and desires that are still without shape.

If Shakespeare and Stendhal are right and beauty is in part a creation of love, then each one of us should have our own standard of beauty and our own list of beautiful people. What would then cry for explanation is not why our views of beauty differ as much as they do, but how we can ever agree with each other. But the fact is that much psychological research supports the idea that standards of beauty are remarkably consistent regardless of culture, race, age, income, or sex. We should take a moment to look at this evidence. It makes a difference to what we should say both about the beauty of people and, as we will see, about the beauty of art.

The most common procedure in this research is to show various subjects a series of photographs of different faces and ask them to rate their attractiveness (fig. 43). The faces, usually posed frontally, are as expressionless as possible in order to avoid variations that may affect how they are judged. Some series contain photographs of particular individuals; some manipulate a single image, say, from "most masculine" to "most feminine"; others consist of composite images, each one a combination of several individual photographs. It turns out that the ratings of people from different backgrounds agree considerably more often than common sense would lead anyone to think, and that most people seem to prefer symmetrical to asymmetrical faces and faces with features associated with youthfulness (and, on occasion, femininity) more than faces without them. It also turns out that people prefer composite to individual faces and more composite faces to less composite ones. The connection with symmetry seems plausible enough, since beauty and symmetry have a long joint history, but the

Figure 43
Faces. Reproduced by permission from www.faceresearch.org

preference for composites is surprising: a beautiful face leaps at us and pushes all others into the background; a composite face, though, represents the average of the faces that have been combined to form it.

Why are symmetry, neoteny, averageness (and other features we don't need to discuss here) attractive to such a broad range of individuals? Since their appeal transcends cultural categories, it may well be the effect of biological mechanisms and, in that case, it can be explained in evolutionary terms. From such a point of view, like the peacock's extravagant tail by which Darwin was so fascinated, human beauty signals reproductive fitness, the likelihood that one will produce viable offspring. As a result of natural selection, we are hardwired to find pleasure in the features that carry that signal and to be drawn to those who, by displaying them, seem to be giving us the best chance to propagate our genes: "Beauty," as Donald Symons has put it, "is in the adaptations of the beholder." Symmetry is attractive because genetic and environmental factors, like inbreeding and parasites, can disrupt the symmetric development of features like fins, horns, eyes, faces, or whole bodies, and greater symmetry indicates greater health and resistance to disease. The importance of being average—average in shape, notice, not in beauty—is that in biological terms it is a recipe for success. In the wildebeest herd, the slowest fall to predators and the

fastest are trampled by the rest when they hesitate before a river or a ravine. Evolutionary pressure is greatest on the extremes of a population, and large deviations are eliminated through the "stabilizing" form of natural selection. Safety is in the middle, and that's where the most promising partners are likely to be. Sometimes, of course, the advantages of a very exaggerated trait may offset its shortcomings: the value of the peacock's tail as a measure of health and potency outweighs the loss of swiftness and flexibility that comes with it. Finally, smaller noses, larger eyes, thinner jaws, and shorter distances between mouth and chin in women are signals of youth, greater fertility and more healthy children ahead, while strong chins, deep-set eyes, heavy brow ridges, and oval or rectangular faces advertise a man's capacity to protect them. Some recent experiments also suggest that the mere pattern of a body's movement, in the absence of any other information, allows people to judge the attractiveness of the person whose body it is.

According to many of the leading figures in this area, this research has far-reaching consequences, for it demonstrates nothing less than the fact that beauty is "ingrained in our biology: characteristics associated with evolutionarily relevant advantages for the choosing individual are perceived as attractive." More directly, "the notion that beauty can be defined by the mean of a population of faces . . . provides a parsimonious answer to the age-old question, 'What is (facial) beauty?'" More directly still,

> Our response to beauty is a trick of our brain, not a deep reflection of self. Our minds evolved by natural selection to solve problems crucial to our survival and reproduction. To find the sight of potentially fertile and healthy mates beautiful and the sight of helpless infants irresistibly cute is adaptive. . . . Beauty is one of the ways life perpetuates itself, and love of beauty is deeply rooted in our biology.

But although there is no question that the answers these experiments elicit from their subjects are remarkably uniform, we may be perhaps permitted to ask what these answers are *about*. What do these experiments measure?

We can agree that when people are shown bodiless faces, devoid of expression and frozen in a moment of time, or faceless bodies, little more than collections of abstract shapes in motion, they judge their attractiveness on the basis of features that signal selective advantages. To find here the core of every reaction to beauty, the real object of love ("one of the ways life perpetuates itself"), we must assume that what people do on the basis of extraordinarily limited information, under very unusual conditions, represents what they do in everyday life. But do extreme circumstances cast more light on behavior than ordinary actions?

Deprived of food for a sufficiently long time, I am likely to eat almost anything. But tearing into a living sea cucumber is no more natural than picking at *filets de sole Mirabeau*, and hunger is no closer to our nature than satiety—it is only more painful and, unfortunately, immensely more common. Although the looting, sniping, and gang violence in New Orleans during the aftermath of hurricane Katrina in the summer of 2005 was often referred to as "Hobbesian" in order to suggest that people had retreated to the state of nature Hobbes had described as "a war of all against all," what the world watched was the behavior of people immersed in the culture of the late twentieth and early twenty-first centuries once *some* but by no means all the institutions of that culture were removed—a removal that led some to violence and others to acts of selfless generosity. Neither on the collective nor on the individual level is culture a distinct component added once the biological component is fully in place, as if they are different layers of a cake or independent geological strata.

Even if the mechanisms the research on attractiveness has isolated are purely biological, however, nothing ensures that they persist and function unaltered whenever one person is attracted to another. In the research we are discussing, people are provided with exceptionally meager cues about size, shape, color, and proportion and are asked to make judgments of no consequence to themselves: they judge "attractiveness" and move on. In such circumstances, it is only to be expected that they will base themselves on general, abstract, and elementary features like the symmetry and neoteny of facial

features, than, say, on race, gender, and whatever such photographs might indicate of personal character. Their judgments are minimally concerned with the future. But given the way of the world, race, gender, and character would matter more if they had to judge whether they were likely to find these people attractive after spending some length of time with them or if, in addition to their photographs, they were also to hear their voices or see them smiling, angry, or scared: blankness accentuates formal similarities whose perception requires fewer specific resources and naturally produces relatively greater agreement.

We must also take into account the serious difference between describing a face as attractive and actually being attracted by it. Beauty mobilizes the emotions and it always looks to the future: these detached ratings do not. More important, it won't help to appeal to a "stratigraphic" view of the mental and the physical and argue that beauty, now thought of as merely "physical" attractiveness, "is one, but certainly not the only, pleasure button we press, and . . . people seeking mates place kindness one step ahead of beauty." For better or worse, most people in the world are not beautiful if beauty is in that sense physical attractiveness. Yet at some time or another most people in the world have both loved and been loved by someone—not always, unfortunately, the same person—and, since *erōs* is by nature a lover of beauty, it is impossible to love someone whom we don't find beautiful.

This is not just naive philosophical idealism. Physical attractiveness is not an independent element, which may be more or less important than "kindness." Whether we find someone attractive actually *depends* on whether we like or respect them, whether we find them talented or easy to work with. That, at least, is the conclusion of three recent studies according to which strangers to a group and people already familiar with it find very different people attractive. Roughly, women tended to find people they liked more attractive, while respect was more important for men. In other words, psychological and bodily features interpenetrate, as I have been trying to argue on more general grounds.

Still, I want to stop before agreeing that "judgments of physical attractiveness are strongly influenced by nonphysical factors." That way of speaking suggests that there is a clear contrast between the physical and the nonphysical, but that becomes hard to believe when we learn what the physical is: "Among people who actually know and interact with each other, the perception of physical attractiveness is based largely on traits that cannot be detected from physical appearance alone, either from photographs or from actually observing the person before forming a relationship." That is an intolerably loose account of what the "physical" is. Why should we agree that photographs only provide information about physical appearance? Is it because they are inert, excluding motion and time? In that case, "actually observing the person," which presumably includes their movements, would provide non-physical information about them, contrary to the claim we are discussing. Is it, then, because photographs are limited to the visual appearance of their subjects? But photographs tell us much more than that: they often tell us much more about people than they can tell us themselves. Don't we, moreover, observe not only the physical appearance but also the behavior of people, their way of moving, how they speak and what they say? What counts as physical and what as nonphysical here?

The key, I think, is in the phrase "before forming a relationship": since we can certainly know something about other people from casual observation, it seems that nonphysical factors enter only when we begin to know them *well*. But that is a hopeless way of going about it. In one sense, all we ever know about a person is physical, since it comes to us through the senses. In another, even a simple smile before the camera or a way of holding one's body is nonphysical, since it manifests, to however small an extent, a character and a personality. "Forming a relationship" provides more information of the same kind, not a different kind of information, and the difference between the physical and the nonphysical, which is supposed to be categorical and absolute, can't possibly be captured by a distinction as relative and vague as that which separates what we know on the basis of less information from what we know on the basis of more.

If that is right, both the traditional research on facial attractiveness and this more sophisticated approach do make a difference to what we can say about beauty, though not in the way they may envisage themselves. In the end, what they show is that beauty and attractiveness are not the same thing—but neither are they different: they are forms of each other. The features that produce them and the desires they in turn inspire are always the same in kind—sensual and intellectual, bodily and psychological, physical and mental, practical and ethical—but different in number, complexity, and the degree they look toward the future. Nothing is attractive, even if all it invites is contemplation, unless it sparks a desire to devote part of one's life to it—a desire that may extend to a vanishingly small part of one's life, as it does in the case of the photographs we have been discussing. If nothing else, both infants and adults spend more of their time looking at attractive faces than at faces they find unattractive.

"Beauty" is the name we give to attractiveness when what we already know about an individual—whether it is from a distance, from up close, or as a result of our interaction—seems too complex for us to be able to describe what it is and valuable enough to promise that what we haven't yet learned is worth even more, perhaps worth changing ourselves in order to come to see and appreciate it.

The psychological evidence on attractiveness is usually interpreted in one of two ways. Either beauty is identical with what these experiments measure and so nothing but "physical" attractiveness, or it is something else altogether, a "higher" complex of features in which physical attractiveness is one among many factors. Either way, physical attractiveness is taken as a feature in its own right, a biological universal, "a trick of our brain," which knows a chance of perpetuating our genes when it sees it and informs our behavior, our feelings, and plans in ways we can't even imagine. But if we can use the same evidence to show that whether I find someone physically attractive depends on what I think and how I feel about her, we may stop wondering whether attractiveness and beauty are or are not the same. With that, we have returned to the beginning of this section: beauty is always revealed in appearance but never completely. But this circle

has also taken us one step further: attractiveness is no longer limited to appearance; we can be attracted to things of which we are not yet fully aware. "Appearance," like "the physical" as we have seen it used in psychology, is only the name we give to everything in the world—or a person—we think we already know.

Much more needs to be said, but, first, we must once again turn our attention to art. What we have said so far points toward the place of beauty within it.

III

Art, Beauty, Desire

More than just windows to the soul, the eyes are part of it. What we know—or think we know or want to think—about them affects how people look to us, and how they look to us affects what we expect to come to know about them in the future. Not limited to appearance, beauty is neither detached from it nor a characteristic of something else—a mind, a soul, an inner self—instead. Beauty is, in a word, everything we love in a person, and when that is *actually* everything, when (as we say) we love not this or that about that person but the person itself, we are unable to say what that is. What we can say, which is what we already know, is never enough to explain the beauty that marks the object of love, and that makes love inseparable from wanting to learn. Our eyes are never more than part of our soul to our lovers; in their eyes, we are all inexhaustible, for the measure of beauty lies not just in the past and the present but most of all in its pledge for the future. Later, we'll have to ask how good a pledge that is.

All that is also true of the arts. Like beautiful people, beautiful works spark the urgent need to approach, the same pressing feeling that they have more to offer, the same burning desire to understand what that is. Their beauty is not just on their surface but it is also not independent of it; it is not something higher, remote, or purely spiritual. Time dulls the glitter of some and burnishes the shimmer of others, the sparkle of still others comes only gradually into view; they all keep shining as long as a gleam of the future remains one of their highlights.

But not all that is true of people is also true of the arts. Our feelings for art don't seem to be primarily sexual—or, to the extent that they are, they involve fantasies regarding the art's subject matter: Pliny's young man was in love with Venus as she was represented by her statue in Cnidus, not with the statue itself. We can't hurt, or be hurt by, works of art in many of the ways we hurt one another. And we are most willing to share them with others.

Collingwood, for one, considered such differences critical:

> When we speak of natural things as beautiful, it may, of course, be with reference to the aesthetic experience which we sometimes enjoy in connexion with them. . . . But . . . it may equally well be with reference to the satisfaction of some desire or the arousing of some emotion. A beautiful woman ordinarily means one whom we find sexually desirable. . . . A very great deal of what we express by calling natural things beautiful has nothing whatever to do with aesthetic experience. It has to do with that other kind of experience which Plato called *erōs*.

Collingwood was right to connect beauty with *erōs*. But do we have any reason to agree with him that, being inconceivable apart from emotion and desire, *erōs* can't be directed at art? In the *Symposium*, most of the objects of *erōs* in all its passionate intensity are things like law, culture, and science, even the purely intelligible Forms—why not also art? Plato himself did not include art among the proper expressions of culture for reasons that were, unlike Collingwood's, epistemological and moral: he believed that no art is either a product or

Figure 44
Peter Paul Rubens, *Holy Family with St. Elizabeth* (*Madonna of the Basket*), c. 1615, Galleria Palatina, Palazzo Pitti, Florence, Italy

Figure 45
Titian, *Man with Bulging Eyes*, c. 1545, Galleria Palatina, Palazzo Pitti, Florence, Italy

a source of serious knowledge and that poetry in particular creates moral and political anarchy. But Plato's reasons needn't be our own: it is perfectly natural to use the vocabulary of beauty and love when we speak of the arts. I can still remember falling in love with *In Search of Lost Time*, an episode for which no other words will do, and it is neither an exaggeration nor a metaphor to say that I now couldn't live without it. I can remember how deceived I felt when, one day, the short stories of Jean-Paul Sartre no longer held any interest for me and faced

> The sceptic disappointment and the loss
> A boy feels when the poet he pores upon
> Grows less and less sweet to him, and knows no cause.

But I can also remember (and I hope you do too) how lovely it felt when I began to hate Hermann Hesse. I once dismayed a good friend at the Palazzo Pitti by cringing before Rubens's *Madonna of the Basket* (fig. 44), feeling as if I was trapped into a cloying, stodgy conversation at a party and eager to extricate myself and go back to Titian's spare, powerful *Man with Bulging Eyes* (fig. 45) in another gallery—although I haven't wanted to return to the Titian as often as I return to Manet's *Olympia*, which really is a very big part of my life.

Isn't it, though, "pure gush to speak of falling in love with a novel? Can one be seduced by a poem or enamored of a melody?" Mary Mothersill asks; and she answers: "Unless the absurdity is supposed to be self-evident, there must be an answer to the question, 'Why not?' and it's not clear that there is any non-boring answer. ('A novel is not a person' is boring.)" We don't want to marry our favorite novel because it is a novel, not because we don't love it; we usually don't want to marry our closest friend, either: what does that have to do with our love for each other? In the same way, we are glad for our friends when they have friends of their own and we often encourage our friends to become friends of each other, although we are generally not nearly as happy when our lovers turn out to have other lovers as well. Depending of course on the nature and strength of my feelings, when your

beauty draws me toward you, I want you, at least for a while, primarily for myself. But when I am moved by a work of art and want to make it part of my life, I also want others to make it part of their life as well. When I praise my lover to you, I am trying to explain why I have fallen in love, not to inspire you to love her yourself, but when I try to explain why I find Cavafy's poetry breathtaking, I am also trying to show you your way to falling in love with it too. I am eager to *give* his poems to you, but that is because they are poems, not lovers or friends. In our feelings for art we are promiscuous because loving the same work of art, we shall soon see, creates friends rather than rivals.

When I find a work of art beautiful I feel there is more about it that I would like to know, which is why, as we have seen, a verdict, or what has been called a "communion of vision," a "unity of feeling," or a "common experience of value," doesn't mark the end of interpretation and criticism but is, on the contrary, a call for their continuation. Kant was right to say that the judgment of taste is "not governed by concepts" and doesn't follow from any account of the beautiful object, however detailed: nothing short of direct interaction can show me whether I will or will not like a particular work. He thought that is because the judgment of taste originates in a subjective feeling of pleasure generated by the object itself, which no description is enough to induce (of course, a beautiful description may itself be the object of a judgment of taste, but that is another matter). I believe, instead, that the reason we can't fully explain either to others or to ourselves why we find something beautiful is that the judgment of taste is simply not a *conclusion* at all.

Whenever we try to say why something is beautiful, we end up disappointed, with a sense that language has failed once again to capture experience fully and, as always, has left out something essential to it. But the problem isn't with language, as it would be if the object's beauty depended on a group of particular features, of all of which we were already aware, without words, and to which our means of communication are not adequate. The problem is with the idea that we already know the features that account for the beauty of the object before us, which doesn't acknowledge the fact that as long as we find

something beautiful we feel certain that it can still yield something of value, despite the fact that we don't know what that is.

And as long as we lack that knowledge, we also can't know—and can't say—why we find that thing beautiful. In art, too, the judgment of taste contains a sense, a guess, a suspicion (it is not easy to choose the right word) that there is more to learn about the object before me that is valuable in ways I can't now specify. Psychologically, I may be willing to risk my life on such a guess, but in logical terms a guess always goes beyond the available evidence and can't ever, like a conclusion, follow from what is already in hand.

At this point, Kant and Plato converge: just as nothing we know is enough to prove that something is beautiful, everything we love is always a step beyond our understanding. The pleasures of the imagination are pleasures of anticipation, not accomplishment. The irony is that if your guess proves to be completely correct, when you have found everything a beautiful thing has to give you will have lost what had made it beautiful, the promise of more, and with it the love that desired what was promised. Beauty beckons as love impels. The art we love is art we don't yet fully understand.

Dave Hickey recalls the first thing he did after discovering *A Simple Heart*, Flaubert's heartless tale of integrity:

> I started calling my friends. I wanted them to read the story immediately, so we could talk about it; and this rush to converse, it seems to me, is the one undeniable consequence of art that speaks to our desire. The language we produce before the emblem of what we *are*, what we know and understand, is always more considered. This language aims to teach, to celebrate our knowledge rather than our wonder. . . . The language that we share before the emblem of what we lack, however, as fractious and inconsequent as it often seems, creates a new society.

I think of beauty as the emblem of what we lack, the mark of an art that speaks to our desire, the ground of such a rush to converse, a figure that intensifies the persistent demands of the will that so frightened Schopenhauer instead of calming them. Beautiful things don't

stand aloof, on their own, but direct our attention and our desire to everything else we must learn and acquire in order to understand and possess them, and they quicken the sense of life, giving it new shape and direction. Far from being selfish or solipsistic, the desire beauty provokes is essentially social: it literally does create a new society, for it needs to be communicated to others and pursued in their company. "An experience of beauty entirely specific to one person probably indicates that the person is insane," Peter Schjeldahl has written, airing a view that Kant, had he condoned its hyperbole, might have expressed himself. It requires me to learn what others think and take it into account as I shape my own understanding, making me willing to spend part of my life in their company. The judgment of taste has an inescapable social dimension, and that, we shall see, accounts for some of the keenest pleasures, but also some of the darkest dangers, of art.

The interaction with others the judgment of taste requires prevents it from being purely subjective or private. As Kant saw, it is subject to argument and cannot evade dissent by retreating to the more arbitrary grounds of the agreeable, what is (merely) pleasant to me. I may continue to hold on to my judgment in the face of rejection or ridicule, but I don't dismiss disagreement as a merely personal matter: I also continue to lay claim to the assent of others. That, in turn, makes it seem that to say that something is beautiful is like saying that it is in New York City, square, and mostly black. That makes the judgment of taste, as Mary Mothersill puts it, "contingent, hence either true or false" and subject to "testing by anyone who cares to take the trouble [by means of] determinate confirmation procedures that can be sketched in advance"—and it creates a real problem. If you have the evidence that is available but refuse to agree that Reinhardt's *Abstract Painting 1960–61* is in fact in New York, square, and mostly black, something must be wrong both with your perception and your reasoning. But if the judgment of taste is in the same category, then we must agree with Mothersill, who thinks that it is, when she concludes that "someone who found nothing remarkable in [what I find beautiful] would strike me as slightly defective—as if something blocked his perception or impaired his sensibility."

We often feel that way, and since tastes differ everywhere, everyone in the world probably finds everyone else slightly defective. Would it be better to live in an ideal world where everyone agreed on the beauty of Reinhardt's painting (or anything else) as we now agree about its shape, where no one could think another defective? To me, that thought is not simply disturbing, it is totally frightening—and I must now say why.

Beauty, Community, Universality

When Oscar Wilde heard a witty remark of Whistler's he cried, "I wish I'd said that!" and Whistler immediately quipped, "You will, Oscar, you will." That is a well-known exchange, although *what* Whistler had said that so excited Wilde is not. Whistler had been listening to Humphry Ward, *The Times'* art critic, expressing his views during an exhibition of his work, and, after a while, the painter took the critic by the elbow and said, "My dear fellow, you must never say this painting is good or that bad, never! Good and bad are not terms to be used by you; but say 'I like this,' and 'I dislike that,' and you'll be within your rights. Now come and have a whisky: you're sure to like that."

I am interested in the difference between judging that something is beautiful (which is what "good" comes to in this particular context) and merely liking it. I have tried to say that such a judgment is not the conclusion of an interpretation, which is why, as Kant saw, it doesn't follow from any description of its object: we can't ever give sufficient reasons for it. Beauty always remains a bit of a mystery, forever a step beyond anything I can say about it, more like something calling me without showing exactly what it is calling me to. Since no words are enough to convince me that something is beautiful (or its opposite), it is a call I can only hear on my own, beyond what anyone can say to show that making it part of my life might be worthwhile. But whenever I find something beautiful, even when I speak only to myself, my judgment goes outward: I expect that others should join me, or would join me if they only had the opportunity, and make

that beautiful thing part of their own lives as well. Whistler's comment was not just a put-down of Ward; it also raised a real question: does anyone have the right to such an expectation?

The question is raised by the difference between "This is beautiful," which seems to be a description of something, and "I like it," which only seems to express a personal preference. Descriptions make a strong claim: they are either true or false, and they demand nothing less than universal agreement. Yet how can I expect *anyone* to accept a judgment that even I can't fully support? "How is a judgment possible," Kant asked, "which, merely from one's *own* feeling of pleasure in an object, independent of its concept, estimates *a priori*, that is, without having to wait upon the agreement of others, that this pleasure is connected with the representation of the object *in every other subject*?" The *Critique of the Power of Judgment* was his effort to answer that question.

It was a magnificent effort, but flawed; and its failure has haunted modern aesthetics. Kant believed that he had shown that "the judgment of taste ascribes assent to everyone, and whoever declares something to be beautiful wishes that everyone *should* approve of the object in question and similarly declare it to be beautiful," and wrote that everyone who ever judges that something is beautiful speaks with "a universal voice." To me, though, all that clamor sounds no stronger than the voice of one crying in the wilderness. The mechanism Kant invoked to support his answer, the "free play" of imagination and understanding, which he assumed to be the same in every human being, has remained mysterious. The price for thinking that aesthetics speaks with a universal voice is in any case too high. Kant hints at it somewhat vaguely when he writes that in making an aesthetic judgment, one "demands" the agreement of everyone else, "rebukes them if they judge otherwise, and denies that they have taste, though he nevertheless requires that they ought to have it"; but it is clear and definite in his contemporary followers, who admit, like Mary Mothersill, that it is natural to find anyone whose judgments differ from ours "slightly defective—as if something blocked his perception or impaired his sensibility."

There are certainly circumstances that would make me consider other people defective—if, for example, they aren't able to discern

the right colors of things or don't see a difference between dreams and waking life (unless, of course, we were having a philosophical conversation). I might consider defective someone who did not understand a rather simple but important idea but was unwilling or unable to learn what it took to see that it was true—defective intellectually or defective in character, defects of which I am aware in myself. I would even find fault with someone who disputed a particular aesthetic judgment of mine—it is disappointing to me that a very good friend of mine has never read, and doesn't plan to read, *In Search of Lost Time*, and I do feel some contempt for someone who, convinced that television is inferior simply out of ignorance of the medium, thinks badly of my admiration of *Frasier* or *Oz*. But I can't begin to imagine what it would be like to consider that *everyone* who disputes my judgment of Proust, *Oz*, or Manet is at least slightly defective. I don't even believe that most of the people who find nothing remarkable in television (or long novels or lyric poetry) in general are defective or impaired in sensibility. My feeling depends on the reasons for their attitude, and ignorance or prejudice are more often to blame for bad reasons than an impaired sensibility. But even if I sometimes fault their sensibility, I certainly don't believe that every aesthetic disagreement is due to some error. Many aesthetic differences just can't be resolved, and that's not altogether a bad thing.

Perhaps that shows that to be willing to live with such differences is not to take our aesthetic commitments seriously enough:

> When you do not laugh at the jokes I love, or when you do not care for baseball, that may sadden or surprise me, but it is a worldly fact that I can tolerate, that I can live with. But when I take a thing to be art, I take my relation to it to put me in touch with everyone else, at least potentially, for I am taking it that the thing ought to be able to be the focus of a catholic community.

This attractive way of developing Kant's view of the judgment of taste in a new direction is due to Ted Cohen. On his understanding, aesthetic judgment (although Cohen focuses primarily on art rather than

beauty) is not so much a straightforward assertion as it is an *invitation* to others to take something seriously, to make it part of what gives their life the pleasure it has. But some things are less important than others—at least they issue a more modest invitation. The agreeable, as Kant saw it, issues no invitation at all, and whether you like the color violet or the tone of wind instruments, both of which give me such pleasure, is a matter of total indifference: "with regard to the agreeable, the principle *Everyone has his own taste* (of the senses) is valid." When I tell you a joke, though, it matters to me whether or not you will laugh at it because in offering you the joke I invite you to join a community to whom humor, and in particular the kind of humor the joke is an example of, is important. The difference is, I think, that a taste for the color violet doesn't indicate anything interesting about the people who share it, while the kind of humor certain people find pleasant tells us something about their character and personality and indicates that they are part of a particular group, a specific community. But there are many such communities: the jokes we like and the games that matter to us depend on relatively idiosyncratic features of ours, and there is no reason to expect that everyone will exhibit them. Although that has never stopped an argument, there is actually little to argue about if your friend's favorite sport is baseball while yours happens to be soccer. But when it comes to art, to the genuine judgment of taste, the stakes are higher: a work of art (and it is clear that Cohen has valuable works of art or genres with valuable instances in mind) is something everyone should be capable of appreciating. The voice is still universal, yet those who don't listen aren't always in error: there are many reasons for refusing even the most tempting invitation, although the best parties remain those everyone joins.

This last step is one I can't take. Aesthetic judgment, I believe, never commands universal agreement, and neither a beautiful object nor a work of art ever engages a catholic community. Beauty creates smaller societies, no less important or serious because they are partial, and, from the point of view of its members, each one is orthodox—orthodox, however, without thinking of all others as heresies. The groupings beauty establishes are less like Christian churches

and more like the pagan cults of ancient Greece, which recognized their common concern with the divine despite the different forms in which they worshiped it, and acknowledged even foreign practices they had no desire to follow as forms of religion. What we all have in common is not, as Kant thought, a theoretical ability to find beauty in the very *same* things as everyone else but in our practical need to find, like everyone else, beauty in *some* parts of the world we inhabit. In that respect, the beautiful is closer to humor than it is either to fact or to morality, the true and the good, which do aim at the assent of all.

Cohen says that to consider "that something is art is to understand that this thing is an object for a community of auditors, and that you belong to this community," defining a community, as David Carrier writes, "in part, by the willingness to engage in intellectual exchange." That is just what I want to say about considering something beautiful, with the understanding that no such community is universal and that what is involved is less a matter of *understanding* and more a matter of hope, of *establishing* a community that centers around it—a community, to be sure, whose boundaries are constantly shifting and whose edges are never stable. But neither its shifting boundaries nor its unstable edges matter.

They don't matter because no community I hope to create around something I find beautiful is ever a universal community. One of the prison inmates in *Oz* also comments on the action of the drama, making me think of the role of the chorus in a classical Greek tragedy, and I find the allusion convincing and moving. I wonder if Aristotle may have just been wrong when he insisted that tragedy should represent people who are better than we are, or if the show is suggesting that in some ways we are no better (and perhaps even worse) than its depraved protagonists. I know I can speak only to a few of my friends about it. I also know that very few of those, in turn, will want to hear about the final scene in the Metropolitan Opera's production of Strauss's *Die Frau ohne Schatten*. During the finale, the set is removed and the house lights come on, disclosing both stage works and audience; performers, producers, and public are revealed to one another

and, as spirits and humans stand next to one another and join voices, the emperor points toward the audience and sings,

Only from far away
was it confused and disturbing;
if you listen closely
this sound is human!
Heart-stirring strains
if you take them in fully!
Brothers, friends!

while their acknowledgment of their collective humanity and their collusion recreates, without props, the theater's magic.

These are judgments few people can share. It is impossible to imagine that everyone could—much less that they should—come to accept them, not only because, as we say, conditions vary, tastes differ, cultures clash, life is short, and so on, but also for another reason. The philosopher C. S. Peirce claimed that a belief is true if it would be accepted by every scientist in an ideal world—a supremely beautiful world in which everything would be known and scientific inquiry would come to an end. Kantianism, from which Peirce drew much of his inspiration, has a similar dream about aesthetics. It dreams of a world where aesthetic difference has been eliminated. If aesthetic judgment makes a claim to universal agreement, then, ideally, everyone would accept every correct judgment: in a perfect world, we would all find beauty in the very same places.

But that dream is a nightmare, already described by Aldous Huxley, a brave new world where everyone is happy "nowadays" except for the Savage, who claims for himself the right to his own taste and, with it, the right to unhappiness. Imagine, if you can, a world where everyone likes, or loves, the same things, where every disagreement about beauty can be resolved. That would be a desolate, desperate world. Such a world, even if Shakespeare, Titian, and Bach were to be part of it—impossible with artists too complex and ambiguous to provoke a uniform reaction—would be no better (but also no worse)

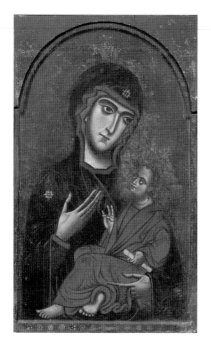

Figure 46
Madonna and Child, known as the "Pisa Madonna," Florentine School, mid-13th century, Galleria degli Uffizi, Florence, Italy

than a world where everyone tuned in to *Baywatch* or turned on Wayne Newton at the same time. What is truly frightful is not *what* everyone likes but simply the fact that *everyone* likes it. Even the idea that everyone might share *one* of my judgments sends shivers down my spine, although it is no less repulsive than the possibility that one other person might accept all of them.

That is a bald claim, abruptly made. It needs support.

Uniformity, Style, Distinction

If ideally aesthetic agreement is to be universal, then in reality, where disagreement is universal instead, everyone is bound to find everyone else defective. No doubt, as I said earlier, we all feel that way about some people sometimes, but if the thought that the judgment of taste is a genuine judgment implies that our species should be held together by bonds of mutual contempt, something must be wrong with it. Aesthetic judgment must move away from a dogmatism that detects a difference in quality in every divergence in taste without, at the same time, falling into a relativism that refuses to make any judgment at all.

It is important to establish such a middle ground, for our aesthetic judgments are most consequential. They don't represent arbitrary choices, made only after the serious business of life is complete. It isn't as if I go through life picking a person here, a novel there, a picture or a mountain further down, enjoy them, add them to the stock of what I have judged to be beautiful, and move on. Prospective as they are, my judgments reflect my willingness to interact with such things over time, longer with some than with others but in every case giving over a part of my life over to them because, far from having made up my mind about what makes them beautiful, I still hope to find in what their beauty consists. Every judgment of beauty prompts, or rather includes, the question "Why is that thing beautiful?" which aims at a better understanding of its nature. It may lead to features that are themselves beautiful and seem to account for the beauty I

have seen so far but only by raising the same question about themselves and pulling me further along, or it may lead me to abandon my original judgment and turn elsewhere instead. By forcing these questions, my aesthetic judgments literally determine the course of my life, directing me for their answers to other people, other objects, other habits and ways of being. The judgment of beauty is, as I have said, essentially social, although it doesn't touch humanity as a whole. But although it is neither completely objective or public, it is also not purely subjective or private. Between these two domains, which have sometimes seemed to exhaust all available social and logical space, there is a third, which extends well beyond the private but falls far short of the public. The judgment of beauty is *personal*.

What we find beautiful is central to our taste or sensibility, and taste or sensibility is manifested whenever we act on our own and not only along lines already drawn by routine and convention. It is revealed when principles aren't enough to account for an idea, a feeling, or a choice. Ironically, it is impossible to give a pure example of this contrast, because what reveals absolutely no sensibility is, so to speak, insensible and disappears into—it becomes—the background. Perfectly trained marching soldiers or assembly-line workers may come close to such an extreme, but most cases involve different degrees of convention and routine. For more than a millennium, the Byzantine techniques for representing the facial features of the Virgin and her interaction with her Child have remained virtually unchanged (figs. 46, 47). Against that background, Duccio's figures (fig. 48), strikingly lively and supple as they are, are an expression of Duccio's own sensibility, which gives his work its marked and unusual character—in other words, they are manifestations of Duccio's personal style.

Taste, sensibility, character, style: they can't exist without a background of principles, systems, and rules, but they are exactly what principles, systems, and rules have no room for. Style can't be fully articulated—a sensibility, as Susan Sontag once wrote, "is almost, but not quite, ineffable." Nor is it something one can adopt or abandon at will. It is part of who one is, a way of being both inevitable and unforced, a necessity that is not the result of compulsion. It is

Figure 47
Nicholas Papas, *Virgin Hodegetria.*
Contemporary, Byzantine Style

Figure 48
Duccio di Buoninsegna, *Madonna and Child*, c. 1300, Metropolitan Museum of Art, New York

what Nietzsche, echoing a view of freedom first expressed by Plotinus, finds in those artists who know "only too well that precisely when they no longer do something 'voluntarily' but do everything of necessity, the feeling of freedom, subtlety, full power, of creative placing, disposing, and forming reaches its peak—in short, that necessity and 'freedom of will' then become one in them." A style that can be captured in a system of rules is no longer a style but a manner or a convention. It has become mere background, against which a new style may come to stand out, adding to the determined domain that makes freedom possible. Whether among the greatest artists or the most ordinary people, character and style are an essential part of what distinguishes a person from the rest of the world. They are the grounds of individuality.

The values of morality bind us to one another. They move us to expand the circle of our concern as widely as we possibly can and, for that reason, both exploit and generate similarities among us. Aesthetic values have a narrower domain. They direct us toward smaller and more special groups, which stand out against the rest of the world and within which it is possible for us, too, to stand out. Both kinds of values can be misapplied. Similarities can be established by force, manipulation, or coercion; individuality may be the expression of pretentiousness, disdain, and wilful exclusion. But when they are not, while the values of morality are the emblems of our commonalities, the values of aesthetics are the badges of our particularities. They are marks of distinction, whose collective name, "Beauty," names those attractions that exceed our ability to articulate them in terms that we already understand, and promise to reveal to us something never seen before.

No style exists at all unless there is at least one other. A single deviation from a universal norm is just that—a deviation from the norm. A style is *another* way of doing things, but a universal norm is not *a* way of doing things at all; it's just the way things are and allows no exceptions. And so, if a style exists there must also be another from which the first can be distinguished. Universal aesthetic agreement would mark the end of aesthetics. "Distinction" always denotes a necessity and, sometimes, a value.

"*One thing is needful*," Nietzsche wrote in *The Gay Science*:

To "give style" to one's character—a great and rare art! It is practiced by those who survey all the strengths and weaknesses of their nature and then fit them into an artistic plan until every one of them appears as art and reason and even weaknesses delight the eye. . . . In the end, when the work is finished, it becomes evident how the constraint of a single taste governed and formed everything large and small. Whether this taste was good or bad is less important than one might suppose, if only it was a single taste!

The subtleties of Nietzsche's views are not important here. What matters is that I can admire you for exhibiting "a single taste," a consistent sensibility, without for that reason admiring the taste you exhibit. Who strikes me as having bad taste? Not everyone whose judgment I reject, since I often abandon my own judgment as a result of disagreeing with someone whose taste I admire despite our other differences, and I am ready to recognize that some people simply have another way of doing things, which, though not mine, I have no reason to criticize. Rather, those whose choices I cannot connect in an interesting way to each other and therefore seem to be random; also those at the other extreme, whose choices have nothing original or even random about them, revealing nothing individual but only the application of somebody else's preferences and rules. In most cases, bad taste is literally the lack of taste, the absence of style—dull randomness or drab uniformity.

The question, of course, is what we are to count as dull or drab, and that's as it should be, for style, as Nietzsche saw, is an accomplishment. As Baudelaire said of Manet, "He will never completely fill the gaps in his temperament. But he has *a temperament*—that's what's important." For that reason, when I detect a style, even a style I don't admire in every respect, I want to understand better how its elements hang together, the character manifested in the choices in which it consists. Conversely, I may become reconciled to the different judgments of someone whose style I admire without thinking of them as a lapse

exactly because they fit with the rest of their taste. And so I understand Dave Hickey's admiration for Norman Rockwell, whom I continue to find trite and banal, because the formal complexities Hickey finds in his work are of a piece with the devices of the widely accessible art (like Raphael's, he might say) that celebrates Hickey's populist democratic values. I also understand, and feel I can come to terms with, Michael Fried's rejection of Minimalism, which I find more valuable than he does, because what Fried misses in Minimalism is the seriousness, impersonality, and "conviction" that are the hallmarks of the Modernist works to which he is devoted, and his attitude is part of a consistent and engaging large picture of the development of modern art. It is no mean feat to exhibit a consistent sensibility.

But it is not always enough. Obvious, predictable consistency is the mark of camp, which, Susan Sontag wrote, remains indifferent to the development of character and understands it "as a state of continual incandescence—a person being one, very intense thing." The camp character is so determined that every new choice, every new action is already old, anticipated, and exhibiting more of the same. Camp is suspect, although I don't think it is always a fault. It is, for example, one of the defining features of movie stars, especially in the Hollywood of the nineteen-thirties and forties. In film after film, Greta Garbo "just played" Greta Garbo, and we love her for that, because of the pleasure of recognizing everything we already know her to be whether she appears as a Swedish Renaissance queen, a nineteenth-century Parisian courtesan, or a fading ballerina in Weimar Germany. She delights precisely because she can remain uncannily the same whatever the drama unfolding around her: the same faraway look is always combined with the same piercing intensity, the same cold hard flame gives ground to the same yielding lassitude, the same (always the same) monosyllabic pelvis gives shape to her various costumes.

Camp, though, as every good mimic knows, can turn all too easily into its own caricature, and even in the best of cases its success is limited—it may have worked in a certain type of film, but it may be too thin for most of the other arts as well as ordinary life. Style and character, as I am thinking of them, can in all their unity and

consistency also surprise: novel dispositions and unanticipated actions can fit well with the old, cast them in a new light, and, in that process, change their significance. Together, old and new compose an original, unpredictable, but still intelligible whole.

Consistency, therefore, is one of the elements of an admirable style or character but not, in general, the whole of it. It comes at a price—the risk of falling into mindless uniformity. Uniformity can be internal and self-imposed, like camp, or social and derived from others, the result of allowing another, whether an individual or a group, dictate what one is to enjoy and appreciate. That is not to say that conformity is without its uses. Think of the punk style or all those men in their grey flannel suits: it is to a degree inevitable and in many cases important for group identification. But if camp is always on the brink of collapsing into doubtful taste, conformity tends toward eradicating it altogether: whether you let Bernard Berenson, Clement Greenberg, Leo Castelli, or Martha Stewart determine your preferences, however happy your choices, your taste is no longer yours but theirs. Style requires originality and originality demands distinctiveness.

It is with us as it is with the arts, and that is one more reason not to draw too stark a distinction between "art" and "the world." T. S. Eliot once wrote that a function of criticism is "to exhibit the relations of literature—not to 'life,' as something contrasted to literature, but to all the other activities, which, together with literature, are the components of life." I would go further: many of the features and values we have, under the influence of Modernism (Eliot's included), limited to the arts are present in all these other activities that, together with the arts, are the components of life. We don't have to agree with Nietzsche that "it is *only* as an aesthetic phenomenon that existence and the world are eternally justified" in order to say that "aesthetic" values (among others) permeate every aspect of life. Recent philosophy has succumbed to a moralism according to which the right way of conducting ourselves toward one another is the full answer to Socrates' question, how one should live. But morality, "what we owe to each other" in Thomas Scanlon's happy phrase, is neither the only nor obviously the most important issue we consider when we try to

Figure 49
Jean Baptiste Siméon Chardin, *La Pourvoyeuse* (*The Cateress*), 1739, Louvre, Paris, France

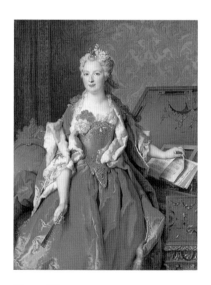

Figure 50
Nicolas de Largillière, *Portrait of Marguerite de Sève*, 1729, The Putnam Foundation, Timken Museum of Art, San Diego, CA

determine how best to lead our lives. For the same reason, it is absurd to think that morality permeates even the domain of art itself. One philosopher, at least, imagines that—unless it is by artists of the caliber of Homer, Shakespeare, "even" Wagner, whose virtues, we are told, overshadow their moral obtuseness—a work marred by "ethical deficiencies" is only worthy of attention "for historical interest or for rhetorical and grammatical interest." Whatever the relations between art and morality—and they are bound to exist—they are considerably more complex. Aesthetic judgment is not, not for adults at any rate, primarily an implement of moral edification.

A style or character we admire must necessarily differ from other styles and characters, just as an admirable work of art stands out among those that surround it. A person or a work lacking distinction can't come to our attention in the first place. Not that difference produces value in its own right. Difference is a catchall idea. It applies to everything in the world without exception, since everything is different from everything else in some way or other. It is not a goal: you can't want to be different, since you are different already, in more respects than you can know. You can only want to be different in specific ways, and it is these that constitute your goals. Aesthetic value depends on very particular features that differ from others in subtle ways and give their bearers a character that is distinctly their own. They are the sort of features that set Chardin apart from his contemporaries (fig. 49), the features Nicolas de Largillière (fig. 50) missed (and, if you consider his own flamboyant style, was bound to miss) when he told Chardin, "You have some very fine paintings there. They must be by a good Flemish painter." They are the features to which Michael Baxandall has given the careful attention they require: Chardin, Baxandall writes,

started from . . . an old heroic formula for lighting composition found in such as Guido Reni; he transferred this to domestic things and to food on tables. But he worked on it and effectively transformed it, not least by distinguishing more sharply between illumination and distinctness, distinctness and force of hue, force of hue and lustre. In effect he asked what

the old formula could be seen as *representing*, and by making it represent perception he made it something else. . . . [His pictures] offer the product of sustained perception in the guise of a glance or two's sensation.

"In the *guise* of a glance": Chardin actually forces you to *see slowly*, which is sometimes necessary if beauty is to appear. Both in art and in the rest of life, beauty may take a long time to emerge, but, once it does, it will absorb you completely and make the rest of the world recede, if only for a moment. One thing, of course, can push another into the background for various and different reasons—it may be the largest, the brightest, or the loudest, the most important or most relevant to our concerns. Beautiful things stand out against the rest in a particular way, but *that* is just what we can never describe in general terms. Our most detailed and careful accounts will always fail to capture either the particular way in which beauty differs from all other values or the particular way in which one beautiful thing differs from another. Words can only get us so far. But why does the judgment of beauty require such a direct experience of its object?

Aesthetics, Directness, Individuality

The judgment of beauty addresses the aesthetic features of things, but we have seen that the same feature can sometimes make a positive and sometimes a negative contribution to aesthetic value. Blue (even International Klein Blue) is not always beautiful, but sometimes it is and so is the object whose color it is. Red streaks are rarely aesthetically relevant, but, if Michael Fried is right, it is impossible to appreciate Manet's *Execution of Emperor Maximilian* without seeing the significance of the streak visible between the legs of one of the members of the execution squad. Not at all remarkable in itself, the same streak might actually provide a good reason to dislike another painting containing it. Arnold Isenberg, to whom every discussion of aesthetic properties must return, noticed these features as well as the fact that the language of criticism is always more general than the

qualities it aims to point out—Fried, for example, only speaks of "a streak" or "a streak of red paint"—and concluded:

> It could not be the critic's purpose to inform us of the presence of a quality as banal and obvious as this. It seems reasonable to suppose that the critic is thinking of *another quality*, no idea of which is transmitted to us by his language, which he *sees* and which by his use of language he *gets us to see*.

But the idea that aesthetic qualities are always *different* from the qualities critics describe is extravagant. Moreover, it is motivated by the assumption that all aesthetic qualities are ultimately perceptual, and that has led some philosophers to claim that the aesthetic dimension is more or less limited to the way a thing "looks (shape and color), the way it sounds, smells, tastes or feels" but that "we are inclined to allow in non-aesthetic criteria 'by courtesy' . . . so that we may *even* include intellectual merit"!

This conception is extraordinarily impoverished—it excludes, for example, both the plot and the characterization of *Hamlet*, making the object of aesthetic appreciation a mystery—and limits the aesthetic to a special class of features, that is, perceptual qualities. But we have also seen that "aesthetic" applies less to such a special class (even if it includes elegance, grace, garishness, and so on) than to a special way in which a large number of features can function under certain conditions. What conditions can these be? Let's think of aesthetic features (now short for "features that function aesthetically") as the features an object shares only with other objects from which it can't be distinguished. That means that two things that have one or more aesthetic features in common can't be told apart, which is to say that in order to establish the aesthetic features (and so the aesthetic quality) of something, you must experience directly either that object or an identical copy of it.

What that has to do with aesthetics, beauty, and art may not be immediately obvious, but think of the times you tried to explain why you admired (or hated) something only to face an uncomprehending

"So what?" If I told you that *St. Elsewhere* is a remarkable work of art partly because its ending, six years after the show first went on the air, suggests that its intricately connected stories were all the fantasies of an autistic boy, I wouldn't be surprised if you replied that you couldn't see how that was relevant or even that turning what is supposed to be real in a fiction into a dream is a very cheap way of leaving a work's loose ends unresolved. I could tell you more about the ending and the show more generally, but I know that at the end, whether I had moved you at all or not, I would have to say something like "You have to see the show (read the book, hear the piece, look at the picture) for yourself to see what I mean."

Thinking of aesthetic features as I have suggested, although not without problems, is meant to account for this characteristic of critical discussion. A description of the features of *St. Elsewhere*, no matter how detailed, will necessarily have to be general and, like all descriptions, specify features that apply to several distinct objects. The only way I can make my description specific enough is to say that I am not thinking of the convention of turning reality into a dream in general but of "the particular way" *St. Elsewhere* uses it for its own purposes. But that, of course, is also to say that I *can't* describe it, since that "particular way" will always lie a step beyond my most detailed account and you will only understand what it is if you see the show for yourself—which brings us back where we started. We have to see for ourselves because an aesthetic feature applies only to one object and those things, if any, from which that object can't be distinguished.

It is exactly for that reason that I think the little patch of yellow wall in Vermeer's *View of Delft* (fig. 51, *Plate 10*) that brought the dying Bergotte, like the dying Proust himself, out of his bed to pay homage to it is beautiful only within that painting and not, as a critic within the fiction of *In Search of Lost Time* is supposed to have written, "like a precious work of Chinese art, of an entirely self-sufficient beauty." It is why I have admired the geometric balance of Piero's *Baptism of Christ* (fig. 52) since I was a child, while the artful equilibrium of Rockwell's *After the Prom* (fig. 53) has always left me cold,

Figure 51
Johannes Vermeer, *View of Delft* (detail), 1662, Mauritshuis, The Hague, Netherlands

Figure 52
Piero della Francesca, *The Baptism of Christ*, c. 1450–55, National Gallery, London, UK

Figure 53

Norman Rockwell, *After the Prom*, 1957. Licensed by and reproduced by permission from Curtis Publishing Co.

and why every description of these two different manifestations of symmetry is bound to be disappointing.

The word "aesthetic" comes from the Greek *aisthēsis*, which means "perception." That has made it seem that all aesthetic features are perceptual, which has given life to the idea that beauty is a matter of appearance and, at the same time, has confined the aesthetic to few of the qualities that move us both in human beings and in works of art. Now, though, we can see that a feature is aesthetic not because it is perceptual but because we can't be aware of it unless we perceive or experience directly (in a sense broad enough to include reading) the object whose feature it is. This way of thinking allows all sorts of features to function aesthetically in particular contexts, since there is no limit to the kind of features objects can share with their identical copies, and all sorts of objects to have aesthetic features, since there is no limit to the kind of objects of which identical copies can be made.

Consider this also. What one person finds indistinguishable another might not, and so whether two things are indistinguishable or not is depends on the observer who is trying to tell them apart. As Mary Mothersill notes, "The relativization is important: differences between, say, two twins, which are imperceptible to one subject, may be obvious to another." Sancho Panza's cousins could taste the difference, imperceptible to everyone else, that a key tied to a leather thong made to the flavor of a hogshead of wine. Most people can't detect the differences between Byron and Shelley that seem self-evident to specialists in Romantic poetry, and most specialists in Romantic poetry probably can't distinguish between the jaded derision of *Seinfeld* and the generous mockery of *WKRP in Cincinnati*. Some people can tell whether they are listening to Callas or Tebaldi after a few bars, while others hear nothing but screeching; some can hear only a deadly, monotonous beat where others savor the obvious differences between Eminem and P. Diddy, and where an angel is revealed to one, the world at large sees a brutish snout: "Every bridegroom," Hegel writes, "regards his bride as beautiful, being possibly the only person who does so; and that an individual taste for beauty of this kind admits of no fixed rules at all may be regarded as a bit of luck for both parties."

Since different people find different things indistinguishable, they also find aesthetic features, and beauty in particular, in different places, none of them limited to one or another specific area—say, works of art, human beings, or landscapes. Although most of my examples have come from the arts, my account of aesthetic features places no restrictions on the kinds of things that have them. Beauty is everywhere. Hegel, for one, wouldn't agree. He thought that only art was worthy of it, and so he denied that the beauty brides and bridegrooms find in each other is real, since he believed that to be purely a matter of taste. By contrast, John Carey, who in *What Good Are the Arts?* takes Hegel and the whole tradition he represents to task, has no problem conceding that beauty is purely a matter of taste—but so, he thinks, is art: the idea that works of art are a particular sort of thing belongs "to the late 18th century, and [is] no longer valid in our culture. The question 'Is it a work of art?' . . . can now receive only the answer 'Yes, if you think it is; no, if not.'" For both, though, beauty and art coincide. The difference between natural and artistic beauty is not, Hegel says, merely "quantitative" or "external" but absolute: "The beauty of art is beauty born of the spirit and born again, and . . . spirit is alone the *true*, comprehending everything in itself;" both (real) beauty and art are objective categories. Carey, on the other hand, thinks that beauty is in every respect a matter of taste and so, he concludes, anything can be a work of art, since anything can be liked by someone or other: "A work of art is anything that anyone has ever considered a work of art, though it may be a work of art only for that person."

Thinking that aesthetic features are those that only indistinguishable objects can share, though, makes it possible to separate the aesthetic from a definition of the arts. Aesthetic features are really everywhere, but that has nothing to do with where the arts can be found. Works of art can be beautiful because everything can be beautiful, but that doesn't mean that anything can be a work of art. Judgments of beauty may exhibit the limited relativity of personal judgments, but works of art may have to be defined in absolute and objective terms—or not: either way, the aesthetic has no connection to the definition of art.

Figure 54
Jacques Louis David, *Death of Marat*,
1793, Louvre, Paris, France

Figure 55
Domenico Ghirlandaio, *Old Man with a
Child*, c. 1489, Louvre, Paris, France

Convinced that aesthetic responses are not limited to the arts, Arthur Danto, too, once argued that "we cannot appeal to aesthetic considerations in order to get our definition of art, inasmuch as we need the definition of art in order to identify the sorts of aesthetic responses appropriate to works of art in contrast with mere real things." He eventually settled on the more complicated view that although *beauty*, which he considers as one particular aesthetic quality among many, does not belong to the essence or the definition of art, that "does not mean that *aesthetics* belongs neither to the essence nor the definition of art." Even beauty, which is for Danto an "optional" rather than a necessary feature of art, can have a crucial role: when, that is, instead of being merely decorative, its presence makes a difference to the meaning of a work.

The hero's corpse in David's *Death of Marat* (fig. 54) is beautiful, for example, not because David always painted beautiful bodies (he did: even the blind, begging Belisarius retains his warrior's musculature) but because, by posing the body as if it were part of a Deposition, David wanted to connect Marat's suffering with the passion of Jesus and inspire his audience with revolutionary zeal. Beauty is here internally connected to the work's significance—but, I want to ask, the beauty of what? Danto has asked why the painting is beautiful, but what he talks about is the beauty of Marat's corpse, which is not at all the same thing. *Death of Marat* may be a beautiful painting, but that is not, I think, because Marat's corpse is beautiful: the beauty of a painting is not necessarily connected to the beauty of its elements.

In fact, a beautiful painting may well contain elements Danto would consider ugly, and sometimes an ugly element may even be responsible for the beauty of the whole. Ghirlandaio's *Old Man with a Child* (fig. 55) is an obvious example: the tenderness of the look grandfather and grandchild exchange is poignant precisely because the man's ugly nose does not come between them. And although it is considerably more difficult to think of an ugly painting that depicts a beautiful body, I believe that John Currin's *Heartless* (fig. 56), like much of the rest of his work, will do.

Danto, we have seen, believes that beauty is "really as obvious as blue: one does not have to work at seeing it when it is there," and he describes how the beauty of Motherwell's *Elegies for the Spanish Republic* series (see fig. 57) stopped him in his tracks the moment he saw them for the first time, when he knew nothing about the work, only gradually coming to realize how appropriate their beauty was to their meaning. By contrast, beauty makes Salgado's photographs of the displaced dissonant and jarring: "If beauty is internally connected to the content of a work, it can be a criticism of the work that it is beautiful when it is inappropriate for it to be so." Danto's attitude manifests his assumption that being beautiful and looking good are the same: Salgado's photographs, like Marat's corpse and even David's painting, are undeniably good-looking. But that does not by itself affect their artistic value. And the reason their good looks are just about the first thing we notice about them is that they conform to our own standards of what counts as looking good.

Figure 56
John Currin, *Heartless*, 1997, Gagosian Gallery

Figure 57
Robert Motherwell, *Elegy to the Spanish Republic No. 110*, Easter Day, 1971, the Solomon R. Guggenheim Museum, New York

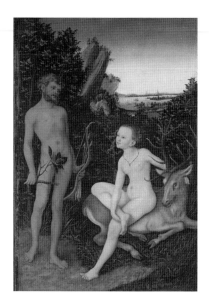

Figure 58
Lucas Cranach the Elder, *Apollo and Diana in Wooded Landscape*, 1533, Gemaeldegalerie, Staatlich Museen zu Berlin, Germany

My own experience of Motherwell's *Elegies* has been very different from Danto's. Apart from thinking that black was the right color for works with that title, I could make nothing of them on first seeing them and I found the shape of their various figures inexplicable. I suspect my reaction was much more common than Danto's, which (I also suspect) owed much to his great familiarity with Modernism and Abstract Expressionism. It was only gradually and after learning much more (some of it from Danto himself) that I came to see the beauty of the forms and their contribution to the work as a whole. If the beauty of a painting depends on its meaning, it may take a long time to see, just as it takes time to perceive how the personality of the person you fall in love with is visible in her face.

David gave Marat's corpse a shape and a pose we still find attractive and find easy to perceive, but standards of attractiveness change drastically over time and are influenced by many different factors. One reason, for example, the naked human body has taken so many forms over the centuries, as Ann Hollander has shown, is that its shape was often determined by the clothes it was fashionable to wear at the time. Assume that the shape fashionable clothes give to a body is exactly the shape of the body itself and subtract the clothes: the result is the naked body as each period would like it to look.

The value of *Death of Marat*, like its historical meaning, need not change when different kinds of bodies (and different ways of representing them) come into fashion, as they inevitably will. We could still understand that David was appealing to the revolutionary masses, and that he was successful, even if Marat's body did not move us as, presumably, it still does. For that, we would need an understanding of David's intentions and a sense of the bodily form his audience would have found attractive, whether or not it seemed that way to us. In the end, the question whether Marat's corpse is beautiful is a question about David's intentions (and his abilities).

It is easy to believe, for example, that in Cranach's *Apollo and Diana* (fig. 58) both gods are intended to be attractive, although one seems to me painfully gaunt and the other disproportionally bottom-heavy, and so to see in the painting the influence of Renaissance

humanism on Cranach's later work and not, as we might have done if we took the bodies to be intentionally misshapen, a criticism of paganism. Even if we find Apollo unattractive, we can still understand and—some of us—admire the painting of which it is an element. You might even be moved by it and find it beautiful, but you won't for that reason find Apollo good-looking.

In the end, then, we have returned by another path to the idea that aesthetic features are not perceptual and beauty not a matter of appearance, although it is impossible to become aware of them without experiencing them directly: "Whether a garment, a house, a flower is beautiful: no one allows himself to be talked into his judgement about that by means of any grounds or fundamental principles." Beauty isn't the final effect of a limited range of features—elegance, grace, harmony, and the other stock components of the pathetic lists of our textbooks—nor is it simply one among them: if anything has a place in such a list it is looking good, prettiness, being handsome. Beauty is the object of love and, for better or worse, love can be provoked by anything, sometimes even a streak of red paint or a blue spot on the upper right-hand corner of a painting. Taste is not a faculty we need to have in order to discern the aesthetic features of things: aesthetic features inform our every waking hour and we are all—every one of us—aware of them surrounding us. Taste is what one exhibits when one focuses on the right ones, in the right way (we shall have to ask what rightness is in the next chapter). But to be aware of any aesthetic features at all we must examine things for ourselves; any effort to describe them, however helpful, will in the end apply to features common to distinct objects, while aesthetic features, if they are shared at all, are common only to things that can't be told apart from one another.

That is another way of saying that a beautiful thing is irreplaceable. Nothing else can play the role you hope a beautiful thing will play in your life as long as the two are distinguished in any way from one another. Even if I love you for your kindness (inadequate as, we have seen, that has to be as a reason), you needn't fear that I would love someone kinder than you are more than I love you—a fear that has

caused not only philosophical disputes but personal quarrels as well. Plato, for example, has been accused of thinking that *erōs* is never for persons but only for the beauty—the image of the Form—they happen to possess, which the philosopher is happy to leave behind as soon as he becomes aware of a better image, a higher beauty, which he also abandons without a second thought as he makes his upward way to the perfect beauty of the Form itself. But Plato didn't believe that, and, more to the point, he didn't have to believe it. To love you for your kindness is not to love your kindness *instead* of loving you (whatever that would mean); and if I did love your kindness, I wouldn't love it *instead* of loving you, for it is *your* kindness, your *particular* kindness, I would love and not kindness in general. But what do these somewhat obscure qualifications signify? Not, I believe, some unique, non-repeatable property that only one object can ever have—a "trope," as some philosophers call such mysterious features. Rather, they signify that kindness functions aesthetically here: it is a factor that draws me to you and contributes to my finding you beautiful, to your being to some extent or another part of what I love in the world. It may be manifested in habits and actions that can be described and found in other people as well, but it plays an aesthetic role only in someone who is in all respects indistinguishable from you: no one else will do, and nothing anyone can say about it is enough to make it function aesthetically for me or anyone else. If it does function aesthetically, we can only see that it does for ourselves.

That is why the aesthetic is so closely connected to the perceptual although, as many have often noticed but seldom squarely faced, they are not the same: both require direct contact, but for different reasons. They may overlap when we are concerned with objects that are themselves perceptual but not otherwise, and for that reason most theoretical discussions of aesthetic qualities center on painting, where vision is central, and are embarrassed by literature, where sound and sight—assonance, alliteration, rhythm, and, perhaps, a poem's shape—are only a very small part of what matters. But all aesthetic features, that is, all features that function aesthetically, lie one step beyond the most insightful elaboration, the most detailed descrip-

tion, the fullest interpretation. Aesthetic features, like the objects they qualify, are not fungible. You can't exchange one for *another* and expect it to play the *same* role, only better, because you make a beautiful object part of your life without knowing whether, but hoping that it will, make it better *whatever* the rest of its qualities: you accept them all, whatever they are, and you admit the beautiful object, just as it is. The only thing that you know is that no other object, no other person, can possibly have the same effect. A beautiful thing stands out against its background and its beauty, which distinguishes it from everything else, promises a happiness impossible to find anywhere else.

Nothing but the beautiful object itself can issue that promise; no one can transmit it. Making beautiful things part of my life is neither loose talk nor a metaphor: I must literally come into direct contact with them and spend part of my life in their presence and company. What that can do for me, or anyone else, remains to be seen. It's time to ask that question.

IV

Love and Death in Venice

What separates the woman with whom I have spent most of my life or my closest friend from others whose paths have crossed mine for shorter or more scattered times, Proust from Rex Stout, *Moby-Dick* from *The Old Man and the Sea* and *Jaws*, Manet from Magritte, is less the kind of feelings they inspire in me than their complexity and the long-term effect of our relationship. I don't need to spend the rest of time with every beautiful person or thing I am aware of—and sometimes I resist any desire to do so—but if I do find something beautiful I do more than simply throw a glance in its direction and, like a bored museum visitor, move on to the next one down the line. Beautiful things require attention and, if only for a limited time, an attachment both deep and intense; to abandon them, like being abandoned by them, is always a source of pain. Despite not knowing what that will make of us, we want to be affected by them. And

that in turn requires both time and trust—a trust that amounts to a forsaking of personality that is not only, as E. M. Forster described it, "a possible prelude to love" but its most direct expression.

In *Death in Venice*, his 1913 novella, Thomas Mann depicts an extreme, frightening form of such forsaking. An aging German author, Gustav Aschenbach, falls in love with a Polish boy during a visit to Venice and, unable to tear himself away despite all sorts of warnings of an epidemic, prolongs his stay and ultimately dies of the cholera sweeping the floating city around him and the despair flooding him from within. Here is one of his first encounters with the boy, described in terms that go back directly to Plato's *Phaedrus*:

> He walked with extraordinary grace—the carriage of the body, the action of the knee, the way he set down his foot in its white shoe. . . . He took his seat, with a smile and a murmured word in his soft and blurry tongue; and Aschenbach, sitting so that he could see him in profile, was astonished anew, yes, startled, at the godlike beauty of the human being. . . . [The boy's head] was the head of Erōs, with the yellowish bloom of Parian marble, with fine serious brows, and dusky clustering ringlets standing out in soft plenteousness over temples and ears.

The narrow world of the hotel where they are both staying allows Aschenbach to be almost constantly in the boy's presence. He can observe him throughout the day, but

> it was the regular morning hours on the beach which gave him his happiest opportunity to study and admire the lovely apparition . . . this it was that filled him with content, with joy in life, enriched his stay, and lingered out the row of sunny days that fell into place so pleasantly one behind the other.

On account of such moments, Aschenbach succeeds in missing the train that would have taken him away and remains in Venice, obsessively following the boy Tadzio about the city. Hair newly dyed and face made up, he makes himself alarmingly conspicuous and becomes

a figure of ridicule, eventually becoming infected by the disease. The boy's beauty does not only provoke Aschenbach's feelings of admiration and joy while he gazes upon him but also the writer's horrible nightmares and, more important, the actions that keep him in the festering city, lead him to make a fool of himself, and finally bring about his own death. Aschenbach's love does not express itself only in his feelings when he gazes upon the boy but in his actions when Tadzio is absent as well—the pleasure and the harm are parts of the same phenomenon, and both are provoked not just by a pure, wordless vision of the boy but also by Aschenbach's way of understanding his beauty:

> What discipline, what precision of thought were expressed by the tense youthful perfection of this form! And yet . . . was not the same force at work in himself when he strove in cold fury to liberate from the marble mass of language the slender forms of his art which he saw with the eye of his mind and would body forth to men as the mirror and image of spiritual beauty?

More than mirror and image,

> his eyes took in the proud bearing of that figure there at the blue water's edge; with an outburst of rapture he told himself that what he saw was beauty's very essence.

Aschenbach's passion is fueled by a particular interpretation of Tadzio's beauty, and he devotes what is left of his life to capturing the force he thinks is manifested in both of them. At the end, from a sandbar that makes it seem as if he is standing on the surface of the sea, Tadzio turns to him and Aschenbach answers his call:

> It seemed to him the pale and lovely Summoner out there smiled at him and beckoned; as though, with the hand he lifted from his hip, he pointed outward as he hovered on before into an immensity of richest expectation. And, as so often before, he rose to follow.
> Some minutes passed before anyone hastened to the aid of the elderly man sitting there collapsed in his chair. They bore him to his room. And

Did Tadzio mislead Aschenbach when he summoned him to the happiness of that immensity of richest expectation? Who knows? We can't even be certain that his gesture was an invitation in the first place.

What we do know is that Aschenbach interpreted Tadzio's gesture as an invitation that promised him something he achingly wanted without knowing precisely what it was and that he took the beauty of the boy's form as a manifestation of the same power that in the writer produces beauty out of words. The experience of beauty is inseparable from interpretation, and just as beauty always promises more than it has given so far, so interpretation, the effort to understand what it promises, is forever work in progress. It is completed only when beauty has nothing more to offer: understanding comes into full blossom as attraction withers, as it always does—unless death comes first. Attraction doesn't consist only in feelings we experience in the presence of a beautiful person or thing. It is concretely manifested in the rest of life, it is an unfolding, a working out, and a constant revision of the interpretation of the beautiful thing that sends us in directions we would not have taken without it. It permeates life, which it would be tempting to say that it changes if it were possible to know what life would have been like had that beautiful thing not been a part of it. Aschenbach's life certainly wouldn't have turned out to be as it did had he not, for particular reasons, visited Venice and fallen in love with the Polish boy, but anything he had done instead would also have led him to a different path.

Manet's *Olympia*

When I say, then, that I find the beauty of Manet's *Olympia* (fig. 59, *Plate 5*) overwhelming I am not just reporting how the painting makes me feel while I am looking at it. I am saying that I literally want to devote part of my life to it—not just to look at it (although

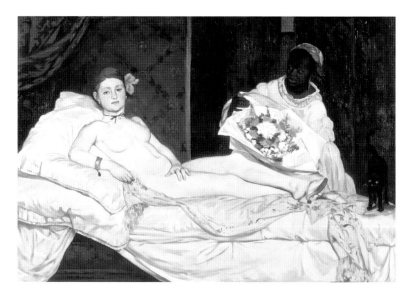

Figure 59
Edouard Manet, *Olympia*, 1863, Musée d'Orsay, Paris, France

that will certainly be part of it) but also to come to know it bet-
ter, to understand it and see what it accomplishes. Most critics and
art historians, I suppose, will consider my judgment banal, although
some may actually disagree with me on aesthetic or perhaps political
grounds, and most of the rest of the world will have no idea what
I am talking about. No one will learn anything about the painting
from my statement; they may, though, learn a little about me.

For over three years, I have been looking long and hard at this pic-
ture. I have discussed it with friends and colleagues, eager to find peo-
ple who share my feelings (and others who dispute them), and I have
spent much of my time learning about it. I have rushed to converse
both with the *Olympia* and about it. It has been a complex affair.

The painting's magnetism is undeniable, and obvious even to those
who dislike it. It attracts its viewers and doesn't let them go, remaining
incomprehensible, and, while it intimates that all they need in order
to put everything in it together is one more look, it refuses to yield
to them just as Olympia herself seems somehow impervious to the
fictional observer—perhaps a client?—who may be supposed to be

standing in front of her. Manet completed it in 1863, along with *Le Déjeuner sur l'herbe*, which he submitted to that year's Salon competition only to have it rejected and then shown in the Salon des Refusés mandated by Napoleon III, but kept it back until the competition of 1865. It was received, as we have seen, with almost universal scorn, within which lurked puzzlement, incomprehension, and discomfort. Manet's original audience found it impossible to give a coherent account of the *Olympia*, and that, according to T. J. Clark, was as it should be, for the painting contains two incompatible orders, both in subject matter and in execution, within it. Clark argues that the *Olympia* inscribes itself in the tradition of the grand European nude through its allusions to one of its first and greatest instances, Titian's *Venus of Urbino* (fig. 60), along with Ingres' *Large Odalisque* or his *Venus Anadyomene* (fig. 29), Cabanel's *Birth of Venus* (fig. 61), and many others, but refuses to follow the rest of the nude's conventions. One of those conventions is that the desire the nude female body inspires is acknowledged only indirectly, through creatures like fauns, satyrs, or cupids within the work or else by relatively abstract signs like flowing hair and the foaming sea. The viewer can think of himself as simply observing the desire the body inspires in others, his own reaction being nothing but an appreciation of an ideal representation of the female human form. The main task of the nude

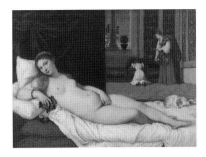

Figure 60
Titian (Tiziano Vecellio), *Venus of Urbino*, c. 1538, Galleria degli Uffizi, Florence, Italy

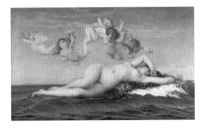

Figure 61
Alexandre Cabanel, *The Birth of Venus*, 1863, Musée d'Orsay, Paris, France

> was to construct or negotiate a relation between the body as particular and excessive fact—that flesh, that contour, those marks of modern woman—and the body as a sign, formal and generalized, meant for a token of composure and fulfilment. Desire appeared in the nude, but it was shown displaced, personified, no longer an attribute of woman's unclothed form.

I am not sure how easily desire can be attributed to the baby cupids of Ingres or Cabanel, but it is certainly true that Manet refused in many ways to play along with the idealizations of the traditional nude: it is difficult, as Clark writes, for his viewers to make Olympia "Woman." Baudelaire saw that when he praised Manet for escaping "the great failing of M. Ingres," that is, the effort "to impose upon

every type of sitter a more or less complete, by which I mean a more or less despotic, form of perfection, borrowed from the repertory of classical ideas." Manet's picture, Clark continues, gave its subject a very particular and not a generalized sexuality, deriving "not from there being *an order* to the body on the bed but from there being too many, and none of them established as the dominant one." Olympia, that is, is both almost-respectable courtesan and shameless prostitute, both innocent and sinner. Her look confronts the spectator directly, catching him in the act of enjoying her naked flesh, in a parody of the generalized, innocuous gaze of the nude. It is both blatant and unreadable, both candid and guarded, and seems so deliberate that it appears to express Olympia herself and not the idealized and universal feminine subject: "it is *her* look, her action upon us, her composition of herself." Olympia's look establishes a situation of "offers, places, payments, particular powers, and status which is still open to negotiation." Parts of her body—her right breast with its pallid nipple, the smudged corner of her mouth, the hair cascading on her left shoulder that is so hard to see—are vague and indistinct. Others—her shoulders, her heels, her strategically placed left hand—are drawn in the starkest manner. Instead of the harmony that usually characterizes the nude, Manet provides "inconsistencies . . . of a curiously unrelieved kind . . . as the best sort of truth when the subject is nakedness." Olympia's left hand, which hides her genitals, does not conform to them and, so to speak, re-represent them like the hand of Titian's model; instead, it calls maleness to mind. Olympia's body is not hairless, but the hair that marks her sexuality—in her underarms, perhaps her stomach, over her left shoulder—is painted so tactfully and indistinctly that it seems a parody of the luxuriant *chevelure* and the hairless body of Cabanel's Venus and the rules of the nude. She has two faces, one visible in its hard edges and "the closed look of its mouth and eyes," the other made softer and more pliable by the hair that hovers between the visible and the invisible by its side.

I can summarize these inconsistencies by saying that Olympia is both courtesan and nude and also prostitute and naked, showing that this woman refuses to participate in the social game that *makes* a

courtesan out of a prostitute, an object of desire out of a seller of a commodity, a lady of leisure out of a working-class woman. I would prefer to stop here, and think of Olympia as holding the mansion and the gutter together. Clark goes a step further: her nakedness amid the signs of her respectability—servant, flowers, jewelry, silks—reveals that she "is not an enigma, not a *courtisane*": in the end, her class makes her what, so to speak, she "really" is.

The point of discussing Clark's interpretation of the painting has not been so much to argue for or against it, but to suggest that engaging with the *Olympia* has been for me inseparable from engaging with his reading—I can't describe one without the other. Doing so, in addition, made it necessary for me to learn about, among other things, the institution of the salon, the history of art criticism, the social structure of mid-nineteenth-century Paris, and the connections between prostitution and the working class at that time. But Olympia, I soon found out, is not the only working woman in this picture. For it turns out, as Griselda Pollock has established, that the figure Clark describes simply as "Negress" and "maid" (Michael Fried calls her a "black maid") is based on a woman by the name of Laure, born in Paris to parents unnamed on 19 April 1839, whom Manet had sketched at least once before he put her in his painting (fig. 62). Being "black" is no more all there is to her than being "white" is all there is either to Victorine Meurend or Olympia. Laure was an African-Carribean-French woman, one of many natives of the city of Paris and part and parcel of its everyday life. Her dress is typical of Parisian clothing of the time and, being at least a size too large for her, is obviously either a hand-me-down or bought at a second-hand shop, a reminder of her concrete position in the city's economy. Laure is neither a figure of "primitive or exotic sexuality" nor "inert and formulaic, a mere painted sign for Woman in one of her states"; she is herself, just like Olympia, a working-class woman. In turn, Manet's insertion of such an "exotic," "formulaic" character within the everyday connects the *Olympia* with the popular orientalist paintings of the time (fig. 63). Similar in strategy to traditional nudes, these works displaced actual desire to an imaginary Orient and allowed their audience to enjoy them vicariously, as if

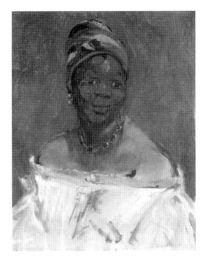

Figure 62
Edouard Manet, *The Negro Woman*, 1862–63, Pinacoteca Gianni e Marcella Agnelli, Turin, Italy

Figure 63
Jean-Léon Gérôme, *The Snake Charmer*, c. 1870, Sterling and Francine Clark Art Institute, Williamstown, MA

their interest in the primitive pleasures of the East was anthropological rather than sensual (the strategy is still common today: the *New York Times*, for example, followed it when it reported on the city's tabloids' gleeful coverage of Donald and Ivana Trump's divorce rather than on the divorce itself). Manet's picture reinserts the categories painters like Gérôme projected onto the fantastic oriental landscape into the mundane world where its audience moved and lived. The picture's

> doubled feminity . . . places the painting in a critical relation to Orientalist myth by making its modernity explicit both through what the painting does to locate the white woman in time, space and class relations and through its calculated and strategic revisions to the trope of the African woman— now also signaled as a figure located in time, space and class relations, that is in the history of the present, as another Parisian proletarian.

I bring in Pollock's account of Laure not so much in order to dispute Clark's interpretation as to indicate, once again, how every step toward understanding the *Olympia* is also a step toward understanding something else as well—Orientalism, everyday Paris, prostitution, or the proletariat. Not to mention, of course, the work of Manet's contemporaries—Fantin, Whistler, and Legros—from which Manet's painting differed in ways that, according to Michael Fried, might help explain the inability of his audience to come to terms with it: "The notorious blankness or inexpressiveness of the outward gaze in such paintings as *Old Musician*, *Déjeuner sur l'herbe*, and *Olympia* distanced and alienated the beholder even as it was felt to solicit his presence." The *Old Musician* (fig. 64), for example, Fried continues,

> seeks by its conspicuous lack of narrative or dramatic coherence as well as various "formal" devices, such as every figure touching those next to it and the abrupt partial elision of the bearded man at the right by the framing edge, to compel the beholder to take it in as a whole, a single intense facing object of vision—a single *striking* object of vision. . . . It's as if the *Old Musician* itself—the painting, not just the figure—gazes at the beholder through a single pair of eyes.

Figure 64
Edouard Manet, *The Old Musician*, 1862, the National Gallery Art,
Washington, DC

On this question, Fried is at one with Clark, who also notes the
strangeness of Olympia's way of looking out of the picture and con-
siders it a parody of the "simple, embodied gaze" of the traditional
nude, "blatant and particular, but . . . also unreadable, perhaps delib-
erately so." Olympia "looks out at the viewer in a way which obliges
him to imagine a whole fabric of sociality in which this look might
make sense and include him" but which, since it is a fabric woven
by prostitution, the beholder can't in fact bring himself to imagine
and thus makes the picture incomprehensible. Fried also, like Clark,
locates the painting's difficulty in its execution as well:

> Manet, in his struggle against absorption, found himself compelled to seek
> not just an alternative compositional route to intensity and strikingness, but
> also an alternative mode of execution, one that would be consistent with,
> that would somehow "project," the facingness and instantaneousness that
> were his main resort. . . . The means by which he tried to bring this about

not only were powerless to enforce such a reading, they threatened, by their glaring departure from traditional norms of finish, to doom his already difficult art to total incomprehensibility.

I now had to go back to the history of the nude in order to see the different ways in which nude models have addressed their audience. I looked at the obvious works—Titian's *Venus of Urbino* once again, Goya's *Naked Maja*, Ingres' *Venus Anadyomene* and *Large Odalisque*, Velasquez's *Venus with a Mirror* (the *Rokeby Venus*), which, I happened to hear, once hung not demurely on the walls of the National Gallery but salaciously from the ceiling over its owner's bed for reasons both obvious and disturbing to a naive aesthete like me. And since *Olympia* has as many descendants as it has ancestors, I found myself spending time with the picture's strange mutations in *Site*, Robert Morris's performance piece, as well as its gradual transformation into camp (kitsch?) in Mel Ramos's *Manet's Olympia* or J. Seward Johnson's full three-dimensional realistically colored bronze version, *Confrontational Vulnerability*.

During the time when I was looking for paintings related to the *Olympia* wherever I went, I happened to see Boucher's *A Lady on Her Day Bed* (fig. 65, *Plate 11*), which may be a portrait of his wife, at the Frick Collection in New York, and I became convinced that Manet had been playing havoc with that picture. In contrast to the naked Olympia, who casts her indecipherable glance from a messy bed that has no place in a proper home, Mme. Boucher, dressed in flouncy taffeta and lying on an elegant *chaise-longue* in a brocaded room full of symbols of wealth and domesticity—laquered étagère, Chinese porcelain, chatelaine watch—looks coyly to the side, away from the beholder. With the exception of their right arm, though, both women are posed in the very same way from top to bottom—from their semi-upright upper body through their crossed legs to their feet, which are clad in similar mules, one of them dangling in each case. The left hand of each rests between her thighs, but although Olympia's gesture is a dare to the spectator, Boucher's model seems almost as if she is gathering her dress about her. The prostitute has kept on the lady's bracelet and neck ribbon after undressing, and the

Figure 65
François Boucher, *A Lady on Her Day Bed* (*Presumed Portrait of Mme. Boucher*), 1743, The Frick Collection, New York

bow on the cap that indicates the married woman's status has turned into a flower—a transformation that did not in fact prove easy to recognize: Olympia's flower has often been described as a bow. The flower draws the eye to the left, where her hair, tightly pulled back in front, frames her forehead in a stern curve that repeats the outline of Mme. Boucher's neat cap, while more of her hair floats like a lush red-brown cloud—extremely difficult to see and, once seen, to keep in sight—over her left shoulder.

And just as Victorine's hair hovers in and out of sight as we look at the *Olympia*, so Olympia herself hovers in and out of sight as we look at Madame Boucher. Manet kept the screen and drapery of Boucher's painting, but transposed them from right to left as if in a mirror. Through that glass, darkly, the prostitute's questionable shadow reveals the traces of the respectable married woman—the courtesan is not her only alter ego.

Mme. Boucher, though, may be less respectable than she first seems. One expert, for instance, has been struck by "something faintly improper in the way Boucher presents his model." Several features of the picture may be, in combination, responsible for that effect: the disarray in her needlework and reading materials, the hint at her effort to gather up the skirt of her dress, and the studied nonchalance of her pose, which she seems to have assumed only at the very last minute, barely avoiding being caught in an embarrassing situation—a situation that may well have involved another person, whose hurried departure from the room could account for the "dramatic swag of orange curtain [that] inexplicably cascades onto the day bed, adding a further note of disorder into the scene." In fact, much more than a note of disorder characterizes a picture—*Lady Fastening Her Garter* (*La Toilette*), fig. 66, *Plate 12*), which Boucher had painted just a year earlier—that features the same model, the same screen, the same cap, and the same sewing

Figure 66
François Boucher, *La Toilette*, 1742, Museo Thyssen-Bornemisza, Madrid, Spain

bag trailing the same ball of white yarn. The clothing that is carelessly strewn around the room, the objects that lie haphazardly on mantelpiece and floor, and the knowing look the women exchange are clear signs that a scene of some passion has taken place before the events we are supposed to be witnessing. This lady has a double life. And if these pictures compromise the innocence they pretend to depict, then *A Lady on Her Day Bed*, which is also known as "Boucher's Untidy Venus," would be less a target for the *Olympia* than a good-humored parody of the tradition of which Manet's painting is an explicit and radical criticism. In either case, looking at the two pictures together adds a further dimension to them both.

Now, compared to Mme. Boucher's almost sly sideways glance, Olympia's look may perhaps seem like "a frank stare," a version of Baudelaire's "Les Bijoux"—"Les yeux fixés sur moi, comme un tigre dompté / D'un air vague et rêveur elle essayait des poses." This seemed such a close echo to G. H. Hamilton that he couldn't "but wonder how much of the expressive quality of *Olympia* may have been due to Manet's having heard from Baudelaire's own lips, in the early days of their acquaintance, the magical words which parallel the cold, haughty beauty of his painted image." Beth Archer Brombert, too, in her detailed analysis of the picture, refers to Olympia's "unabashed gaze." We have already seen that Michael Fried considers directness—he calls it "strikingness" or "facingness"—the central feature of Manet's paintings of the 1860s. Fried sees in that the influence of photography, with which not only Paris but the whole of Europe was intensely fascinated at the time. In "the direct gaze" of Olympia, Beatrice Farwell, too, finds "the portrait photographer." Anne McCauley, more specifically, detects the hand of A. A. Disdéri, inventor of the carte-de-visite photograph, who also shifted the practice of turning the model's face at a forty-five-degree angle from the operator, eyes directed vaguely off to the side, to pictures that "show women who stare fixedly at the camera in a manner that might have inspired Manet's *Olympia* and the nude in his *Déjeuner sur l'herbe*."

That Manet was interested in photography is well documented, and many features of his work, the absence of modeling, for instance, or

Figure 67
Félix Jacques Moulin, *A Moorish Woman and Her Maid*, c. 1865, German, The J. Paul Getty Museum, Los Angeles, CA

Figure 68
Nadar (Gaspard Félix Tournachon), photograph of Charles Baudelaire, c. 1843. Private collection

the stark contrasts between light and dark that proved so upsetting to the original audience of the *Olympia*, have been traced to the influence of the new technology. Pornographic photographs were ubiquitous in Paris, and perhaps the very idea of depicting a prostitute with her black maid may have its origin there (fig. 67). Manet, in addition, often worked directly from photographs: his etching of Baudelaire's portrait (figs. 68, 69), not to mention *The Execution of the Emperor Maximilian*, makes that clear. Still, I think that if Baudelaire's verses did have an effect on Manet, they gave him not only Olympia's "fixed eyes" but also her "vague and dreamy air," which in combination produce a look that is as indefinite as it is direct, as yielding as it is assertive, as arrogant as it is tender (fig. 70, *Plate 13*). Her gaze acknowledges the viewer precisely as it ignores him, attracting him with the promise of a secret that it insists on keeping back—a gaze both beautiful and an emblem of beauty. The smudged outline of the right side of her mouth may indicate the shadow of a smile, but not whether she is smiling in surrender, defiance, resignation, or indifference. It is hard to say whether she is being affectionate, sad, or simply professional. Hers is a hard look, harder than the look of Titian's Venus, and unwilling to engage directly, wandering somewhere beyond the beholder's left shoulder, making it impossible to lock eyes with her.

Victorine's look, as Clark rightly argues, is very much her own and not the generic look of the nude: it is neither aggressive nor compliant; compliance, he continues, "is the Negress's character, and what makes her inert and formulaic, a mere painted sign for Woman in one of her states." But once we have been alerted to the particularity of Laure, we can begin to see that her own look and character are no less complex and elusive than Victorine's. If you look carefully, you will find much more than compliance in her face, perhaps a hint of contempt and even pity as she offers the flowers to her mistress. Her mouth contains the faintest trace of a smile that might suggest a kind of vicarious pride in the small triumph that the extravagant bouquet clearly indicates but could also be a sign of uncertainty, a quizzical expression of uncertainty as to how Victorine is likely to react to the gift. Laure, when we look at her as a concrete individual, becomes

pictorially as well as ideologically complex: social context and thematic significance interpenetrate.

In any case, no matter what we take her look to suggest, we must face the fact that Victorine's eyes are focused almost infinitesimally off to the side and not at the viewer directly. And it is exactly *here*, I believe, that we can see the most important contribution of photography to Manet's painting, for the notion that a photographic subject is likely to look directly at the viewer is in most cases an illusion, an effect created only when the subject is focusing directly on the camera's lens (fig. 71). But that, I realized during a retrospective of Diane Arbus's work, is relatively rare: even Arbus's photographs, which have so disturbed their beholders by their unswerving looks at her subjects, show that their subjects' own look at their beholders is less unswerving than we commonly suppose. We already know that Manet may have had specific pornographic photographs in mind while working on the painting (fig. 72). He also deliberately exploited, as Fried puts it,

Figure 69
Edouard Manet, *Charles Baudelaire* [1820–67], 1868, etching, Nationalmuseum, Stolkholm, Sweden

Figure 70
Edouard Manet, *Olympia* (detail), 1863, Musée d'Orsay, Paris, France

Figure 71
Félix Nadar, photograph of Edouard Manet, 1865, Musée d'Orsay, Paris, France

Figure 72
Louis-Camille Olivier, nude photograph, untitled, George Eastman House, Museum Collection, Rochester, NY

certain broadly photographic effects, above all, first, the contemporary photograph's emphasis on abrupt contrasts between areas of light and shadow with a consequent suppression of halftones and interior modeling, and second, the impression the carte de visite inescapably conveyed that the sitter knowingly posed for the photographer.

But, in addition, photography plays a substantive part in the *Olympia*: beyond inspiring its structure and subject matter, it is one of its most essential elements, as Jean Clay must have suspected when he wrote that "in some sense" Manet painted "not Victorine Meurend but her photograph, not her image but a reproduction of it—in accordance with the code for pornographic albums of the period." But in taking the *Olympia* not merely to *look like* a photograph but actually to *represent* one, Clay doesn't go far enough, for Manet has painted not just Olympia's photograph, but Olympia herself *being photographed*—he painted Olympia as she might have looked to— and at—a photographer taking her picture. That explains immediately why the *Olympia* (like *Le Déjeuner sur l'herbe*, which I also take to depict a group as it is being photographed, although here not everyone seems to be aware of it) failed, and continues to fail, to make narrative sense—that is to say, it fails to make narrative sense *as a painting*. We normally expect a painting like the *Olympia* to tell a story of sorts, but it has proved impossible to describe the story this picture tells coherently. The bouquet, for instance, could be a gift from a customer in whose place the beholder is currently standing, but in that case Laure should be standing between the beholder and Olympia, not behind her, as if she has come into the room through the curtain in the background. If on the other hand she has entered through the curtain, Olympia—not to mention her cat—should be paying some attention to her instead of staring away. And if the point of Laure's entrance is to show the client who is supposed to be standing in front of Olympia that he is far from her only admirer, it is difficult to understand why her look is so complex and, especially, indirect: hers is not a triumphant expression. But no such questions can even be raised as soon as we imagine that the scene we are witnessing is of

two women posing for a photograph—along with a cat that, upset by the photographer's flash, refuses to play the cuddly part it would have had in a "real" painting.

The beholder now finds himself, in the first place, in the role of the photographer, who is taking Olympia's picture either as an advertisement or simply as pornography. As one professional working with another, the photographer (and the beholder in his role) remains indifferent to Olympia's sumptuous sensuality, with which the picture is nevertheless suffused. His purpose, after all, is to purvey Olympia's body to his clients and in this he has been perfectly successful. Olympia's sensuality is palpable to his fictional client, in whose role the actual beholder now finds himself. But her attraction is now doubly disturbing: not only does the *Olympia*, unlike the traditional nude, acknowledge its sexuality, but it also forces the beholder to realize that Olympia is no longer alone responsible for it. The beholder experiences it because he shifts from the photographer's to the client's role, and so as a result of his own activity: he too is responsible for bringing it into the picture; he is not simply the prostitute's quarry but her predator as well. As Olympia looks on with eyes that are both professional and affectionate, selling a product as well as a person, the beholder oscillates between desire and detachment—a movement, moreover, that reenacts his relationship to the painting itself: confronted with what announces itself to be mere canvas and paint, he finds himself nevertheless bewitched by a beckoning body.

True, this beckoning body also pushes away. Olympia's left hand draws the eye irresistibly to her genitals (fig. 73), but if it were to be removed it would as likely result in a gesture of dismissal as of display. And even when displayed, Olympia's body remains her own: as they veer off your left shoulder her eyes reveal that you are not really there as far as she is concerned; full intercourse with her is impossible—as impossible as it is with the subjects of many Byzantine icons, to which, surprisingly, the *Olympia* now sent me. The reasons behind this unfocused regard are, of course, profoundly different in each case. Although both Christ—in the earliest image to have survived, a sixth-century icon from the monastery of St. Catherine on Mount Sinai

Figure 73
Edouard Manet, *Olympia* (detail), 1863, Musée d'Orsay, Paris, France

Figure 74
Christ Pantocrator, 6th century,
Monastery of Saint Catherine, Mount
Sinai, Egypt

Figure 75
Christ Pantocrator (detail), 6th century,
Monastery of Saint Catherine, Mount
Sinai, Egypt

(figs. 74, 75)—and Olympia are inaccessible partly because their eyes are not both focused on the same point, the icon, and the icon only, communicates the double being of its subject—ordinary human being on the left, stern divine judge on the right. And when the Virgin Mary does not look directly at the faithful, that is intended to remind them that, being divine, she does not fully belong to their world (fig. 76).

Divinity, naturally, has nothing to do with Manet's prostitute. And yet, when all is said and done, Olympia too doesn't fully belong to the world of her viewers. Her look, aware and indifferent, acknowledges her clients as it casts them aside and, like the beholder's double role, heralds the painting's own double being—both inanimate matter and alluring creature. All of Manet's "modernism" is in this picture.

Interpretation, Depth, Breadth

Every effort to go more deeply into the *Olympia* required me to range more broadly into the rest of the world. Beauty induces us to look for the aesthetic features of things, which, since they are the features things share only with their indistinguishable doubles, constitute their most distinctive and individual aspects. To understand the beauty of something we need to capture it in its particularity, which calls for knowing how it differs from other things, and that, in turn, is to be able to see, as exactly as possible, what these things are and how each one of them, too, differs from the rest of the world. To love something and to want to come to know and understand it can't possibly be separated from each other, and that desire, far from closing us off from the world, leads us directly into it.

As with so many other issues that have to do with love and beauty, Plato was there first: the *Symposium* gives voice to his vision of beauty as a force that draws its lovers constantly further along, toward a more synoptic vision of the world to which the object of their love belongs. Plato's was a metaphysical picture that may have led him to think of that world as an intelligible realm of unchanging essences and relations rather than the world of ordinary experience, but that picture is not necessary in order to account for the power

of beauty he was first to articulate: "What happens when there is no immortal realm behind the beautiful person or thing is just what happens when there *is* an immortal realm behind the beautiful person or thing: the perceiver is led to a more capacious regard for the world." To understand something better is not to isolate it and, having isolated oneself as well, to delve into its depths: it is to see how it is like and unlike every thing that surrounds it—and that, in the end, is everything. Montesquieu was much more nearly right than Schopenhauer when he wrote that "the pleasure given us by one object inclines us toward another. That is why the soul always seeks new objects and is never at rest."

It may, though, seem too academic (if not simply anemic) to couple beauty with interpretation and love with understanding—an intellectual's prejudice that weakens the impact and dampens the pleasures of art. For isn't to interpret to try to go beyond enjoyment and delight, discarding what is clear and accessible in favor of a hidden structure or an obscure message that only few can understand—an effort to replace pleasure with edification? When we interpret, a critic writes, we often take it that "a text means beyond itself: a railroad is more than a railroad." Susan Sontag agreed:

> Interpretation says, Look, don't you see that X is really—or, really means—A? . . . Interpretation . . . presupposes a discrepancy between the clear meaning of the text and the demands of (later) readers. . . . The manifest content must be probed and pushed aside to find the true meaning—the latent content—beneath,

and so came to reject interpretation, with its "overt contempt for appearances," as "the revenge of the intellect upon art . . . upon the world": "In place of a hermeneutics," it was her famous conclusion, "we need an erotics of art."

But hermeneutics and erotics, as Plato knew, do not exclude one another. Interpretation doesn't require the sharp distinction between the superficial and the deep, the apparent and the real, that Sontag rightly rejects. What something *is* is not nearly as independent of what it *means* as it may seem to be—no more, in fact, than what

Figure 76
Virgin Hodegetria (known as "Glykophilousa"), 14th century, Byzantine Museum, Athens, Greece

something *seems to be* is independent of what it *is*. Here is an illustration of that perhaps puzzling claim.

In Bob Fosse's autobiographical film, *All That Jazz* (1979), the leading character, who is a choreographer and filmmaker, is convinced that his most recent work is a total failure and his young daughter, who has not seen an R-rated movie before, tries to reassure him by telling him how much she enjoyed it:

> Father (*doubtful*): But did you understand it?
> Daughter: I understand everything except for the part where two girls were in bed together and they were kissing. What was *that* supposed to mean?
> Father (*very embarrassed*): Well, there are . . . , certain women who just don't relate to men, so they . . .
> Daughter (*interrupting*): I think lesbian scenes are a big turnoff.

The father thinks his daughter believes that the scene—the surface, the appearance, the phenomenon—*is* the kiss between the women that *means*, as he goes on to explain, that they are lovers. But what he believes to be the meaning his daughter has failed to grasp is in fact the very phenomenon whose meaning she questions: she wants to know the point of this love scene. What the scene is and what it means can't be distinguished once and for all: to a less worldly girl, it is a scene of two women in bed, kissing; to this one, it depicts two lovers kissing; what it means in the first case is what it is in the second. And if the father had explained the meaning of that, he would have provided a new specification of the scene and raised a new question about what *that* meant.

If the question "What does that mean?" has an answer, what lies in the depths (or beyond) rises to the surface (or comes to the fore) and becomes the phenomenon that needs to be further interpreted. The distinction between merely describing what a work of art is and interpreting what it means—like the distinction between observing what people merely look like and understanding what they are, which we discussed earlier—can't be systematically maintained. Its role is

practical. And, in practice, a description of a work is made up of interpretations that are not, at the moment, in question: for a less worldly audience, "two lovers" could well be the interpretation of a scene described as "two women in bed, kissing"; for the father and his daughter, once things are made clear, "two lovers" is the description that requires further interpretation. An interpretation is what accounts for a feature being as it is (as it is agreed to be on some particular occasion) and, once accepted, becomes more surface for which a further account is needed.

We often say that specifying a novel's plot is merely to describe the novel and not to interpret it. But since it's true (isn't it?) that *Jaws, The Old Man and the Sea*, and *Moby-Dick* all have the same simple plot—a man hunts a fish—saying more, that *Moby-Dick*, for example, is the story of Captain Ahab's hunt for a whale, would turn out to be an interpretation. Yet that too is an elementary specification of the plot of *Moby-Dick* and so is saying that Ahab is seeking revenge on the whale to which he lost his leg; so too is saying that it is the story of Ahab's seeking revenge on the whale to which he lost his leg and his pride; or the story of Ahab's seeking revenge on the whale to which he lost his leg and his pride and which has gradually come to stand in his eyes for everything that limits human power; or the story of "crazy Ahab" seeking revenge on the whale to which he has lost his leg and his pride and which has gradually come to stand in his eyes for everything that limits human power and every other evil in the world; and so on, and so on, without end. What belongs to the plot and what not, what counts as description and what as interpretation, depends in each case on how well we and our audience know a work of art and on our purposes on that particular occasion.

Interpretation doesn't push the manifest content of a work aside in order to reveal the real meaning hidden beneath. Far from leading away from its starting point, it yields a better understanding of it, beginning from how it seems at first to how it seems once we have come to know it better. Interpretation isn't a geological project. "Depth" is a metaphor, less an indication of the location of what

we understand and more of the quality of the understanding we are able, sometimes, to reach: the deeper it is, the more it encompasses. We would do well to recall Plato's idea that to know what something is is to know how it is similar to and how it differs from other things and look at interpretation as establishing a web of connections between the elements of one thing and between one thing and another. We should be mindful of what Michel Tournier called the "strange prejudice which sets a higher value on depth than on breadth, and which accepts 'superficial' as meaning, not 'of wide extent' but 'of little depth,' whereas 'deep,' on the other hand, signifies 'of great depth' and not 'of small surface.'" Or as Oscar Wilde put it more succinctly, "It is only the shallow people who do not judge by appearance."

As I said a little earlier, though, what counts as appearance doesn't remain constant. It is simply what we take to be indisputable at some particular moment: what counts as an observation, as W. V. Quine insisted, is what the members of a particular group with a similar background will agree to immediately when presented with the same phenomenon. Moreover, both the members of such a group and their background are subject to change, and the very appearance of things changes as we come to understand them better and learn more about how they resemble and differ from others. And since each thing resembles and differs from indefinitely many others, the process can go on forever. Where interpretation is concerned, there are no unexplained explainers, nothing that provides an account of something else but, being self-evident, requires no account itself. Interpretation ends either when we can find no further account, although one is required, or when we reach full understanding, which we do when our interest, rather than what we are interested in, is—as eventually it always is—exhausted.

Interpretation itself is interminable, especially since life, as it goes on,

is ceaselessly weaving . . . threads between individuals and between events, it interweaves them, doubles them, to make the weave thicker, to

such an extent finally that between the least significant point in our past and all the others a rich network of memories gives us in fact a choice about which connections to make.

That is what the narrator of Proust's *In Search of Lost Time*—an unlikely companion of the no-nonsense, scientifically minded Quine—finally recognizes. Despite his talk of uncovering the meaning and essence of people and things through some part of himself that exists outside time and change—the part summoned by the flavor of a madeleine that transports him to his childhood in Combray, by two uneven flagstones that bring him back to a visit to Venice, by the sound of silverware on porcelain that returns him to a vacation in Balbec—he remains rooted in time and incompleteness. For he finally resolves to begin the book he has been dreaming of writing his whole life—the book that will in fact be the book of his life—only when he comes to see that "it would not be possible to recount our relationship, even with a person we hardly knew, without recreating a succession of the most diverse settings of our life." Nothing is what it is independently of anything else; no moment, no person, no thing has a meaning in and of itself. Marcel's story will have to be a story of time, in time, and

the idea that in a book whose intention was to tell the story of a life it would be necessary to use, in contrast to the flat psychology people normally use, a sort of psychology in space, added a new beauty to the resurrections that had taken place in my memory, while I was lost in my thoughts alone in the library, since memory, by bringing the past into the present without making any changes to it, just as it was at the moment when it was the present, suppresses precisely this great dimension of Time through which a life is given reality.

Always incomplete in itself, interpretation continues as long as love and beauty—perhaps hate and ugliness as well—persist: its death lies in indifference and in indifference only (also in death itself). We have no choice but to interpret the objects of our love; no choice but to

try to understand what makes them beautiful, what provokes our love; no choice but to try to see how they accomplish something—if they do—that nothing else in the world does and why, therefore, we will give them up for nothing else, however valuable; no choice but to desire to be in turn interpreted—affected—by them and so find something in ourselves that is ours and ours alone in the world. That is the least beauty inspires and love requires.

Interpretation, Beauty, Goodness

As interpretation progresses, what something means at one time can become what it is at another, and that affects directly what we see in the world—no longer, for example, two women kissing for some reason or other but two lovers; no longer a painting of a strange-looking prostitute but of a prostitute having herself photographed in order to advertise herself and also raise doubts about the status and integrity of her middle-class clients and their proper wives. But as what we see changes because of our interaction with it, so does its effect upon us—and so do we ourselves. For in order to understand the object of our interpretation as it has been transformed in the process, we may need to go in directions we couldn't have taken before. Every new path we follow is bound to lead to ideas, feelings, and actions, to people and places, we could have never anticipated. What will become of us is as a result is impossible to tell until it has already happened, and perhaps not even then. My fascination with the *Olympia*, for example, has steered me to vast numbers of female nudes: I don't know that the motives with which I approached them or the pleasures I derived from them are altogether innocent, and I am not sure how to go about finding out. Not that I think that half an hour with the *Rokeby Venus* in London's National Gallery is likely to send me to the darkest alleys of Soho. Culture, as Plato knew, works in subtler ways, gradually and imperceptibly. He wasn't worried (though some have thought he was) that Euripides' *Medea* would cause its audience to go home and strangle their children; he was afraid of a world where they are consistently "brought up on images of evil, as if in a meadow

of bad grass, where they crop and graze in many different places every day until, little by little, they unwittingly accumulate a large evil in their soul." I don't know, and I may possibly never learn, whether my love of the *Olympia* has led me to a meadow of bad grass.

Plato believed that the problem was not with beauty but with what people wrongly take beauty to be: true beauty, he was convinced, is inextricably linked with moral goodness. I find it impossible to think what such beauty could be and so, though I expect that something I find beautiful will make my life somehow better if it becomes a part of it, I also know I may be wrong and that even if I am right it may do little for its moral quality. Whether my expectation was correct will depend on whether interacting with the beautiful object proves to have been worthwhile. But what is worthwhile and what not, what valuable and harmful, is known only in the course of time, in retrospect, and since interpretation remains unfinished as long as beauty continues to cast its spell, it is impossible to tell to what and to whom it will lead. Beauty's relation to morality is always in question.

When it comes to the arts, some are more confident. Richard Rorty, for instance, wants us to read Nabokov and Orwell because he thinks they make us more aware, and so less tolerant, of cruelty. In connection with an image in Nabokov's *Pale Fire*, he writes: "That poor lame boy trying to get his spastic brother out of the range of the stones hurled by schoolchildren will remain a familiar sight in all countries, but a slightly less frequent one in countries where people read novels." I sometimes wish that I could share that view, but it seems to me as difficult to do so as it is to agree with Elaine Scarry that beauty promotes the sense of justice: the ancient Athenians, on whom she relies, adored beauty, valued democracy, and were vicious to friend and foe alike. Again and again, history has smashed to pieces Plato's assurance that to love the beautiful is to desire the good. Beautiful villains, graceful outlaws, tasteful criminals, and elegant torturers are everywhere about us. Salome, Scarpia, and Satan do not exist only in fiction (neither, of course, does Quasimodo).

It might seem reasonable to take the more modest view that, whatever their moral benefits, the moral dangers of the arts are small: how harmful could George Eliot be? But let me confess that when I am

not trying to catch Olympia's elusive gaze, I often turn to the vicious, violent world of *Oz*, the implacable self-absorption of Larry David, or the ambiguous characters of *St. Elsewhere*—not, as we sometimes say, just to relax or simply for entertainment but to enjoy their serious pleasures, which many would consider as a sign of moral as well as aesthetic corruption. Watching television and spending time thinking and even writing about it may well be ruining my character and wasting my life. Perhaps, though, you are missing something that could really add to yours. My own sense is that I became a better philosopher through my interest in television—and enjoyed myself in the process—but to you my claim that contemporary contempt of television is no better (and no worse) than Plato's rejection of Homer and Aeschylus in fourth-century Athens is a further sign of corruption and itself worthy of contempt.

How are we to decide such questions? They seem more urgent when we raise them in regard to the "low" or the "popular" arts: the perils of the popular arts, aesthetic and moral, seem greater because the jury, so to speak, is still out and their place within culture is not yet determined. To assume they are in general degrading is both socially and intellectually less risky: one can then wait safely until they eventually find such a place, which neutralizes much of their danger, or else disappear and no longer give cause for concern. Plato, who was the first to make that assumption, used it against epic and tragic poetry—not to play it safe, of course, but to eliminate them altogether. He failed, since Homeric epic and Attic tragedy—popular entertainment for the Athenians—are no less than his own works (how he would have hated it if he knew!) among the paradigms of culture in whose name today's popular media are denounced. Plato's assumption has often been invoked against theatrical media—Tertullian used it against the circus, Henry Prynne against Shakespeare, the Jansenists against the Jesuits' religious drama—but its history is complex. Coleridge, in fact, appealed to Shakespeare in his attack on the novel:

> I will run the risk of asserting that where the reading of novels prevails as a
> habit, it occasions in time the entire destruction of the powers of the mind:

it is such an utter loss to the reader, that it is not so much to be called pass-time as kill-time. It . . . provokes no improvement of the intellect, but fills the mind with a mawkish and morbid sensibility, which is directly hostile to the cultivation, invigoration, and enlargement of the nobler powers of the understanding,

while, uncannily anticipating the language and imagery of today's attacks against mass culture, television, popular music, video games, and the internet, a German tract of 1796 condemned *reading itself*:

Readers of books . . . rise and retire to bed with a book in their hand, sit down at table with one, have one lying close by when working, carry one around with them when walking, and . . . once they have begun reading a book are unable to stop until they are finished. But they have scarcely finished the last page of a book before they begin looking around greedily for somewhere to acquire another one; and when they are at the toilet or at their desk or some other place, if they happen to come across something that fits with their own subject or seems to them to be readable, they take it away and devour it with a kind of ravenous hunger. No lover of tobacco or coffee, no wine drinker or lover of games, can be as addicted to their pipe, bottle, games or coffee-table as those many hungry readers are to their reading habit.

Although none of this is to say that watching television is bound to be morally benign, it should undermine our confidence in quick—and wholly negative—judgments about the effects of genres or media as a whole, especially while we are still unfamiliar with them. Even the narrowest judgment of beauty has far-reaching consequences and makes a difference to one's mode of life. What such a life will bring is impossible to predict and, once it has brought it, difficult to evaluate. You can't know in advance the sort of person it will make you and you can't ever be sure of the worth of the person you have become. You can't even be certain that you will eventually consider what you find through the pursuit of beauty to have been worth your while. Perhaps you will feel about it as Swann came to

feel about Odette after all the years he devoted to her: "To think that I have wasted years of my life, that I wanted to die, that I felt my deepest love, for a woman who did not appeal to me, who was not even my type!" Perhaps—that might be worse—you may find yourself satisfied, not realizing that what you loved has led you into a degraded life that you can't recognize for what it is. Before I was attracted to television, for instance, I thought it despicable and felt a mixture of pity and scorn for those who seemed to enjoy it. These days I feel, instead, that I can see why it is worth enjoying—but can I? It seems to me that, other things being equal, I am better off now than I was then. But how can I tell, since, along with a taste for television, I have also developed standards of judgment that, from the point of view of my earlier self, are depraved and corrupt? By my earlier standards, I am now debased and miserable although I don't know that I am. By the standards that are currently mine, my earlier standards were silly, prejudiced, and deprived me of great beauty. Which standards are right?

Plato, for whom no disagreement is ultimately intractable, answered: the standards of philosophy, the only standards that establish when a life has been truly worthwhile. Such a life, the *Symposium* tells us, is one that, spent in the pursuit of beauty, "gives birth" to beauty of its own. It is a life of beautiful thoughts and actions (*logoi*), which, since for Plato beauty and goodness converge, turns out to be the life of virtue and happiness that only philosophy can provide. I believe, on the contrary, that there is no clear answer to such questions and no reason to expect one. To think of beauty as only a promise of happiness is to be willing to live with ineradicable uncertainty—finding, in a surprising twist, reason enough to do so in Plato's own idea of giving birth to beauty, stripped of its moral connotations.

Beauty, Uncertainty, Happiness

It may be even more surprising to realize that the way to Plato follows a path laid out by one of his most implacable enemies. Although

nothing can match the elation that comes with the feeling that things are well with us when a beautiful thing enters our world, no amount of elation can show that feeling is justified. However alluring the promise of beauty, it reveals neither what it is that it promises nor what will become of me if I obtain it. Beauty and certainty pull in opposed directions in more ways that one. We are in Nietzsche's territory now:

> One day the wanderer slammed a door behind himself, stopped in his tracks, and wept. Then he said: "This penchant and passion for what is true, real, non-apparent, certain—how it aggravates me! Why does this gloomy and restless fellow keep following and driving *me*? I want to rest, but he will not allow it. How much there is that seduces me to tarry! Everywhere Armida's gardens beckon me; everywhere I must keep tearing my heart away and experience new bitternesses. I must raise my feet again and again, weary and wounded though they be; and because I must go on, I often look back in wrath at the most beautiful things that could not hold me—*because* they could not hold me."

Uncertainty is an inescapable aspect of life. Beauty, which draws us forward without assurance of success, is its visible image, a call to look attentively at the world and see how little we see.

Why tarry in Armida's gardens, then? Why turn away from what appears to be the serious business of life to look attentively if looking attentively will seldom reveal better things and follow beauty even when it leads to harm? Where does its value lie?

Neither in pleasure—love can survive pain and humiliation, and the desire for beauty can produce the deepest suffering—nor passive contemplation—erotics and hermeneutics, we have seen, go hand in hand and enter every aspect of life. To find something beautiful is inseparable from the need to understand what makes it so, the features that make it stand out in my world. As I begin to see these features, which are distinctly its own, I also begin to understand why I wouldn't exchange it for anything else, since these are features it shares with nothing from which I can distinguish it. I can find such

an exchange unthinkable even if the beautiful thing is not actually mine: once, many years ago, someone told me she no longer loved me, and I remember thinking that I too would one day love her no longer and dreading that time, when I would perhaps be happy again; I was mourning in advance the loss of the unhappy self who was in love, dismayed at the prospect of becoming a different, indifferent self, unmindful of her particularity. Why should that be?

Because whenever we find something beautiful—whether it is a person with whom I want a relationship unlike any other or a painting from which you might learn how to paint better than everyone else, not just when we are trying to decipher the meaning of a word or a line—we are actively engaged in interpretation. To interpret is to try to see in things what is distinctly their own. That is in turn to see them in ways that are distinctly *our* own and, to the extent that they are ours alone, these ways of seeing turn out to be aesthetic features in their own right and have themselves a claim to beauty: "I want to learn more and more to see as beautiful what is necessary in things; then I shall be one of those who make things beautiful." There is no real distinction here; in finding beauty we create it ourselves. That may be reason enough to prefer present misery to future contentment, since the misery is tinged with beauty's promise.

Nietzsche went further. "What do we long for at the sight of beauty?" he wrote. "To be beautiful. We imagine that there is much happiness bound up in this"; but he refused to take the final step: "that," he remarked, "is an error." Except for that last comment, however, which Plato would have rejected out of hand, he went far enough: we are confronted here with the most remarkable convergence in the views of these two deeply antithetical philosophers. When Plato writes in the *Symposium* that life is worth living only in the contemplation of beauty, he makes clear that contemplation is not a haphazard gazing into the blue but a whole mode of life that combines creative thought and considered action and transforms the desire to possess beautiful things into the urge to create in their presence beauty of one's own—beauty that characterizes equally both its producers and their products. At every stage of his ascent toward the Form of Beauty, the

philosopher, in the company of one or more young men, gives birth to beautiful and virtuous ideas and actions, and so becomes, like them, virtuous and beautiful in his own right.

Unlike Plato, I don't believe that the pursuit of beauty leads necessarily to virtue and happiness, and for that reason I find in it an element of ineliminable risk. But, like him, I am convinced that beauty is a spur to creation and sometimes results in its creators becoming beautiful themselves. I would agree with Elaine Scarry that although one can pursue goodness or justice in the hope of becoming good or just oneself, "it does not appear to be the case that one who pursues beauty becomes beautiful. It may even be accurate to suppose that most people who pursue beauty have no interest in becoming themselves beautiful," only if being beautiful were the same as looking good (which *is* the same as *looking* beautiful), as we have seen it is not. Beautiful people are not those who just look good, and beautiful things are not created only by artists. They don't even have to be particular, distinct artifacts—they can be simply those ways of seeing the things and people we love that manifest our character and style. And sometimes, if the range of things we find beautiful and what we find beautiful in them are connected with each other in the right ways, we may become beautiful in our own right: we will provoke others to love and want to come to know us for themselves, starting the cycle over again.

Beauty so understood is a matter of distinction, of standing out among things of one's kind, whether people or objects. It is always manifested in appearance—in look or action or what actions produce—and it requires a discernible structure, a unity that gives its possessor its own character among the many things it is like, that invites love and demands interpretation in order to be seen exactly for what it is. Such an unmistakable arrangement is part of anything that is importantly new. It demonstrates that more is possible than had been imagined so far. It constitutes an individual. But individuality and distinction in turn require coherence and unity, without which it isn't even possible to point something out, much less to admire it and even less to be struck by its beauty. If these values,

Figure 77
Edouard Manet, *Music in the Tuileries Garden*, 1862. © The National Gallery, London, UK. Reproduced by permission from The National Gallery, London, UK

which belong to both art and life, are discernible in my aesthetical choices and intimate possibilities that make their own promise of happiness, I may have managed to put things together in my own manner and form. I may have established, through what I loved, a new way of looking at the world, and left it, if only by a little, richer than I had found it. Engaging in aesthetic action is justified when it results in beauty, in something attractive not only for the things to which it gives access but for its own sake as well, not just as a means to a distinct end but also as an end in its own right. Beautiful things interpose themselves between me and what I already want. They give me new things to desire. They are valuable not just as guides but also as destinations:

> Style for the writer, no less than colour for the painter, is a question not of technique but of vision: it is the revelation, which by direct and conscious means would be impossible, of the qualitative difference, the uniqueness of the fashion in which the world appears to each one of us,

a difference which, if there were no art, would remain the secret of every individual.

I see that "qualitative difference" revealed not just in the arts, as Proust does, but also in philosophy, in criticism, and even in some people I know. I think I see it in every beautiful thing around me. It is what draws me to each with the promise that if it became part of my life it would make, as Plato and Nietzsche (along with Proust and my close friends) have done, a valuable difference to the fashion in which the world appears to me.

What makes one difference valuable and another not? That is impossible to say in general terms. We know, for example, that Manet loved Velasquez and devoted great time and effort to copying Velasquez's works and using his techniques in his own paintings. We could say that Manet wanted to learn how to paint like Velasquez, but it is clear that his goal didn't include producing either perfect copies of Velasquez or perfect Velasquez fakes. To say that Manet wanted to paint *like* Velasquez is to say that he wanted to paint *as well as* Velasquez, and only pictures that, incorporating what he had learnt from Velasquez, were still *significantly different* from Velasquez's own would do, just as Velasquez's pictures had been significantly different from Caravaggio's, Rubens's and Titian's. We might even say that Manet was imitating Velasquez, but only in the sense of imitating his *accomplishment* rather than the works that constituted that accomplishment. That kind of "imitation" is successful only if its results differ seriously from their direct models, and fails to the extent it duplicates them. But saying that both Manet and Velasquez differ "significantly" or "seriously" from their predecessors can't even begin to tell us something informative about the way in which Velasquez proved valuable to Manet or Rubens to Velasquez. On the other hand, the way *Music at the Tuileries* (fig. 77) adapts and complicates the composition of *The Little Cavaliers* (fig. 78), which Manet also copied (fig. 79), depends so intimately on features specific to Manet's picture that no account of it will apply to the relationship between Velasquez and his predecessors. The stamp of one's own character, like beauty, always lies one step beyond the point where principles and instructions lead:

Figure 78
Diego Velasquez, *The Little Cavaliers*, c. 1650, Louvre, Paris, France

Figure 79
Edouard Manet, *The Little Cavaliers*, 1858–59, the Chrysler Museum of Art, Norfolk, VA

Imitators.—A: "What? You want no imitators?" B: "I do not want to have people imitate my example: I wish that everybody would fashion his own example, as *I* do." A: "So?"

Aesthetic values are values of difference and individuality. Individuality depends inherently on going beyond what has been already established, and that is the truth in Kant's description of genius as "a talent for producing that for which no determinate rule can be given, not a predisposition of skill for that which can be learned in accordance with some rule." It is also the truth in Oscar Wilde's subversion of Matthew Arnold's idea of criticism as an effort "to see the object as in itself it really is" by the retort that "the primary aim of the critic is to see the object as in itself it really is not. . . . To the critic, the work of art is simply a suggestion for a new work of his own, that need not necessarily bear any obvious resemblance to the thing it criticizes." That may first seem like studied irresponsibility—but think of "the new work" less as a particular piece of criticism and more as who one becomes as a result of everything one has loved, admired, and criticized, and Wilde turns out to be less wild than he has seemed.

How is "new work," though, to be judged, and by what standards, if our standards seem no more secure than any judgment based on them? How can we tell what we should give a place to in our life and what we should keep away? Wilde thought that such questions are impossible to answer and rejoiced in the fact:

A man is called selfish if he lives in the manner that seems to him most suitable for the full realisation of his own personality; if, in fact, the primary aim of his life is self-development. But this is the way in which everyone should live. *Selfishness is not living as one wishes to live, it is asking others to live as one wishes to live.* And unselfishness is letting other people's lives alone, not interfering with them. Selfishness always aims at creating around it an absolute uniformity of type. Unselfishness recognises infinite variety of type as a delightful thing, accepts it, acquiesces in it, enjoys it.

I doubt that the primary aim of life is self-development, since I doubt that life has a primary aim, and for that reason I don't believe there is an "infinite variety of type." There are many types, and every now and then new ones are introduced and stretch the limits of our possibilities. There are no principles for telling what in general makes some types good and others bad, any more than there are principles for distinguishing the valuable differences in the ways the world appears to us from those that are harmful or inconsequential, and no single type is best of all any more than some particular work of art or artist can be said to be the best there is. Our world is a world of art. It isn't necessary to "treat Art as the supreme reality and life as a mere mode of fiction" in order to acknowledge that factors crucial to art are essential to the rest of life. Beauty, which has a place in both, brings them together: we need to take account of the aesthetic features that pervade our interactions with one another and of values that provoke admiration but impose no obligation. The passion for ranking, the fervor for verdicts, that has deformed our attitude toward the arts, and our lives, is simply another manifestation of selfishness.

The values of aesthetics aspire toward distinction and individuality, the values of morality are grounded on similarity and connectedness. For that reason, beauty and virtue can come into conflict. Both Plato and Nietzsche—that most unlikely philosophical alliance—deny this, though for opposed reasons. Plato writes that "only in the contemplation of beauty is human life worth living" because he saw nothing of value in beauty, or anywhere else, that was not already moral; Nietzsche declares that "only as an aesthetic phenomenon are existence and the world eternally justified" because he believed there are no moral values at all. Yet the evil have not always been unloved, while the moral defects of those who, by displaying the virtues of art, extend the range of human possibility are often ignored or reinterpreted. Nietzsche had a point when he denied that greatness is always moral virtue—"In great human beings, the specific qualities of life—injustice, falsehood, exploitation—are at their greatest. But insofar as they have had an *overwhelming* effect, their essence has been most misunderstood and interpreted as goodness. Type: Carlyle as

interpreter"—though not, I think, when he denied that moral virtue is of any value. In any case, their moral virtue isn't among our reasons for admiring Caesar or Napoleon, Verlaine or Picasso; it isn't possible to condone everything about Odysseus, while Humbert Humbert isn't altogether hateful; Caravaggio's sensual *St. John* is anything but innocent but neither, for a very different reason, is the naked Child in Correggio's *Madonna of the Basket*. Sometimes, a single taste and a moral virtue may pull in different directions and we may simply have to live with the tension between them: ask any Wagner fan.

In *Oliver Twist*, when Oliver is overwhelmed by the great number of books in Mr. Brownlow's house, that good man tells him: "You shall read them, if you behave well." Even Dickens, that most edifying of novelists, could see that aesthetic values aren't justified by their moral significance and couldn't bring himself to write, "If you read them, you shall behave well." The value of beauty lies no further than itself: it is its own reward—a thought that, finally, brings me to Socrates, the riddle through whom Plato and Nietzsche found themselves following the same philosophical road, in opposite directions. For Socrates, virtue was nothing but its own pursuit. And only the promise of happiness is happiness itself.

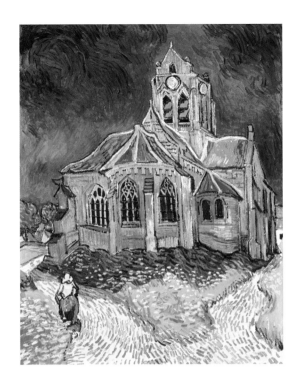

Plate 1.
Vincent van Gogh, *Church at Auvers-sur-Oise*, 1890, Musée d'Orsay, Paris, France.

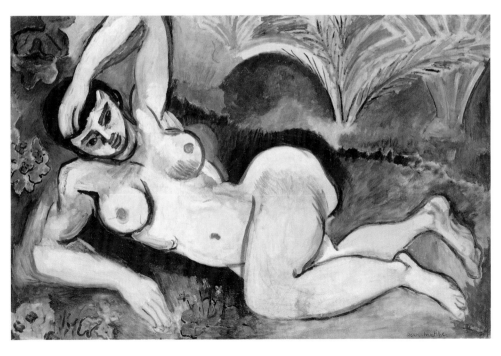

Plate 2.
Henri Matisse, *Blue Nude*, 1907, The Baltimore Museum of Art: The Cone Collection, Baltimore, MD.

Plate 3.
Pablo Picasso, *Seated Bather [La Baigneuse]*, 1930.
Oil on canvas, 64 ¼ × 51". Mrs. Simon Guggenheim
Fund. (82.1950) The Museum of Modern Art, New
York, NY. Reproduced by permission from Art
Resource, NY. Pablo Picasso (1881–1973) © ARS,
NY. Digital Image © The Museum of Modern Art /
Licensed by SCALA / Art Resource.

Plate 4.
William-Adolphe Bouguereau, *Seated Bather*,
1884, Sterling and Francine Clark Art Institute,
Williamstown, MA.

Plate 5. Edouard Manet, *Olympia*, 1863, Musée d'Orsay, Paris, France.

Plate 6.
Edouard·Manet, *Execution of Emperor Maximilian of Mexico*, 1867,
Staedtische Kunsthalle, Mannheim, Germany.

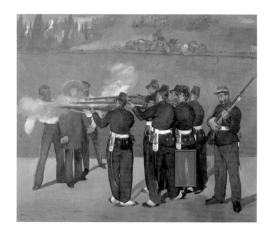

Plate 7.
Edouard Manet, *Execution of Emperor Maximilian of Mexico* (detail), 1867,
Staedtische Kunsthalle, Mannheim,
Germany.

Plate 8.
Yves Klein, *Vénus bleue (Blue Venus)*,
S 41, 1962 / Pure pigment and
synthetic resin on plaster / 27 × 13 × 7
in. 1970. Copyright: Yves Klein, ADAGP,
Paris. Reproduced by permission from
the Yves Klein Archives, Paris, France.

Plate 9.
Damien Hirst, *Alantolactone*, 1965. Gloss household paint on canvas 38 x 58 in.
(96.5 × 147.3 cm) (10 × 15 spots). Copyright © the artist. Reproduced by permission
from Jay Jopling, White Cube, London, UK.

Plate 10.
Johannes Vermeer, *View of Delft* (detail), 1662, Mauritshuis, The Hague, Netherlands.

Plate 11.
François Boucher, *A Lady on Her Day Bed* (Presumed Portrait of Mme. Boucher), 1743, The Frick Collection, New York, NY.

Plate 12.
François Boucher, *La Toilette*, 1742, Museo Thyssen-Bornemisza, Madrid, Spain.

Plate 13.
Edouard Manet, *Olympia* (detail), 1863, Musée d'Orsay, Paris, France.

Notes

Page 1, line 3 Plotinus, *Enneads* I.6.4.

Page 1, line 17 José Ortega y Gasset, *The Dehumanization of Art and Other Essays on Art, Culture, and Literature* (Princeton: Princeton University Press, 1968), p. 9.

Page 2, line 24 Plato, *Phaedrus*, translated by Alexander Nehamas and Paul Woodruff (Indianapolis: Hackett Publishing Company, 1995), 251a–252a, modified. Readers of this book will notice that I speak of erotic beauty, especially in the first person, in the language of a heterosexual man. Anything else would be both cumbersome and disingenuous. I hope, though, that what I try to say in that language will ring true to others who would most readily use different forms of expression. I don't doubt that gender and sexuality affect one's attitudes, but I also believe that the differences they introduce are not the only subject worth addressing in this context: C. P. Cavafy's early erotic poetry, which exploits the ability of Greek to eliminate gender markers altogether, has shown me that one can often recognize a feeling without knowing either whose feeling it is imagined to be or in whom it is intended to be provoked. See also the sensible remarks of C.D.C. Reeve, *Love's Confusions* (Cambridge, MA: Harvard University Press, 2005), p. vii.

Page 2, line 33 According to Plato's calculation (*Republic* 587d–e), the life of philosophy is 729 times more pleasant than the life of the tyrant, who represents the worst human specimen. He is not altogether facetious.

Page 3, line 11 John Ruskin, *Modern Painters* (New York: E. P. Dutton, 1906), vol. II, Appendix, §13.

Page 3, line 27 Strictly speaking, the term "aesthetic" (from a Greek word connected with perception) and the call for a science of the liberal arts, perception, beauty, and intuition were introduced by Alexander Baumgarten in his *Aesthetica* (1750–58), which continued the project outlined in his doctoral dissertation of 1735. Modern thinking about aesthetics as we understand it today, however, begins with Kant.

Page 3, line 31	Immanuel Kant, *Critique of the Power of Judgment,* translated and edited by Paul D. Guyer (Cambridge: Cambridge University Press, 2000), §5, p. 96.
Page 4, line 7	Kant's arguments for his view are complex and controversial. See Paul D. Guyer, *Kant and the Claims of Taste* (Cambridge, MA: Harvard University Press, 1979), pp. 170–179.
Page 4, line 15	Kant, *Critique of the Power of Judgment*, §§3–4, pp. 91–94.
Page 4, line 31	Ibid., §2, p. 91.
Page 5, line 1	Ibid., §2, p. 90.
Page 5, line 7	Ibid., §1, p. 89.
Page 5, line 15	Some of these complexities are discussed by Paul Guyer in "Kant's Conception of Fine Art" (*Journal of Aesthetics and Art Criticism* 52 (1994): 175–185), which exhibits the many functions Kant was willing to attribute to the various arts. The common idea that there is such a thing as a characteristic "aesthetic" pleasure that differs from pleasures of other kinds, even if true, cannot be traced to Kant, who thought the agreeable, the beautiful, and the good refer to "three different relations of representations to the [single] feeling of pleasure" (*Critique of the Power of Judgment*, §5, p. 95). An account of the strategic importance of the autonomy of (fine) art for defending it against charges of immorality and distinguishing it from popular entertainment is given by Jonathan Gilmore, "Censorship, Autonomy and Artistic Form," in *Art History, Aesthetics, Visual Studies*, edited by Michael Ann Holly and Keith Moxey (Williamstown, MA: Sterling and Francine Clark Art Institute, 2002), pp. 105–121.
Page 5, line 30	Arthur Schopenhauer, *The World as Will and Representation*, translated by E. J. Payne (Indian Hills, CO: Falcon's Wing Press, 1958), vol. I, book III, §38, p. 196.
Page 6, line 8	Ibid., vol. I, book III, §38, pp. 197–198.
Page 6, line 24	All this is sketchy and controversial, but I try to give it some substance and support in "'Only in the Contemplation of Beauty Is Human Life Worth Living' (Plato, *Symposium* 211d)," *European Journal of Philosophy*, forthcoming.
Page 6, line 31	Recent discussions of Athenian paederasty begin with K. J. Dover's *Greek Homosexuality* (New York: Random House, 1978). Other important works include Michel Foucault, *The History of Sexuality*, vol. II: *The Use of Pleasure* (New York: Random House, 1985); John J. Winkler, *The Constraints of Desire: The Anthropology of Sex in Ancient Greece* (New York: Routledge, 1990); David M. Halperin, *One Hundred Years of Homosexuality* (New York: Routledge, 1990); and David Cohen, *Law, Sexuality and Society: The Enforcement of Morals in Classical Athens* (Cambridge: Cambridge University Press, 1991). *The Sleep of Reason: Erotic Experience and Sexual Ethics in Ancient Greece and Rome*, edited by Martha C. Nussbaum and Juha Sihvola (Chicago: University

of Chicago Press, 2002), contains several relevant essays. On the sense and scope of *aretē*, see my discussion in *The Art of Living: Socratic Reflections from Plato to Foucault* (Berkeley: University of California Press, 1998), pp. 77–78.

Page 7, line 20 That they are in fact not impersonal (although they may well at some point exclude sexuality) is something I argue for in "'Only in the Contemplation of Beauty Is Human Life Worth Living' (*Symposium* 211d)."

Page 7, line 29 Plato, *Symposium* 211d6 (*sunontas*), 211d8 (*suneinai*). Not unlike "intercourse" in English, *suneinai* also carries the sense *being, spending time with*, but its sexual aspects are always in play: see H. J. Liddell and Robert Scott, *A Greek-English Lexicon*, revised by H. R. Jones (Oxford: Clarendon Press, 1968), s.v. *suneimi*.

Page 8, line 12 Schopenhauer, *The World as Will and Representation*, vol. II, chap. 44, pp. 533–534.

Page 9, line 6 Ibid., vol. I, book III, §38, p. 196.

Page 9, line 17 Plato, *Symposium*, translated by Alexander Nehamas and Paul Woodruff (Indianapolis: Hackett Publishing Company, 1989), 203e.

Page 9, line 33 Parts of the story of this transformation are well told in James Kirwan, *Beauty* (Manchester: Manchester University Press, 1999).

Page 10, line 17 Pliny the Elder, *Natural History* 36.21; Pliny also tells us that Praxiteles' *Erōs of Parion* suffered a similar fate in the hands of a certain Alcetas of Rhodes (36.22). For more instances, see Leonard Barkan, "Praxiteles' Stained Aphrodite, and Other Tales of Sex and Art," manuscript, Princeton University, 2004. Barkan, very cautiously, suggests that perhaps all aesthetic pleasure may be a form of erotic delight. I would prefer to see them on a continuum: the attraction of beauty always includes an erotic aspect, but not every form of eroticism need manifest itself sexually.

Page 11, line 6 Mark Twain, *A Tramp Abroad* (New York: Penguin, 1997), p. 370.

Page 11, line 28 Bram Dijkstra, *Idols of Perversity: Fantasies of Feminine Evil in Fin-de-Siècle Culture* (New York: Oxford University Press, 1986), p. 100.

Page 11, line 31 The identity of the central figure is still a matter of dispute. Although an entry in James II's inventory of 1688 refers to "The sliding piece before Madam Gwynn's picture naked, with a Cupid," and several scholars believe the reference to be to this painting, not everyone is convinced; see Oliver Millar, *Sir Peter Lely, 1618–80* (London: National Portrait Gallery, 1978), p. 62. Mr. Paul Cox of the National Portrait Gallery was kind enough to provide me with some additional information about this work.

Page 12, line 3	Clive Bell, *Art* (New York: Capricorn Books, 1958), pp. 27–28; originally published in 1914.
Page 12, line 15	Ibid., p. 17.
Page 12, line 18	Ibid., p. 21. In *Revealing Art* (Oxford: Routledge, 2005), Matthew Kieran suggests that Bell actually tried to capture "something like the traditional notion of beauty" in relation to modern art (p. 50). It is clear that the "aesthetic emotion," which only what Bell called "significant form" can produce, shares some of its features with that traditional notion, but what it does not share—the connection with desire—is enough to establish a sharp contrast between them.
Page 12, line 21	Ibid., p. 20.
Page 13, line 1	See Roger Fry, *Vision and Design* (London: Chatto and Windus, 1920), and "Some Questions in Esthetics," in *Transformations: Critical and Speculative Essays on Art* (New York: Doubleday, 1956), pp. 1–57.
Page 13, line 7	R. G. Collingwood, *The Principles of Art* (Oxford: Clarendon Press, 1938), pp. 38–41.
Page 13, line 16	Barnett Newman, "The Sublime Is Now," *The Tiger's Eye* 6 (1948): 51.
Page 14, line 5	See John Brewer, *The Pleasures of the Imagination: English Culture in the Eighteenth Century* (New York: Farrar, Straus and Giroux, 1997), pp. 228–251, and Richard Wrigley, *The Origins of French Art Criticism: From the Ancien Régime to the Restoration* (Oxford: Clarendon Press, 1993), pp. 40–44.
Page 14, line 29	Our knowledge of Roman education is incomplete and sometimes ambiguous. Two good recent sources are Stanley F. Bonner, *Education in Ancient Rome: From the Elder Cato to the Younger Pliny* (Berkeley: University of California Press, 1977), esp. pp. 212–249, and Raffaella Cribiore, *Gymnastics of the Mind: Greek Education in Hellenistic and Roman Egypt* (Princeton: Princeton University Press, 2001), esp. pp. 185–219. See also Henri-Irénée Marrou, *Saint Augustin et la fin de la culture antique*, 4th ed. (Paris: Éditions E. de Boccard, 1958), pp. 3–46.
Page 15, line 3	James Elkins, in *What Happened to Art Criticism?* (Chicago: Prickly Paradigm Press, 2003), has claimed that contemporary art criticism has abandoned evaluation in favor of pure description: "In the last three or four decades, critics have begun to avoid judgments altogether, preferring to describe or evoke the art rather than say what they think of it" (p. 12). He finds that *The Visual Art Critic: A Survey of Art Critics at General-Interest News Publications in America* by the National Arts Journalism Program at Columbia University (2002) shows that "judging art is the least popular goal among American art critics, and simply describing art is the most popular" (p. 12, cf. p. 35). That is not quite what the survey shows. The critics were asked "In your writings, how much emphasis do you place on the following aspects of criticism?" and were given five choices, ranging from "A great deal of emphasis" to "No emphasis at all." It

is true that 51 percent of the respondents said that they place "a great deal of emphasis" on "an accurate descriptive account of the artwork or exhibition reviewed" (37 percent placed "some emphasis" on it), while only 27 percent placed "a great deal of emphasis" on "rendering a personal judgment or opinion about the works being reviewed" (55 percent said they place some emphasis on it). That is not the same as asking what critics take their purpose to be; and giving an accurate description of what one evaluates (explicitly or, as we shall see, implicitly) does indeed require great attention and may well constitute the bulk of a critic's writing. It is also difficult to believe that to say that criticism is a matter of "motivating readers to see and buy art" is, as Elkins claims (p. 35), to take description to be its main goal. If nothing else, the survey does not give a clear answer to the question we are asking.

Page 15, line 11	Kant, *Critique of the Power of Judgment*, §1, p. 89; my italics.
Page 15, line 17	Arnold Isenberg, "Critical Communication," in his *Aesthetics and the Theory of Criticism*, ed. by William Callaghan et al. (Chicago: University of Chicago Press, 1973), p. 164. See also, in the same volume, "Some Problems of Interpretation," p. 215.
Page 15, line 20	Monroe C. Beardsley, *Aesthetics: Problems in the Philosophy of Criticism* (New York: Harcourt, Brace & World, 1958), pp. 10–11. Beardsley's thesis is slightly more qualified than this quotation suggests, since he doesn't believe that "description and interpretation are important only as grounds for evaluation." It could still be interesting, he says, to establish what works mean even if we were not interested in judging them, "for, after all, describing and interpreting are the two halves of understanding" (p. 11). But although interpretation can be undertaken for its own sake, it represents only part of the function of criticism, which is fulfilled only when, on the basis of interpretation, a judgment of value is finally reached.
Page 15, line 29	Alan H. Goldman, *Aesthetic Value* (Boulder, CO: Westview Press, 1995), p. 102.
Page 15, line 34	Mary Mothersill, *Beauty Restored* (Oxford: Clarendon Press, 1984), p. 31. That difference aside, Mothersill's original and wide-ranging study is one of the best philosophical efforts to address the questions surrounding the role of beauty in art and philosophy. I am very much in her debt.
Page 15, line 37	Ann Sheppard, *Aesthetics: An Introduction to the Philosophy of Art* (New York: Oxford University Press, 1987), p. 82.
Page 16, line 4	Isenberg, "Critical Communication," p. 167.
Page 16, line 11	Joseph Addison, *The Spectator*, no. 411 (1712), in Hazard Adams, *Critical Theory since Plato*, p. 289.
Page 16, line 14	Perhaps we could reconcile these facts if we took the purpose of criticism to be not to *establish* the value of a work of art but to *give reasons* for a value judgment made as soon as we are first exposed to it. The judgment is made as soon as beauty, or its absence, strikes us, and the purpose of interpretation is to establish

the features of the work that justify it. I don't think, though, that it is possible to argue that a work's value is the first thing, or even one of the first things, we know about it and that we can determine it independently of knowing anything, or almost anything, about the work's specific features.

Page 16, line 22 Johann Joachim Winckelmann, *History of Ancient Art*, translated by G. Henry Lodge (London: Sampson Low, Marston, Searle & Rivington, 1881), vol. I, p. 301.

Page 16, line 28 Plato, *Phaedrus* 250d.

Page 16, line 34 Danto, *The Abuse of Beauty*, p. 89.

Page 17, line 3 Ibid., p. 92; italics in the original. Danto uses the term "aesthetic beauty" for the ordinary beauty of things and "artistic beauty" for the beauty that requires criticism, but nothing of substance depends on this verbal difference.

Page 17, line 9 Ludwig Wittgenstein, *Lectures and Conversation on Aesthetics, Psychology and Religious Belief*, edited by Cyril Barrett (Berkeley: University of California Press, 1967), p. 3.

Page 17, line 13 J. L. Austin, "A Plea for Excuses," in *Philosophical Papers* (Oxford: Clarendon Press, 1961), p. 131. The questions I raise here are discussed in more detail, but given different answers, by Nick Zangwill in "The Beautiful, the Dainty, and the Dumpy" and several other engaging essays collected in *The Metaphysics of Beauty* (Ithaca, NY: Cornell University Press, 2001).

Page 17, line 19 Addison, *The Spectator*, p. 289.

Page 18, line 18 The most forceful expression of a view of the arts that interprets aesthetic reaction along purely social lines, as a means of acquiring and exercising power, has been offered in a series of books by Pierre Bourdieu, beginning with *Distinction: A Social Critique of the Judgement of Taste* (Cambridge, MA: Harvard University Press, 1984). Bourdieu's views have been very influential, although the research of David Halle (*Inside Culture: Art and Class in the American Home*, Chicago: University of Chicago Press, 1993) provides sobering empirical information.

Page 18, line 33 Sabine Rewald, *Bathus* (New York: Harry N. Abrams, 1984), p. 92.

Page 19, line 8 See Plato, *Republic* 580d–588a.

Page 19, line 12 Plato, *Republic* 586a–587a, 554a.

Page 19, line 25 Virginia Postrel, *The Substance of Style: How the Rise of Aesthetic Value Is Remaking Commerce, Culture, and Consciousness* (New York: HarperCollins, 2003), p. 6. Postrel's use of "aesthetic" and "aesthetic value" is different from their use in writings on the philosophy of art.

Page 19, line 26 Postrel, *The Substance of Style*, p. 18. Hal Foster's view of design is less rhapsodic; see *Design and Crime (and Other Diatribes)* (London: Verso, 2002), pp. 13–26.

Page 20, line 1 Ibid., p. 57.

Page 20, line 22	Dave Hickey, *The Invisible Dragon: Four Essays on Beauty* (Los Angeles: Art Issues Press, 1993), p. 16.
Page 20, line 32	Ibid., p. 57. Hickey seems to be arguing that the more beautiful a picture is, the more likely it is that its content will be "litigious or neurotic."
Page 21, line 2	Richard Huelsenbeck, cited by Calvin Tomkins, *Duchamp: A Biography* (New York: Henry Holt, 1996), pp. 191–192.
Page 21, line 14	Danto, *The Abuse of Beauty*, p. 58.
Page 23, line 3	See L. S. Boersma, *The Last Futurist Exhibition of Painting* (Rotterdam: 0.10, 1994), p. 22.
Page 23, line 8	Letter of 1927, quoted by Hans Belting, *The Invisible Masterpiece* (Chicago: University of Chicago Press, 2001), p. 303.
Page 23, line 13	Wassily Kandinsky, *Concerning the Spiritual in Art* (New York: George Wittenborn, Inc., 1947), p. 44.
Page 24, line 6	Danto, *The Abuse of Beauty*, p. 89. Danto, who prefers to use "aesthetic" in its original meaning of "sensual," applies it to beauty and uses it in contrast to "artistic value" (p. 92).
Page 24, line 11	Herni Matisse, quoted by Richard Weston, *Modernism* (London: Phaidon Press, 1996), p. 65.
Page 24, line 14	William Carlos Williams, "A Matisse," *Contact* 2 (1921), n.p., cited in *Matisse and the Subject of Modernism* (Princeton: Princeton University Press, 2004), p. 164, by Alastair Wright, whose discussion of the picture culminates in a considerably more complicated account of the subject's racial, ethnic, and sexual characteristics.
Page 25, line 9	Hickey, *The Invisible Dragon*, p. 40. See also "This Mortal Magic," in *Air Guitar: Essays on Art and Democracy* (Los Angeles: Art Issues Press, 1997), pp. 181–189.
Page 25, line 16	See Ronald Penrose, "Beauty and the Monster," in *Picasso: A Retrospective*, edited by Daniel-Henri Kahnweiler (New York: Praeger Publishers, 1973), pp. 157–196.
Page 25, line 23	Leo Steinberg, "The Algerian Women and Picasso at Large," in *Other Criteria* (London: Oxford University Press, 1972), pp. 125–234.
Page 27, line 4	Kenneth Clark, *The Nude: A Study in Ideal Form* (New York: Pantheon Books, 1956), p. 7.
Page 27, line 11	See Hans Belting, *The Invisible Masterpiece* (Chicago: University of Chicago Press, 2001), p. 167.
Page 28, line 16	Wendy Steiner has argued that the modernist exclusion of beauty is an expression of a deep-seated misogyny; see *Venus in Exile: The Rejection of Beauty in Twentieth-Century Art* (Chicago: University of Chicago Press, 2002).
Page 28, line 27	Guillaume Apollinaire, "On the Subject of Painting" (1908), in *Art in Theory: 1900–2000*, edited by Charles Harrison and

Paul Wood (Malden, MA: Blackwell Publishing, 2003), pp. 186–187.

Page 28, line 33 For the first view, see Hickey, *The Invisible Dragon*, p. 57; for a good historical account of a more complex process that comes closer to the second, see Donald Sassoon, *Becoming Mona Lisa* (San Diego: Harcourt, Inc., 2001).

Page 29, line 10 Stéphane Mallarmé, "Mystery in Literature," in *Critical Theory since Plato*, edited by Hazard Adams (San Diego: Harcourt Brace Jovanovich, 1971), p. 693.

Page 29, line 29 Adolf Loos, "Ornament and Crime," in *Ornament and Crime: Selected Essays*, edited by Adolf Opel (Riverside, CA: Ariadne Press, 1998), pp. 174–175.

Page 30, line 9 Diane Waldman, *Mark Rothko, 1903–1970: A Retrospective* (New York: Harry N. Abrams, 1978), p. 69.

Page 30, line 14 Ibid., p. 68.

Page 30, line 32 Clement Greenberg, "Avant-Garde and Kitsch," in *Art and Culture* (Boston: Beacon Press, 1961; originally published in 1939), pp. 3–21. The literature surrounding Greenberg's criticism is enormous, and it is still being actively augmented. A good selection of essays, including two by Greenberg himself, can be found in Francis Francina, *Pollock and After: The Critical Debate*, 2nd ed. (London: Routledge, 2000).

Page 31, line 10 Greenberg, "Avant-Garde and Kitsch," p. 6.

Page 31, line 15 Ibid., p. 10.

Page 31, line 26 Ibid., p. 15. It is worth remarking that Repin never painted a war scene, as Greenberg asserted in the original version of his essay—an inaccuracy he acknowledged in a note added in 1972.

Page 31, line 28 Ibid., p. 11.

Page 32, line 4 Ibid., pp. 16–17. The same holds true, Greenberg argues, of Renaissance art, which was obliged to be realistic, and, as a consequence, "the masses could still find in the art of their masters object of admiration and wonder" (p. 17).

Page 32, line 8 Ibid., p. 13.

Page 32, line 33 Clement Greenberg, "Modernist Painting," reprinted in *The Collected Essays and Criticism*, vol. 4, ed. John O'Brian (Chicago: University of Chicago Press, 1993), p. 87. Greenberg argues that painting shares the "enclosing" space of the support with the theater and color with both theater and sculpture. But if "to achieve autonomy painting has had above all to divest itself of everything it might share with sculpture," as Greenberg claims when he discusses three-dimensionality (p. 88), are we to conclude that it should also give up *color*?

Page 33, line 5 Greenberg, "Modernist Painting," p. 92.

Page 33, line 18 Clement Greenberg, "Necessity of 'Formalism,'" *New Literary History* 3 (1971): 171–172.

Page 33, line 24	Greenberg, "Modernist Painting," p. 86.
Page 33, line 34	T. S. Eliot, "The Metaphysical Poets," *Times Literary Supplement*, 20 October 1921, p. 669.
Page 34, line 26	Ibid., p. 670. The italics are Eliot's own.
Page 35, line 11	Ibid., pp. 669–670.
Page 35, line 27	Hal Foster, *The Anti-Aesthetic: Essays on Postmodern Culture* (New York: The New Press, 1983), p. xvi.

Notes to II

Page 36, line 9	J. Claretie, writing in *Le Figaro*, 20 June 1865, quoted by G. H. Hamilton, *Manet and His Critics* (New Haven: Yale University Press, 1954), p. 73.
Page 36, line 10	Félix Jahyer, *Étude sur les Beaux-Arts, Salon de 1865* (Paris, 1865), p. 283, quoted by T. J. Clark, *The Painting of Modern Life: Paris in the Art of Manet and His Followers* (Princeton: Princeton University Press, 1984), p. 85.
Page 36, line 16	In *Manet's Modernism or, The Face of Painting in the 1860s* (Chicago: University of Chicago Press, 1996), chapter 4, Michael Fried takes up the first criticism, which was made often against Manet in the 1860s; Clark, *The Painting of Modern Life*, chapter 2, makes more of the second. Both are invaluable; so is Theodore Reff, *Manet: Olympia* (New York: Viking Press, 1976).
Page 37, line 2	See Clark, *The Painting of Modern Life*, pp. 90–93.
Page 37, line 6	The critic was Dubosc de Pesquidoux, writing in the Catholic journal *L'Union* on 24 May 1865, cited by Clark, *The Painting of Modern Life*, p. 92.
Page 37, line 12	See Stanley Cavell, "Music Discomposed," in *Must We Mean What We Say?* (New York: Charles Scribner's Sons, 1969), pp. 180–212.
Page 38, line 33	Fabienne Darge, "Une prétentieuse méditation sur le clown et l'échec," *Le Monde*, 22 July 2005.
Page 39, line 12	Théophile Gautier *fils*, *Le Monde Illustré*, 6 May 1865, p. 283, in Clark, *The Painting of Modern Life*, p. 92.
Page 39, line 13	See Clark, *The Painting of Modern Life*, p. 90 with references.
Page 39, line 26	Amédée Cantaloube, writing in *Le Grand Journal*, 21 May 1865, cited by Clark, *The Painting of Modern Life*, p. 94 and n. 59. The translation of the description of Olympia is Clark's, that of the servant and the cat, mine. The quoted passages are from the poem by Zacharie Astruc that, most unfortunately, accompanied the entry for the painting in the catalogue of the Salon. Clark includes several similar accounts in his discussion.
Page 39, line 28	I believe the import of criticizing Manet's early work for consisting simply of *morceaux* (fragments) that could not add up to

a *tableau* (a finished, unified work) reveals the same confusion. On *morceaux*, see Fried *Manet's Modernism*, pp. 142, 305–333. Only one critic seems to have come to terms with the painting; see Clark, *The Painter of Modern Life*, pp. 139–146.

Page 41, line 9 Émile Zola, writing in *La Revue du XIXe siècle*, 1 January 1867, pp. 97–98, cited by Reff, *Manet: Olympia*, pp. 22–23. The essay, which eventually appeared as a pamphlet, was an extended version of an earlier article published in *L'Evénement* on 7 May 1866. Manet gave it a prominent role in his portrait of Zola, which he painted as a gift to the writer in 1868. For a detailed and novel account of Manet and Zola, see Carol Armstrong, *Manet Manette* (New Haven: Yale University Press, 2002), chapters 2 and 3,

Page 41, line 27 Jean Ravenel, writing in *L'Epoque*, 7 June 1865, cited by Clark, *The Painting of Modern Life*, p. 140.

Page 41, line 33 Michiko Kakutani, "Headed toward a Crash, of Sorts, in a Stretch Limo," *New York Times*, 24 March 2003.

Page 41, line 33 Jed Perl, "Shrieks," in *Eyewitness: Reports from an Art World in Crisis* (New York: Basic Books, 2000), p. 56.

Page 42, line 2 Susan Sontag, "Godard's *Vivre Sa Vie*," in *Against Interpretation* (New York: Dell Publishing Company, 1961), p. 207.

Page 42, line 30 One of those who do think that criticism is, and should be, objective is Northrop Frye in *Anatomy of Criticism* (Princeton: Princeton University Press, 1957); see, for example, p. 18: "The first step in developing a genuine poetics is to recognize and get rid of meaningless criticism . . . all casual, sentimental, and prejudiced value judgments, and all the literary chit-chat that makes the reputation of poets boom and crash in an imaginary stock exchange. That wealthy investor Mr. Eliot, after dumping Milton on the market, is now buying him again." A case against the possibility of objectivity in art history has been made by Jonathan Harris in *The New Art History: A Critical Introduction* (New York: Routledge, 2001), where he argues that traditional objective approaches to art understood truth "as an unquestionable objective knowledge," which he finds unacceptable (p. 25).

Page 43, line 1 Harold Bloom, *Shakespeare: The Invention of the Human* (New York: Riverhead Books, 1998), p. vii.

Page 43, line 23 Nelson Goodman, "Merit as Means," in his *Problems and Projects* (Indianapolis: Bobbs-Merrill Company, 1972), pp. 120–121.

Page 43, line 30 See, for example, Dabney Townsend's *An Introduction to Aesthetics* (Malden, MA: Blackwell Publishing, 1997), pp. 155–159, and Roger Seamon, "Criticism," in *The Routledge Companion to Aesthetics*, edited by Berys Gaut and Dominic McIver Lopes (London: Routledge, 2001), pp. 315–328. Here is what the *Encyclopedia of Aesthetics* has to say: "For any given work, a set consisting of existing (if there are any existing comparable works) and possible works or a set of only possible works (if

there are not any existing comparable works) can be imagined as a hierarchical value matrix, and the value of the given work can be compared to the values of the other members of the imagined matrix. The place of the given work within the imagined matrix determines the *specific* evaluation to be assigned to it—a rank at the top means *excellent*, and so on" (George C. Dickie, "Aesthetic Evaluation," in *Encyclopedia of Aesthetics*, edited by Michael Kelly (New York: Oxford University Press, 1998), vol. 2, p. 131. The entry on art criticism in *The Grove Dictionary of Art* begins by saying that it "may be defined loosely as writing that evaluates art" (James Elkins, "Art Criticism," *Grove Art Online*, Oxford University Press, [2005], http://www.groveart.com/).

Page 44, line 7 The model and the examples are from Colin Lyas, *Aesthetics* (Montreal and Kingston: McGill-Queen's University Press, 1997), p. 118.

Page 44, line 16 Lyas, *Aesthetics*, p. 118.

Page 45, line 1 Arthur C. Danto, *The Transfiguration of the Commonplace: A Philosophy of Art* (Cambridge, MA: Harvard University Press, 1981), p. 155.

Page 45, line 12 Michael Kimmelman, "40 Years of Making Much Out of Little," *New York Times*, 11 November 2005, p. E1.

Page 45, line 24 Anthony Lane, "Space Case: 'Star Wars: Episode III,'" *New Yorker*, 23 May 2005.

Page 46, line 7 In fact, both criticism and reviewing itself have been from the beginnings of their expansion in the eighteenth century much more complex than such a "juridical" model envisages, with many roles and purposes. See Richard Wrigley in *The Origins of French Art Criticism: From the Ancien Régime to the Restoration* (Oxford: Clarendon Press, 1993).

Page 47, line 2 Clement Greenberg, "Soutine," in *Art and Culture* (Boston: Beacon Press, 1965), p. 115.

Page 47, line 10 David Hume, "Of the Standard of Taste," in *Essays, Moral, Political and Literary*, edited by Eugene F. Miller, rev. ed. (Indianapolis: LibertyClassics, 1987), pp. 226–249. The best recent discussion of the issue and its implications for aesthetics is Mary Mothersill's *Beauty Restored* (Oxford: Clarendon Press, 1984).

Page 47, line 23 Kant, *Critique of the Power of Judgment*, §9, p. 104.

Page 47, line 25 Ibid., §8, p. 101.

Page 47, line 30 Arnold Isenberg, "Critical Communication," in his *Aesthetics and the Theory of Criticism*, edited by William Callaghan et al. (Chicago: University of Chicago Press, 1973), p. 164. See also Mary Mothersill, *Beauty Restored* (Oxford: Clarendon Press, 1984), pp. 326–342.

Page 48, line 13 On the "Laudable Conditions" (*laudabile conditione*) of Mary, see Michael Baxandall, *Painting and Experience in Fifteenth-Century Florence*, 2nd ed. (Oxford: Oxford University Press, 1988), pp. 49–56, 164–165.

Page 48, line 15	Since our attitudes toward the critic are part of what defines the situation, and since we disagree, it might seem that the situations are actually two. The rule would then say something to that effect: "If a critic you admire praises something, you will like it; if a critic you detest praises it, you won't." But since there is no rule that determines when to like and when to dislike a critic, the original problem remains unscathed.
Page 49, line 3	The project originated with Frank Sibley's "Aesthetic Concepts," in *Art and Philosophy: Readings in Aesthetics*, edited by W. E. Kennick (New York: St. Martin's Press, 1964), pp. 351–373. Sibley's influential essay has been discussed extensively since its original publication in 1959, and many different explanations for the difference between descriptive and aesthetic terms have been offered since. A good response to Sibley's original view is given by Ted Cohen in "Aesthetic/Non-Aesthetic and the Concept of Taste," *Theoria* 39 (1973): 113–152.
Page 49, line 14	Göran Hermeren, "Qualities, Aesthetic," in *Encyclopedia of Aesthetics*, edited by Michael Kelly (New York: Oxford University Press, 1988), vol. IV, p. 98. The entry introduces a distinction between aesthetic and "artistic" value (aesthetic features being relevant only to the former) but does not depend on it in the discussion that follows.
Page 50, line 4	Michael Fried, *Manet's Modernism or, The Face of Painting in the 1860s*, pp. 359–360.
Page 50, line 27	Rosalind Krauss, "LeWitt in Progress," in *The Originality of the Avant-Garde and Other Modernist Myths* (Cambridge, MA: MIT Press, 1986), pp. 254, 258.
Page 51, line 7	See Baxandall, *Painting and Experience in Fifteenth-Century Italy*, p. 11.
Page 51, line 18	William Gass, *On Being Blue: A Philosophical Inquiry* (Boston: David R. Godine, 1976), p. 11.
Page 51, line 21	In *The Prose of the World* (Evanston, IL: Northwestern University Press, 1973. p. 62), Maurice Merleau-Ponty writes that André Malraux once told a story about an innkeeper at Cassis, who saw Renoir working by the sea and went over to observe him: "'There were some nude women bathing in some other place. Goodness knows what he was looking at, and he changed only a little corner.' . . . The blue of the sea had become that of the brook in *The Bathers*. . . . This vision was less a way of looking at the sea than the secret elaboration of a world to which that depth of blue whose immensity he was recapturing pertained." It is clear that the color blue, on its own, has immense aesthetic significance here. I am grateful to Sean Kelly for this reference.
Page 51, line 28	T. J. Clark, *Farewell to an Idea: Episodes from a History of Modernism* (New Haven: Yale University Press, 1999), pp. 15–53.
Page 54, line 9	Not necessarily: affection, respect, love, and passion can grow through various means of correspondence.

Page 54, line 25 Friedrich Nietzsche, *Beyond Good and Evil*, translated by Walter Kaufmann in *Basic Writings of Nietzsche* (New York: Random House, 1968), §75.

Page 55, line 15 Ludwig Wittgenstein, *Philosophical Investigations* (New York: Macmillan, 1955), §536.

Page 55, line 26 Plato, *Symposium* 204d.

Page 56, line 2 Marcel Proust, *In Search of Lost Time*, vol. 1, *The Way by Swann's*, translated by Lydia Davis (London: Penguin Books, 2002), p. 243.

Page 56, line 14 Ibid., pp. 201, 202.

Page 56, line 28 Ibid., pp. 249, 250.

Page 57, line 5 Ibid., pp. 347–355.

Page 57, line 7 See Thomas Hobbes, *Leviathan*, book I, chap. 16.

Page 57, line 14 See Richard Rorty, "The Pragmatist's Progress: Umberto Eco on Interpretation," in *Philosophy and Social Hope* (London: Penguin, 1999), pp. 144–145.

Page 57, line 17 I am afraid the term "possess" can be misleading: In *Speaking of Beauty* (New Haven: Yale University Press, 2003), p. 10, for example, Denis Donoghue seems to take it in the sense I am trying to avoid here when he criticizes my use of it and says that "Kant would regard the desire to possess the beautiful thing, in any sense, as disabling to the aesthetic experience." I hope the present discussion clarifies matters a bit, convincing Donoghue, whose book and generous remarks on an earlier version of this chapter have been very valuable to me, that on this issue at least there is no disagreement between us.

Page 57, line 22 See J. David Velleman, "Love as a Moral Emotion," *Ethics* 109 (1999): 338–374. Velleman's views, especially his criticisms of various common conceptions of love, are very valuable, and his own phenomenology of love is extremely attractive. His Kantian conclusion that love is directed at the rational nature of our lovers, however, is not easy to accept.

Page 57, line 35 Aristotle, *Nicomachean Ethics* VIII–IX.

Page 58, line 28 This last is a favorite example of philosophers discussing whether we can rightly say we love people for their features without having also to say that we love their features instead of those people themselves. It refers to Yeats' poem "For Anne Gregory," in *The Collected Poems of W. B. Yeats* (New York: Macmillan, 1956), p. 240. A girl hopes that some young man might love her "'for myself alone,/And not my yellow hair'"; but the reply comes "'That only God, my dear,/Could love you for yourself along/And not your yellow hair.'"

Page 59, line 7 To find some people ugly is not simply to *believe* that they are ugly—which is to say that you can understand why others might think of them as ugly, how others might *find* them ugly—but to be directly struck by them as ugly, to be, to that

extent, repelled by them. The case is parallel to finding some people beautiful, which implies being actually attracted to them, not just realizing that *others* might be attracted to them.

Page 60, line 10	Isabel Allende, *Paula*, translated by Margaret Sayers Peden (New York: HarperCollins, 1994), pp. 48–49.
Page 60, line 20	Stendhal, *De l'amour* (Paris: Champion, 1926) chap. 17, p. 74; English translation by Gilbert and Suzanne Sale, *Love* (London; Penguin Books, 1957), p. 66.
Page 60, line 32	Gustave Flaubert, *Madame Bovary*, translated by Margaret Mauldon (Oxford: Oxford University Press, 2004), pp. 157, 165.
Page 61, line 3	I am not thinking of that version of Christian love that is addressed to everyone indiscriminately, simply as a child of God. But even there, the practice, for example, of kissing lepers' wounds during parts of the Middle Ages suggests that love and repulsion exclude one another.
Page 61, line 7	Helen Vendler, *The Art of Shakespeare's Sonnets* (Cambridge, MA: Harvard University Press, 1997), which includes among its many virtues a refusal to accept the easy solution of reducing "fair" and "foul" to moral terms so as to avoid the paradoxes the sequence generates; see, for instance, pp. 540–542.
Page 61, line 22	Ibid., pp. 643, 645.
Page 61, line 26	See G. Blakemore Evans, *The Sonnets*, part of *The New Cambridge Shakespeare* (Cambridge: Cambridge University Press, 1996), pp. 271–272.
Page 61, line 31	Plato, *Symposium* 203c.
Page 62, line 14	Ibid., 216e–217a.
Page 62, line 16	For a few remarks on the history of the image, see *The Art of Living: Socratic Reflections from Plato to Foucault* (Berkeley: University of California Press, 1998), p. 109 and notes.
Page 62, line 24	Plato, *Symposium*, 221b.
Page 62, line 27	Friedrich Nietzsche, "The Problem of Socrates," §3, in *The Twilight of the Idols*, *The Portable Nietzsche*, edited and translated by Walter Kaufmann (New York: The Viking Press, 1968), p. 475.
Page 63, line 5	Marcel Proust, *In Search of Lost Time*, vol. 5, *The Prisoner*, translated by Carol Clark (London: Penguin Books, 2002), p. 94. That, of course, is also the starting point of Socrates' speech on *erōs* in the *Symposium*.
Page 63, line 18	"La beauté n'est jamais, ce me semble, qu'une *promesse de bonheur*," *Rome, Naples et Florence* (Paris: Champion, 1919), pp. 45–46; "La beauté n'est jamais que la *promesse* du bonheur." *De l'amour* chap. 17, p. 74 n.1 (*Love*, p. 66 n.1).
Page 64, line 19	The literature on this issue is very large. A representative sample includes the following: Michael Cunningham et al., "'Their

Ideas of Beauty Are, on the Whole, the Same as Ours': Consistency and Variability in the Cross-Cultural Perception of Female Physical Attractiveness," *Journal of Personality and Social Psychology* 68 (1995): 261–279; Doug Jones and Kim Hill, "Criteria of Facial Attractiveness in Five Populations," *Human Nature* 4 (1993): 271–296; Doug Jones, "Sexual Selection, Physical Attractiveness and Facial Neoteny: Cross-Cultural Evidence and Implications," *Current Anthropology* 36 (1995): 723–748; Judith H. Langlois and Lori A. Roggman, "Attractive Faces Are Only Average," *Psychological Science* 1 (1990): 115–121; Judith H. Langlois et al., "What Is Average and What Is Not Average about Attractive Faces?" *Psychological Science* 5 (1994): 214–220; D. I. Perrett et al., "Facial Shape and Judgements of Female Attractiveness," *Nature* 368 (1994): 239–242; D. I. Perrett et al., "Effects of Sexual Bimorphism on Sexual Attractiveness," *Nature* 394 (1998): 884–887; Anthony Little and David Perrett, "Putting Beauty Back in the Eye of the Beholder," *The Psychologist* 15 (2002): 28–32. Nancy Etcoff, *Survival of the Prettiest: The Science of Beauty* (New York: Random House, 1999), provides a lively introduction, and *Evolutionary Aesthetics*, edited by Eckart Voland and Karl Grammar (Berlin: Springer-Verlag, 2003), contains extensive bibliographies.

Page 64, line 22 This sentence is ambiguous: does the question concern the beauty of the photographs or of the faces the photographs depict? This ambiguity is evident, for example, when Langlois and Roggman ("Attractive Faces Are Only Average") refer to "digitizing faces" instead of photographs (pp. 116, 118). It is not clear what effect this could have on the participants' answers, since, as Aristotle remarked in the *Poetics* (1448b9–1448b12), a representation of an ugly subject can be itself very beautiful. There are indications, though, that at least in the case of symmetry, what goes for the representation also goes for its subject; see L. Mealey, R. Bridgstock, and G. C. Townsend, "Symmetry and Perceived Facial Attractiveness: A Monozygotic Co-Twin Comparison," *Journal of Personality and Social Psychology* 76 (1999): 151–158.

Page 64, line 24 Some ask questions about the persons whose faces are pictured (e.g., Mealey et al., "Symmetry and Perceived Facial Attractiveness," p. 153: subjects "were instructed to identify which *twin* of each pair was the more attractive and to rate . . . the attractiveness of each *individual*"), others seem to focus more on the photographs or the faces themselves (e.g., Perrett et al., "Facial Shape and Judgements of Female Attractiveness," p. 241: subjects were "given pairs of composites and asked to choose the most attractive in each pair"). I don't know whether this makes a difference to what the subjects understand themselves to be judging.

Page 65, line 3 The history probably begins with two relatively casual hints in Plato's *Timaeus* 87c, "The beautiful (*to kalon*) is not without measure," and Aristotle's *Metaphysics* M 3, 1078a36–1078b2, "The three greatest forms of beauty (*to kalon*) are order and symmetry

and definiteness." It is difficult to believe that these are serious definitions: *to kalon* is too important to both of them to be defined only as an aside, and without much further elaboration.

Page 65, line 15 D. Symons, "Beauty Is in the Adaptations of the Beholder: The Evolutionary Psychology of Human Female Sexual Attractiveness," in *Sexual Nature/Sexual Culture*, edited by P. R. Abramson and S. D. Pinkerton (Chicago: University of Chicago Press, 1995), p. 80.

Page 65, line 20 Symmetry is correlated with heterozygosity (the possession of different alleles of one or more genes at a particular locus in a chromosome). Heterozygosity, in turn, indicates a low level of inbreeding and the absence of hereditary diseases that require two identical genes, like sickle-cell anemia.

Page 66, line 8 This line of thought is used to explain why the faces that are acknowledged to be most beautiful are usually far from average. See Etcoff, *Survival of the Prettiest*, p. 150, but also D. I. Perrett, K. A. May, and S. Yoshikawa, "Facial Shape and Judgments of Female Attractiveness," *Nature*, 368 (1994): 239–242.

Page 66, line 15 Karl Grammar, Viktoria Keki, Beate Striebel, Michaela Atzmüller, and Bernhard Fink, "Bodies in Motion: A Window to the Soul," in Voland and Grammar, *Evolutionary Aesthetics*, pp. 295–323.

Page 66, line 20 Little and Perrett, "Putting Beauty Back in the Eye of the Beholder," p. 31.

Page 66, line 23 Langlois et al., "What Is Average and What Is Not Average about Attractive Faces?" p. 214.

Page 66, line 29 Etcoff, *Survival of the Prettiest*, p. 234.

Page 67, line 26 On the difficulties of such a "stratigraphic" conception, see Clifford Geertz, "The Impact of the Concept of Culture on the Concept of Man" and "The Growth of Culture and the Evolution of Mind," both in *The Interpretation of Cultures* (New York: Basic Books, 1973), pp. 33–54, 55–83, esp. pp. 43–51, 63–69.

Page 68, line 18 Etcoff, *Survival of the Prettiest*, p. 234.

Page 68, line 33 Kevin M. Kniffin and David Sloan Wilson, "The Effect of Nonphysical Traits on the Perception of Physical Attractiveness: Three Naturalistic Studies," *Evolution and Human Behavior* 25 (2004): 88–101.

Page 69, line 2 Ibid., p. 88.

Page 69, line 9 Ibid., pp. 98–99.

Page 70, line 15 See Judith H. Langlois et al., "Infant Preferences for Attractive Faces: Rudiments of a Stereotype?" *Developmental Psychology* 23 (1987): 363–369; Judith H. Langlois et al., "Infants' Differential Social Responses to Attractive and Unattractive Faces," *Developmental Psychology* 26 (1990): 153–159; Judith H. Langlois et al., "Facial Diversity and Infant Preferences for Attractive Faces";

Developmental Psychology 27 (1991): 79–84; Judith H. Langlois et al., "Infant Attractiveness Predicts Maternal Behaviors and Attitudes," *Developmental Psychology* 31 (1995): 464–472; Thomas G. Power, Katherine A. Hildebrandt, and Hiram E. Fitzgerald, "Adults' Responses to Infants Varying in Facial Expression and Perceived Attractiveness, *Infant Behavior and Development* 5 (1982): 33–44.

Notes to III

Page 73, line 25	R. G. Collingwood, *The Principles of Art* (London: Oxford University Press, 1938), pp. 39, 40–41.
Page 74, line 2	One of his reasons is his view that the arts that concerned him—painting, sculpture, and poetry—didn't require knowledge of the nature of the objects they represented but only familiarity with their appearance. Instead of being able to lead to the next stage of the ascent he describes in the *Symposium*, they undermined the morality of their audience and made them incapable of taking even its very first steps. See my "Plato on Imitation and Poetry in *Republic* X" and "Plato and the Mass Media," in *Virtues of Authenticity: Essays on Plato and Socrates* (Princeton: Princeton University Press, 1999), pp. 251–278, 279–299.
Page 74, line 12	Gerard Manley Hopkins, "The Beginning of the End," quoted by Elaine Scarry, *On Beauty and Being Just* (Princeton: Princeton University Press, 1999), p. 13.
Page 74, line 26	Mary Mothersill, *Beauty Restored*, p. 274.
Page 76, line 29	Dave Hickey, "Simple Hearts," in *Air Guitar: Essays on Art and Democracy* (Los Angeles: Art Issues Press, 1997), p. 30.
Page 77, line 10	Peter Schjeldahl, "Notes on Beauty," in *Uncontrollable Beauty*, edited by Bill Beckley with David Shapiro, (New York: Allworth Press, 1998), p. 58.
Page 77, line 27	Mothersill, *Beauty Restored*, p. 164.
Page 77, line 35	Ibid., p. 165.
Page 78, line 18	Frank Harris, *Oscar Wilde: His Life and Confessions* (New York: Brentano's, 1916), vol. I, p. 64, and see also Richard Ellmann, *Oscar Wilde* (New York: Knopf, 1988), p. 133.
Page 79, line 13	Immanuel Kant, *Critique of the Power of Judgment*, edited by Paul D. Guyer and translated by Paul D. Guyer and Eric Matthews (Cambridge: Cambridge University Press, 2000), §36, pp. 168–169.
Page 79, line 19	Ibid., §19, p. 121.
Page 79, line 21	Strictly speaking, Kant writes that "if one . . . calls the object beautiful, one *believes* oneself to have a universal voice, and lays

claim to the consent of everyone" (ibid., §8, p. 101). He thinks, of course, that this belief is correct.

Page 79, line 25	Ibid., §§9, 35, 40.
Page 79, line 30	Ibid., §7, p. 98.
Page 79, line 33	Mary Mothersill, *Beauty Restored* (Oxford: Clarendon Press, 1984), p. 165. David Hume, unlike Kant and Mothersill, believed that "there are certain general principles of approbation and blame" (that the judgment of taste, in Kant's terms, is in fact governed by concepts): "Some particular forms or qualities, from the original structure of the internal fabric, are calculated to please, and others to displease." Faced, then, with the fact of widespread disagreement, he accounted for it by claiming that "if they fail of their effect in any particular instance, it is from some apparent defect or imperfection in the organ." See "Of the Standard of Taste," in David Hume, *Essays, Moral, Political, and Literary*, edited by Eugene F. Miller, rev. ed. (Indianapolis: LibertyClassics, 1987), p. 233.
Page 80, line 30	Ted Cohen, "The Very Idea of Art," *NCECA Journal* 9 (1988): 12.
Page 81, line 3	Paul Guyer has also pointed out that *Anthropology from a Pragmatic Point of View* (§67) expresses what he calls "a striking variation" on the Third Critique's theme of speaking with a universal voice and laying claim to everyone's consent (§8, p. 101): "Kant describes the judgment of beauty as an invitation (*Einladung*) to others to experience the pleasure one has oneself felt in an object." That is also a wonderful way of putting the point, although I am not sure that Kant offers us here a variation and not a new and independent theme: "welche beide das Bestreben enthalten eine Vorstellung, die zum Genuß dargeboten wird, von sich zu stoßen, da hingegen Schönheit den Begriff der Einladung zur innigsten Vereinigung mit dem Gegenstande, d.i. zum unmittelbaren Genuß, bei sich führt" (*Gesammelte Schriften, hrsg. von der Königlich Preussischen Akademie der Wissenschaften*, Berlin: Reimer, 1902–, vol. 7, p. 241).
Page 81, line 8	*Critique of the Power of Judgment*, §7, p. 97.
Page 82, line 4	See, for example, Louise Bruit Zaidman and Pauline Schmitt Pantel, *Religion in the Ancient Greek City* (Cambridge: Cambridge University Press, 1992), pp. 176–214.
Page 82, line 7	See Mothersill, *Beauty Restored*, pp. 170–176, and, for the evidence she provides though not for the conclusions she draws from it, Ellen Dissanayake, *Homo Aestheticus: Where Art Comes From and Why* (Seattle: University of Washington Press, 1995).
Page 82, line 13	Cohen, "The Very Idea of Art," p. 10.
Page 82, line 14	David Carrier, *Writing about Visual Art* (New York: Allworth Press, 2003), p. 188. Carrier devotes a chapter to the connection between art and community, to which he takes a sociological approach.

Page 82, line 28	Aristotle, *Poetics* 1448a18.
Page 83, line 9	"Nur aus der Ferne / was es verworren bang, / hör es nun ganz genau, / menschlich ist dieser Klang! / Rühende Laute— / nimmst du sie ganz in dich. / Brüder, Vertraute!" The translation, found in the Deutsche Grammophon version of the opera conducted by Karl Böhm in 1977, is by Gertrude M. Holland.
Page 83, line 19	See John P. Murphy, *Pragmatism from Peirce to Davidson* (Boulder, CO: Westview Press, 1990), p. 31.
Page 83, line 21	Kant certainly does not believe that aesthetic judgment is subject to "dispute," that is, a proof that some aesthetic judgments are correct and others not, and his resolution of "the antinomy of taste" explicitly denies that it is: what he wants to reconcile is the commonplace that "everyone has his own taste" with the idea that it is still rational to expect aesthetic agreement and so to "argue" for our judgments (*Critique of the Power of Judgment*, §§55–57). The important point, though, does not concern truth but Kant's view that it is rational to expect aesthetic agreement from *everyone*: that is the claim I dispute (although perhaps I can do no better than argue with it).
Page 85, line 12	Richard Rorty has made extensive and fruitful use of the distinction between the public and the private. He uses it instead of the distinction between the objective and the subjective, which he rejects. See, for example, *Contingency, Irony, and Solidarity* (Cambridge: Cambridge University Press, 1989), esp. part II, as well as "Solidarity or Objectivity," in *Objectivity, Relativism, and Truth: Philosophical Papers*, vol. I (Cambridge: Cambridge University Press, 1991), pp. 21–34, and "Moral Identity and Private Autonomy: The Case of Foucault," in *Essays on Heidegger and Others: Philosophical Papers*, vol. II (Cambridge: Cambridge University Press, 1991), pp. 193–198. The distinction corresponds to Rorty's exhaustive contrast between "philosophers" and "poets" or "metaphysicians" and "ironists." I find his discussions consistently illuminating, but I believe the picture must be complicated by the addition of such an intermediate stage as the personal, where, we might say, philosophy and poetry (or art) meet and affect one another.
Page 85, line 33	Susan Sontag, "Notes on 'Camp,'" *Against Interpretation* (New York: Dell, 1966), p. 276.
Page 86, line 2	Plotinus, *Enneads* VI. 8.
Page 86, line 6	Friedrich Nietzsche, *Beyond Good and Evil: Prelude to a Philosophy of the Future*, translated by Walter Kaufmann (New York: Random House, 1966), §213. See also Jonathan Gilmore, *The Life of a Style: Beginnings and Endings in a Narrative History of Art* (Ithaca, NY: Cornell University Press, 2000), pp. 38–47.
Page 87, line 9	Friedrich Nietzsche, *The Gay Science*, translated by Walter Kaufmann (New York: Random House, 1974), §290.
Page 87, line 29	Charles Baudelaire, *Correspondance* (Paris: Éditions de la Pléiade, 1966), vol. II, p. 501.

Page 88, line 6	Dave Hickey, "The Kids Are All Right: After the Prom," in *Norman Rockwell: Pictures for the American People*, edited by Maureen Hart Hennessey and Anne Knutson (New York: Harry N. Abrams: 1999), pp. 115–130.
Page 88, line 11	Michael Fried, "Art and Objecthood," in *Art and Objecthood* (Chicago: University of Chicago Press, 1998), pp. 148–172.
Page 88, line 16	Sontag, "Notes on 'Camp,'" pp. 285–286.
Page 89, line 24	T. S. Eliot, quoted by Wendy Lesser, *Pictures at an Execution: An Inquiry into the Subject of Murder* (Cambridge, MA: Harvard University Press, 1993), p. 10.
Page 89, line 29	Friedrich Nietzsche, *The Birth of Tragedy*, translated by Walter Kaufmann (New York: Random House, 1966), §5, p. 32; see also §24, p. 141.
Page 89, line 33	That is the charge made by Bernard Williams in *Ethics and the Limits of Philosophy* (Cambridge, MA: Harvard University Press, 1985), although Williams himself was not directly motivated by concern for values that can be characterized as aesthetic. Neither is Harry G. Frankfurt, *The Importance of What We Care About* (Cambridge: Cambridge University Press, 1988) and *Necessity, Volition and Love* (Cambridge: Cambridge University Press, 1999).
Page 90, line 1	In *What We Owe to Each Other* (Cambridge, MA: Harvard University Press, 2000) T. M. Scanlon discusses moral obligation without claiming that it is the only source of value for life.
Page 90, line 7	Martha C. Nussbaum, "Exactly and Responsibly: A Defense of Ethical Criticism," *Philosophy and Literature* 22 (1998): 356. Nussbaum's view is not perfectly clear because although here she seems to envisage that these are the only reasons for reading other than "reading 'for life,'" she also claims that "works that we agree in condemning on one front may still offer us a great deal on another." That suggests that we may have something to gain even from artists lesser than Homer and the rest. Nussbaum also seems to believe that the moral quality of works of art is of extraordinary importance, appealing to Dickens's criticism of Utilitarianism in *Hard Times* as one of her paradigms. Her choice has been criticized by Richard Posner in "Against Ethical Criticism," *Philosophy and Literature* 22 (1998): 12–14, and it is relevant to recall Humphry House's bleak view of Dickens as a sophisticated critic of Utilitarianism: "It is impossible to say that he disliked Bentham's theories, because there is no evidence that he knew what they were" (*The Dickens World* [London: Oxford University Press, 1941; 2nd ed. 1942], p. 38; cited by Peter Gay, *Savage Reprisals: Bleak House, Madame Bovary, Buddenbrooks* [New York: W. W. Norton & Company, 2002], p. 25 n.).
Page 90, line 29	The anecdote, reported by Cochin, is repeated by Pierre Rosenberg, "Chardin: The Unknowing Subversive?" in Pierre Rosenberg et al., *Chardin* (Paris: Editions de la Réunion des Musées Nationaux, 2000), p. 29.

Page 91, line 3 Michael Baxandall, *Patterns of Intention: On the Historical Explanation of Pictures* (New Haven: Yale University Press, 1985), pp. 98–99. See also his *Shadows and Enlightenment* (New Haven: Yale University Press, 1997).

Page 91, line 4 See Jed Perl, *Eyewitness: Reports from an Art World in Crisis* (New York: Basic Books, 2000), pp. 311–330.

Page 92, line 2 Michael Fried, *Manet's Modernism or, The Face of Painting in the 1860s* (Chicago: University of Chicago Press, 1996), p. 359.

Page 92, line 7 Arnold Isenberg, "Critical Communication," in *Aesthetics and the Theory of Criticism: Selected Essays of Arnold Isenberg*, edited by William Callahan et al. (Chicago: University of Chicago Press, 1973), p. 162. The first set of italics is mine.

Page 92, line 10 Ibid., p. 166 and *passim*.

Page 92, line 15 J. O. Urmson, "What Makes a Situation Aesthetic?" in *Art and Philosophy: Readings in Aesthetics*, edited by William Kennick (New York: St. Martin's Press, 1964), pp. 561, 562. I say "more or less" because Urmson allows for some "slightly more sophisticated cases," like descriptions of a building as strong or spacious, which, though not strictly perceptual, are still "concerned with a thing's looking somehow without concern for whether it really is like that" (p. 562).

Page 92, line 18 Urmson, "What Makes a Situation Aesthetic?" p. 561.

Page 93, line 8 I have in fact done so in "Serious Watching," in *The Politics of Liberal Education*, edited in Darryl J. Gless and Barbara Herrnstein Smith (Durham, NC: Duke University Press, 1991), pp. 163–186.

Page 93, line 13 In giving that account I follow Mothersill, who in turn follows Sue Larson; see *Beauty Restored*, pp. 343–345. The issue is complicated, and needs to be discussed in more detail. For example, it may be that two vases are identical in shape but different in color: can't they share some aesthetic features in respect of their shape? There is also a problem surrounding the question whether being indistinguishable is a transitive relation, whether "*a* is indistinguishable (by A) from *b*" and "*b* is indistinguishable (by A) from *c*" imply that "*a* is indistinguishable (by A) from *c*." If they do not, as Nelson Goodman, for example, argued in *The Structure of Appearance* (Cambridge, MA: Harvard University Press, 1951, p. 230) and also in *Languages of Art* (Indianapolis: Bobbs-Merrill, 1968, pp. 99–112), then none of the properties of *a* can be aesthetic. For if *a* has the property of being *F* and we suppose that *F* is aesthetic, then *b* must also be *F*, since *a* and *bb* are indistinguishable. But then *c* is also *F*, since *b* and *c* are indistinguishable. In that case, *F* can't be an aesthetic property of *a*, since it shares it with at least one object from which it is distinguishable. However, Delia Graff has recently argued that the relation is transitive, and, if she is right, this particular problem can be avoided ("Phenomenal Continua and the Sorites," *Mind* 110 (2001): 905–935). The question is far from settled.

Page 93, line 33 Marcel Proust, *In Search of Lost Time*, vol. 5, *The Prisoner*, translated by Carol Clark (London: Penguin Books, 2002), p. 169.

Page 94, line 21 Mothersill, *Beauty Restored*, p. 343.

Page 94, line 23 This is David Hume's famous example, drawn from *Don Quixote*, part II, chap. 13, of the "delicacy" necessary for becoming aware of beauty; see "Of the Standard of Taste," in *Essays Moral Political and Literary*, pp. 234–235.

Page 94, line 35 Georg Wilhelm Friedrich Hegel, *The Philosophy of Fine Art*, translated by F.B.P. Osmaston (London: G. Bell and Sons Ltd., 1920), vol. I, p. 61. Quoted by John Carey, *What Good Are the Arts?* (London: Faber and Faber Ltd., 2005), p. 12.

Page 95, line 16 Carey, *What Good Are the Arts?*, p. 30.

Page 95, line 20 Georg Wilhelm Friedrich Hegel, *Lectures on Fine Art*, translated by T. M. Knox (Oxford: Oxford University Press, 1975), vol. I, p. 2.

Page 95, line 26 Carey, *What Good Are the Arts?* p. 29.

Page 96, line 5 Arthur C. Danto, *The Transfiguration of the Commonplace: A Philosophy of Art* (Cambridge, MA: Harvard University Press, 1981), pp. 94–95.

Page 96, line 10 Arthur C. Danto, *The Abuse of Beauty: Aesthetics and the Concept of Art* (Chicago: Open Court, 2003), p. 59.

Page 96, line 13 For the optional status of beauty, see *The Abuse of Beauty*, p. 160; Danto discusses "internal" beauty on pp. 81–102.

Page 96, line 19 Arthur C. Danto, "The Art Seminar," in *Art History versus Aesthetics*, edited by James Elkins (New York: Routledge, 2005), pp. 152–153.

Page 97, line 7 Danto, *The Abuse of Beauty*, pp. 89, 109.

Page 97, line 10 Ibid., p. 113.

Page 98, line 21 Anne Hollander, *Seeing through Clothes* (Berkeley: University of California Press, 1993), chap. 3.

Page 99, line 12 Kant, *Critique of the Power of Judgment*, §8, p. 101.

Page 99, line 16 Danto thinks that beauty (as he construes it) is coordinate with other aesthetic features; see *The Abuse of Beauty*, pp. 58–60.

Page 100, line 7 See Gregory Vlastos, "The Individual as an Object of Love in Plato," in his *Platonic Studies*, 2nd ed. (Princeton: Princeton University Press, 1981), pp. 3–42.

Page 100, line 12 See Simon Keller, "How Do I Love Thee? Let Me Count the Properties," *American Philosophical Quarterly* 37 (2000): 163–173.

Page 100, line 16 See Keith Campbell, "Abstract Particulars and the Philosophy of Mind," *Australasian Journal of Philosophy* 61 (1983): 129–141, and *Abstract Particulars* (Cambridge: Blackwell's, 1990).

Notes to IV

Page 103, line 3	E. M. Forster, *Howards End* (New York: Alfred A. Knopf, 1991), p. 24.
Page 103, line 19	Thomas Mann, *Death in Venice and Seven Other Stories*, translated by H. T. Lowe-Porter (New York: Random House, 1954), p. 29.
Page 103, line 27	Ibid., p. 42.
Page 104, line 19	Ibid., p. 44.
Page 105, line 2	Ibid., p. 75.
Page 107, line 15	See, for example, Theodore Reff, *Manet: Olympia* (New York: Viking Press, 1977), chap. 2; T. J. Clark, *The Painting of Modern Life: Paris in the Art of Manet and His Followers* (Princeton: Princeton University Press, 1984), pp. 93–96; Michael Fried, *Manet's Modernism or, the Face of Painting in the 1860s* (Chicago: University of Chicago Press), chaps. 2 and 3. Needless to say, each work presents a different overall interpretation of the significance of Manet's allusions to the tradition.
Page 107, line 27	Clark, *The Painting of Modern Life*, p. 126.
Page 108, line 3	Charles Baudelaire, *The Painter of Modern Life and Other Essays*, translated and edited by Jonathan Mayne (London: Phaidon Press), pp. 13–14.
Page 108, line 6	Clark, *The Painting of Modern Life*, p. 132.
Page 108, line 16	Ibid., p. 133.
Page 108, line 23	Ibid., p. 135.
Page 108, line 32	Ibid., pp. 136–137.
Page 109, line 7	Ibid., p. 133.
Page 109, line 18	Ibid., pp. 133, 138; Fried, *Manet's Modernism*, p. 318. And see the more general discussion in Theodore Reff, *Manet: Olympia* (New York: Viking Press, 1977), chap. 3.
Page 109, line 30	Reff, *Manet: Olympia*, p. 93; Clark, *The Painting of Modern Life*, p. 133.
Page 110, line 5	"Trumps! Scoops! Frenzy! Competition!" *New York Times*, 16 February 1990, section B, p. 1.
Page 110, line 13	Griselda Pollock, "A Tale of Three Women," in her *Differencing the Canon: Feminist Desire and the Writing of Art's Histories* (London: Routledge, 1999), pp. 247–317. The quotation is from p. 294.
Page 110, line 25	Fried, *Manet's Modernism*, p. 339.
Page 110, line 32	Ibid., p. 289.
Page 111, line 5	Clark, *The Painting of Modern Life*, p. 133.

Page 112, line 3	Michael Fried, *Manet's Modernism*, p. 307.
Page 112, line 22	See Colin B. Bailey, "François Boucher's Presumed Portrait of Mme. Boucher," *Frick Collection Members' Magazine*, Fall 2001, p. 8, and "Marie-Jeanne Buzeau, Madame Boucher (1716–96)," *Burlington Magazine,* April 2005, pp. 224–234. The painting, completed in 1743, was part of the collection of M. Davoust until 1772, when, according to Alexandre Ananoff, *François Boucher*, vol. I (Lausanne: La Bibliothèque des Arts, 1976), it was bought by "Le Dart de Caen," where it remained until 1912; according to the Getty Provenance Index Databases, it may have come into the possession of Joseph Bardac, in Paris, by 1880, although the date remains uncertain. Unfortunately, it has proved impossible to determine what "Le Dart de Caen" is: the phrase might be a misprint for "le Musée d'Art de Caen" or, more correctly, "le Musée des Beaux-arts de Caen."
Page 112, line 32	Manet had experimented with that position in at least two of his preliminary sketches for *Olympia* and in other works; see Reff, *Manet: Olympia*, pp. 67–74.
Page 113, line 3	See Reff, *Manet: Olympia*, p. 108. Reff took the flower to be an orchid, and in this is followed by most interpreters with the exception of Beth Archer Brombert, who describes it as an hibiscus in *Edouard Manet: Rebel in a Frockcoat* (Boston: Little, Brown and Company, 1996), p. 144, and has been generous enough to show me direct horticultural evidence for her interpretation.
Page 113, line 8	It may actually have been missed by many in the work's early audiences (as it still is by many casual observers today). The many contemporary caricatures of the *Olympia* leave it out altogether. Clark, *The Painting of Modern Life*, p. 137, suggests that this was because the flowing hair, once you see it, changes the overall effect: "[T]his body has abundance after all; it has a familiar sex." Though seeing Victorine's hair does make a serious difference, I am not sure it has quite that effect. If anything, it complicates the already complex and inconsistent information the painting provides about its subject: the face is still sternly framed by the pulled-back hair, but an *additional* softness is added to Victorine. Clark writes that it is difficult to make it "part of the face it belongs to. Face and hair are incompatible." My own reaction is that it is Victorine's hair itself that does not add up to one thing—not just the hair and her face. It is important to note that Fantin-Latour (1883), Gauguin (1889), and Picasso (1901) all omitted that shock of frizzy hair from their sketches or caricatures of the work (in contrast to Cézanne's version of 1875–77 and Gauguin's full copy of 1890–91).
Page 114, line 3	Colin B. Bailey, Philip Conisbee, and Thomas W. Gaethens, *The Age of Watteau, Chardin and Fragonard* (New Haven: Yale University Press, 2003), p. 224.
Page 114, line 12	Bailey, "François Boucher's Presumed Portrait of Mme. Boucher," p. 8.

Page 115, line 13	Carol Armstrong, *Manet Manette* (New Haven: Yale University Press, 2002), p. 152.
Page 115, line 15	"Eyes fixed on mine with the speculative glare / of a half-tame tiger, she kept altering poses": translated by Richard Howard, *Charles Baudelaire: Les Fleurs du Mal* (Boston: David R. Godine, 1982), p. 26—a more literal version of "un air vague et rêveur," perhaps "with the vague and dreamy air," would be better for my purposes.
Page 115, line 20	G. H. Hamilton, *Manet and His Critics* (New Haven: Yale University Press, 1954), p. 79.
Page 115, line 22	Brombert, *Edouard Manet*, p. 146. Despite our difference on this issue, I am very grateful to Beth Brombert for many wonderful conversations about the painting over the years.
Page 115, line 26	Fried, *Manet's Modernism*, pp. 323–326.
Page 115, line 27	Beatrice Farwell, *Manet and the Nude: A Study in Iconography in the Second Empire* (New York: Garland, 1981), p. 128.
Page 115, line 33	Elizabeth Anne McCauley, *A. A, Disdéri and the Carte de Visite Portrait Photograph* (New Haven: Yale University Press, 1985), p. 106.
Page 116, line 3	See, for example, Aaron Scharff, *Art and Photography* (New York: Penguin Books, 1974), pp. 61–75.
Page 116, line 18	I believe Clark (*The Painting of Modern Life*, pp. 132–133) has something similar in mind when he contrasts Olympia's look to the look of *Venus Anadyomene* or the *Venus of Urbino* and describes it as "blatant and particular, but also . . . unreadable, perhaps deliberately so . . . candid but guarded, poised between address and resistance."
Page 116, line 26	Ibid., p. 133.
Page 118, line 5	Fried, *Manet's Modernism*, p. 325.
Page 118, line 11	Jean Clay, "Ointment, Makeup, Pollen," *October* 27 (1983): 6, cited by Fried, *Manet's Modernism*, p. 325.
Page 119, line 3	Aaron Scharff claims that magnesium wire, which produces a strong flare, had come into common use by the 1850s (*Art and Photography*, pp. 61–62), but that, as Anne McCauley has pointed out to me, is disputable. It is true, though, that Nadar had begun to make use of electric batteries to generate artificial light (which also accentuated the contrasts between dark and light masses and eliminated intermediate tones—a characteristic feature of Manet's early work and *Olympia* in particular) in order to photograph interior scenes (and eventually the sewers of Paris) by the end of that decade.
Page 121, line 5	Elaine Scarry, *On Beauty and Being Just*, pp. 47–48. Scarry, I think, believes that when I perceive the beauty of one thing, I become open to the beauty of others. That is true. What is also true, and what I am trying to say here, is that to perceive the beauty of one thing, which is in most cases not a one-time

affair but a longer story, sometimes even an affair of a lifetime, is *identical* with perceiving the beauty of others.

Page 121, line 11 Charles de Montesquieu, writing on taste in the *Encyclopaedia*, in *Encyclopedia: Selections*, translated by Nelly S. Hoyt and Thomas Cassirer (Indianapolis: The Bobbs-Merrill Company, 1965), p. 345.

Page 121, line 20 An example used by Susan R. Horton, *Interpreting Interpreting: Interpreting Dickens' "Dombey"* (Baltimore: Johns Hopkins University Press, 1979), p. 7.

Page 121, line 25 Susan Sontag, "Against Interpretation," in *Against Interpretation* (New York: Dell, 1966), pp. 5–7.

Page 121, line 29 Ibid., pp. 5, 7, 14.

Page 121, line 33 Arthur Danto has argued that Sontag's argument applies only to what he calls "deep" as opposed to "surface" interpretation, which establishes the meaning of a work and yields to the authority of its creator. Deep interpretation, by contrast, assumes that the work of surface interpretation has been done and, according to Danto, attributes to the work meanings over which its creator has no authority at all (he considers Marxism, Structuralism, and psychoanalysis, among others, as instances); see "Deep Interpretation," in *The Philosophical Disenfrachisement of Art* (New York: Columbia University Press, 1986), pp. 47–67. There is much to be said for that distinction, but I suspect Danto underestimates the range of Sontag's challenge, since she seems to believe, for example, that interpretation applies wherever there is "content" of any sort or, conversely, content that is so obvious that it makes interpretation useless. Abstract painting is an instance of "no content," while the content of Pop Art is so "blatant, so 'what it is,' it, too, ends by being uninterpretable" ("Against Interpretation," p. 10). Danto, moreover, seems to accept a strong form of Sontag's distinction between surface and depth, which I question below.

Page 123, line 9 What counts as a *good* interpretation is, of course, a further question, which I am not raising here. My suspicion is that, as in most cases that involve aesthetics, it can't be given an answer that is both general and informative.

Page 123, line 11 For a clear statement of this way of looking at the issue, see Monroe C. Beardsley, *Aesthetics: Problems in the Philosophy of Criticism* (New York: Harcourt, Brace & World, 1958), pp. 9–11, and "The Limits of Critical Interpretation," in his *The Aesthetic Point of View*, edited by Michael J. Wreen and Donald M. Callen (Ithaca, NY: Cornell University Press, 1982), pp. 165–187.

Page 123, line 13 See *Moby-Dick*, chapter 32, "Cetology."

Page 123, line 29 I have tried to give a more detailed argument, and further examples, for the views in this paragraph in "Mythology: The Theory of Plot," in *Essays on Aesthetics: Perspectives on the Work*

of Monroe C. Beardsley, edited by John Fisher (Philadelphia: Temple University Press, 1983), pp. 180–197.

Page 123, line 31 What lies beneath may be taken to be either more or less valuable than what lies on the surface. Supporters of this picture of interpretation believe the former; opponents, like Sontag, the latter: for them, interpretation leads from the concrete reality of direct, living experience to a pale reflection; see Nelson Goodman, *The Structure of Appearance* (Indianapolis: The Bobbs-Merrill Company, 1966), pp. 127–140.

Page 123, line 32 See Beardsley, *Aesthetics*, p. 9: "I use the term 'meaning' for a semantical relation between the work itself and something outside the work"; and Eddy M. Zemach, *Real Beauty* (University Park, PA: Pennsylvania State University Press, 1997), p. 116: "To interpret X is to say what X means . . . meanings are things. . . . A sign is a thing that refers us to, makes us focus on, another thing, and a meaning is a thing to which a sign, in its role as a sign, calls our attention."

Page 124, line 11 Michel Tournier, *Friday or the Other Island* (Hammondsworth: Penguin, 1974), p. 58.

Page 124, line 13 Oscar Wilde, *The Picture of Dorian Gray*, in *The Works of Oscar Wilde*, edited by G. F. Maine (London: Collins, 1948), p. 32.

Page 124, line 20 W. V. Quine and J. S. Ullian, *The Web of Belief* (New York: Random House, 1970), esp. chap. 2, "Observation."

Page 125, line 3 Proust, *In Search of Lost Time*, vol. 5, *The Fugitive*, translated by Ian Patterson (London: Penguin Books, 2002), p. 340. I have discussed that idea in more detail, again in connection with Proust, in "Writer, Text, Work, Author," in *Literature and the Question of Philosophy*, edited by Anthony J. Cascardi (Baltimore: Johns Hopkins University Press, 1987), pp. 267–291; Richard Rorty has recently given his own version of it in "Being That Can Be Understood Is Language," *London Review of Books*, 16 March 2000, pp. 23–25.

Page 125, line 12 Ibid., vol. 5, pp. 175–179.

Page 125, line 28 Ibid., vol. 5, pp. 340–341. Here, then, is a reason why the structure of *In Search of Lost Time has* to be circular and closed upon itself: why the book Marcel announces himself ready to write at the end of the novel is the very book we have finished reading. If the novel is open-ended and Marcel announces a book he has not yet composed, it will be impossible for him to capture any of the experiences it will recount, since by continuing to live he will be constantly placing them in new relations and continually changing them—*before* he can write about them! As it is, though, the book's hermetic structure insulates the events it recounts (if that's the right word) from any further interaction and change. All they are is what *In Search of Lost Time* says that they are.

Page 126, line 30 See M. F. Burnyeat, "Culture and Society in Plato's *Republic*," *The Tanner Lectures in Human Values*, vol. 19, edited by Grethe

	Petersen (Salt Lake City: University of Utah Press, 1998), pp. 217–324.
Page 127, line 3	Plato, *Republic*, translated by G.M.A. Grube and C.D.C. Reeve (Indianapolis: Hackett Publishing Company, 1993), 401c.
Page 127, line 24	Richard Rorty, introduction to Vladimir Nabokov's *Pale Fire* (New York: Everyman's Library, 1992), p. xvii.
Page 127, line 29	Scarry, *On Beauty and Being Just* (Princeton: Princeton University Press), chap. 2.
Page 127, line 30	See, in addition to the *Symposium*, *Republic* 400a–400e.
Page 128, line 14	See my "Plato and the Mass Media," *The Monist* 71 (1988): 214–234, reprinted in *Virtues of Authenticity: Essays on Plato and Socrates* (Princeton: Princeton University Press, 2000), pp. 279–299, and "Serious Watching," *South Atlantic Quarterly*, 1990: 157–180.
Page 128, line 32	See Jonas Barish, *The Anti-Theatrical Prejudice* (Berkeley: University of California Press, 1981). It is worth noting that "theater" can have an extended sense in the context of such polemics, one of its best-known instances occurring in Michael Fried's attacks on Minimalism and its tradition on account of their "theatricality": see "Art and Objecthood" in *Art and Objecthood* (Chicago: University of Chicago Press, 1998), pp. 148–172 (several other essays in that volume address that issue as well), and *Absorption and Theatricality: Painting and Beholder in the Age of Diderot* (Chicago: University of Chicago Press, 1980).
Page 129, line 5	Samuel Taylor Coleridge, *Seven Letters on Shakespeare and Milton* (London, 1856), p. 3.
Page 129, line 20	Quoted in *A History of Reading in the West*, edited by Guglielmo Cavallo and Roger Chartier (Amherst: University of Massachusetts Press, 1999), p. 285.
Page 130, line 4	Marcel Proust, *In Search of Lost Time*, vol. 1, translated by Lydia Davis (London: Penguin Books, 2002), p. 383 (translation slightly modified).
Page 130, line 24	Plato, *Symposium* 209b8, 209c6–209c7, 210a8, 210c1–210c2.
Page 131, line 17	Friedrich Nietzsche, *The Gay Science*, translated by Walter Kaufmann (New York: Random House, 1974), §309.
Page 132, line 18	Ibid., §276.
Page 132, line 28	Friedrich Nietzsche, *Human, All Too Human: A Book for Free Spirits*, translated by Marion Faber, with Stephen Lehman (Lincoln: University of Nebraska Press, 1984), vol. I, §149, slightly modified.
Page 133, line 6	Plato clearly thinks of virtue in moral terms and so, even if we took it to include every feature that makes a human being admirable, I would still have a dispute with him. He also thinks of happiness less in terms of pleasure than (as Aristotle would eventually put it) as a feature of a life engaged in activities that

manifest human virtue. We could then agree that the pursuit of beauty leads—through a different path—to happiness.

Page 133, line 15	Scarry, *On Beauty and Being Just*, pp. 87–88.
Page 134, line 17	Marcel Proust, *In Search of Lost Time*, vol. 6, translated by Ian Patterson (London: Penguin, 2002), p. 204.
Page 136, line 3	Friedrich Nietzsche, *The Gay Science*, §255.
Page 136, line 9	Immanuel Kant, *Critique of the Power of Judgment*, translated by Paul D. Guyer (Cambridge: Cambridge University Press, 2000), §46, p. 186.
Page 136, line 19	Matthew Arnold, in *On Translating Homer* (London: Longman, Green, Longman and Roberts, 1861), p. 64. Oscar Wilde, "The Critic As Artist," in *The Works of Oscar Wilde*, edited by G. F. Maine (London: Collins, 1948), p. 969.
Page 136, line 33	Wilde, "The Soul of Man under Socialism," *The Works of Oscar Wilde*, p. 1040.
Page 137, line 13	Wilde, "De Profundis," *The Works of Oscar Wilde*, p. 857; see also Richard Ellmann, *Oscar Wilde* (New York: Alfred A. Knopf, 1988), p. 541.
Page 137, line 24	Plato, *Symposium* 211d.
Page 137, line 27	Friedrich Nietzsche, *The Birth of Tragedy*, translated by Walter Kaufmann (New York: Random House, 1966), §§5, 24; slightly modified.
Page 138, line 1	Friedrich Nietzsche, *The Will to Power*, translated by Walter Kaufmann and R. J. Hollingdale (New York: Random House, 1968), §969.
Page 138, line 2	See my "Nietzsche and 'Hitler,'" *Southern Journal of Philosophy* 1999, 37 (supp): 1–17.
Page 138, line 7	Very roughly, while Caravaggio puts a holy figure to sensual use, Correggio employs sensuality for theological ends; see Leo Steinberg, *The Sexuality of Christ in Renaissance Art and Modern Oblivion*, 2nd ed. (Chicago: University of Chicago Press, 1996).

Permissions

Color Plates

(following page 138)

Plate 1. Vincent van Gogh, *Church at Auvers-sur-Oise*, 1890, Musée d'Orsay, Paris, France. Reproduced by permission from Art Resource, NY. Photo credit: Réunion des Musées Nationaux.

Plate 2. Henri Matisse, *Blue Nude*, 1907. Reproduced by permission from The Baltimore Museum of Art: The Cone Collection, formed by Dr. Claribel Cone and Miss Etta Cone of Baltimore, Maryland, BMA 1950.228. Image is © 2006 Succession H. Matisse / Artists Rights Society (ARS).

Plate 3. Pablo Picasso, *Seated Bather* [*La Baigneuse*], 1930. Oil on canvas, 64 ¼ × 51". Mrs. Simon Guggenheim Fund. (82.1950) The Museum of Modern Art, New York, NY, USA. Reproduced by permission from Art Resource, NY. Pablo Picasso (1881–1973) © ARS, NY. Photo credit: Digital Image © The Museum of Modern Art / Licensed by SCALA / Art Resource.

Plate 4. William-Adolphe Bouguereau, *Seated Bather*, 1884. Reproduced by permission from Sterling and Francine Clark Art Institute, Williamstown, Massachusetts, USA.

Plate 5. Edouard Manet, *Olympia*, 1863, Musée d'Orsay, Paris, France. Reproduced by permission from Art Resource, NY. Photo Credit: Hervé Lewandowski, Réunion des Musées Nationaux.

Plate 6. Edouard Manet, *Execution of Emperor Maximilian of Mexico*, 1867, Staedtische Kunsthalle, Mannheim, Germany. Reproduced by permission from Art Resource, NY. Photo Credit: Erich Lessing.

Plate 7. Edouard Manet, *Execution of Emperor Maximilian of Mexico* (detail), 1867, Staedtische Kunsthalle, Mannheim, Germany. Reproduced by permission from Art Resource, NY. Photo Credit: Erich Lessing.

Plate 8. Yves Klein, *Vénus bleue* (*Blue Venus*), S 41, 1962 / Pure pigment and synthetic resin on plaster / 27 × 13 × 7 in. 1970. Copyright: Yves Klein, ADAGP, Paris. Reproduced by permission from the Yves Klein Archives, Paris, France.

Plate 9. Damien Hirst, *Alantolactone*, 1965. Gloss household paint on canvas 38 × 58 in. (96.5 × 147.3 cm) (10 × 15 spots). Copyright © the artist. Reproduced by permission from Jay Jopling, White Cube, London, UK.

Plate 10. Johannes Vermeer, *View of Delft* (detail), 1662, Mauritshuis, The Hague, Netherlands. Reproduced by permission from Art Resource, NY. Photo Credit: Scala.

Plate 11. François Boucher, *A Lady on Her Day Bed* (*Presumed Portrait of Mme. Boucher*), 1743. Reproduced by permission from The Frick Collection, New York.

Plate 12. François Boucher, *La Toilette*, 1742. Reproduced by permission from Museo Thyssen-Bornemisza, Madrid, Spain. Photo Credit: akg-images, London.

Plate 13. Edouard Manet, *Olympia* (detail), 1863, Musée d'Orsay, Paris, France. Reproduced by permission from Art Resource, NY. Photo Credit: Hervé Lewandowski, Réunion des Musées Nationaux.

Halftones

Figure 1. Masolino da Panicale, *The Original Sin*, c. 1427, S. Maria del Carmine, Florence, Italy. Reproduced by permission from Art Resource, NY. Photo credit: Scala.

Figure 2. Titian (Tiziano Vecellio), *Venus of Urbino*, c. 1538, Galleria degli Uffizi, Florence, Italy. Reproduced by permission from Art Resource, NY. Photo credit: Alinari.

Figure 3. Arthur Hacker, *Pelagia and Philammon*, 1887. Reproduced by permission from the Walker Art Gallery, National Museums, Liverpool, UK.

Figure 4. Sir Peter Lely. *Portrait of Nell Gwynne* [1650–87] *as Venus, with her son, Charles Beauclerk* [1670–1726] *as Cupid* (oil on canvas), Army and Navy Club, London, UK. Copyright © Army and Navy Club, London, UK. Reproduced by permission from The Bridgeman Art Library Nationality/copyright status: English/out of copyright.

Figure 5. Vincent van Gogh, *Church at Auvers-sur-Oise*, 1890, Musée d'Orsay, Paris, France. Reproduced by permission from Art Resource, NY. Photo credit: Réunion des Musées Nationaux.

Figure 6. Balthasar Klossowski de Rola (Balthus), *Therese Dreaming*, 1938. Reproduced by permission from The Metropolitan Museum of Art, New York. All rights reserved.

Figure 7. Michael Graves, *Toilet Brush*. Reproduced by permission from Michael Graves and Associates. Photo credit: George Kopp.

Figure 8. Sebastião Salgado, *Rwandan refuge camp of Benako, Tanzania, 1994*. © Sebastião Salgado/Amazonas/nbpictures.

Figure 9. Robert Mapplethorpe, *Elliot and Dominick*, 1979. Reproduced by permission from The Robert Mapplethorpe Foundation. © The Robert Mapplethorpe Foundation, Art + Commerce.

Figure 10. William-Adolphe Bouguereau, *The Nymphaeum*, 1878. Reproduced by permission from The Haggin Museum, Haggin Collection, Stockton, California.

Figure 11. Raffaello di Sanzio (Raphael), *The Transfiguration*, 1518–20, Pinacoteca, Vatican Museums, Vatican State. Reproduced by permission from Art Resource, NY. Photo credit: Scala.

Figure 12. Kazimir Malevich, *Black Square*, c. 1923–30, Musée National d'Art Moderne, Centre Georges Pompidou, Paris, France. Reproduced by permission from Art Resource, NY. Photo credit: Jacques Faujour, CNAC/MNAM/Dist. Réunion des Musées Nationaux.

Figure 13. Henri Matisse, *Blue Nude*, 1907. Reproduced by permission from The Baltimore Museum of Art: The Cone Collection, formed by Dr. Claribel Cone and Miss Etta Cone of Baltimore, Maryland, BMA 1950.228. Image is © 2006 Succession H. Matisse/Artists Rights Society (ARS).

Figure 14. Pablo Picasso, *Seated Bather* [*La Baigneuse*], 1930. Oil on canvas, 64 ¼ × 51". Mrs. Simon Guggenheim Fund. (82.1950) The Museum of Modern Art, New York, NY, USA. Reproduced by permission from Art Resource, NY. Pablo Picasso (1881–1973) © ARS, NY. Photo credit: Digital Image © The Museum of Modern Art/Licensed by SCALA/Art Resource.

Figure 15. William-Adolphe Bouguereau, *Seated Bather*, 1884. Reproduced by permission from Sterling and Francine Clark Art Institute, Williamstown, Massachusetts, USA.

Figure 16. Edouard Manet, *Le Déjeuner sur l'herbe* (*Luncheon on the grass*), 1863, Musée d'Orsay, Paris, France. Reproduced by permission from Art Resource, NY. Photo credit: Réunion des Musées Nationaux.

Figure 17. Mark Rothko, *Untitled*. © 1998 Kate Rothko Prizel and Christopher Rothko. Reproduced by permission from Kate Rothko Prizel and Christopher Rothko / Artists Rights Society (ARS), New York.

Figure 18. Pablo Picasso (1881–1973), *Three Musicians*, 1921. Oil on canvas, 6'7" × 7'3 ¾". Mrs. Simon Guggenheim Fund. (55.1949), The Museum of Modern Art, New York. Reproduced by permission from Art Resource, NY. Photo credit: © The Museum of Modern Art / Licensed by SCALA / Art Resource, NY.

Figure 19. Ilya Repin, *St. Nicholas Delivers Three Unjustly Condemned Men from Death*, 1888, State Russian Museum, St. Petersburg, Russia. Reproduced by permission from The Bridgeman Art Library

Figure 20. Theodore G. Haupt, *New Yorker*. Reproduced by permission from Condé Nast Publications. Copyright © 1930 *The New Yorker* / Condé Nast Publications. Reprinted by permission. All rights reserved.

Figure 21. Edouard Manet, *Olympia*, 1863, Musée d'Orsay, Paris, France. Reproduced by permission from Art Resource, NY. Photo credit: Hervé Lewandowski, Réunion des Musées Nationaux.

Figure 22. Bertall, *The Cat's Tail, or the Charcoal-seller of Batignoles*. Wood engraving in *L'Illustration*, June 3, 1865.

Figure 23. Alfred Stieglitz, *Fountain*, Tate Gallery, London, UK, photograph of sculpture by Marcel Duchamp, 1917. Reproduced by permission from Art Resource, NY. Photo credit: Tate Gallery, London.

Figure 24. Andy Warhol, *Brillo Box*, 1965, The Museum of Modern Art, New York. Copyright The Andy Warhol Foundation for the Visual Arts / ARS, New York. Photo credit: Digital Image © The Museum of Modern Art / Licensed by SCALA. Reproduced by permission from Art Resource, NY.

Figure 25. Stelarc, *Spin Suspension*, 1997. Reproduced by permission from Stelarc. Photo credit: Helmut Steinhausser.

Figure 26. Feeding funnel (koropata), Maori peoples, Aotearoam, New Zealand, nineteenth century. Wood, 16.5 cm (6 ½ in.). Gift of

William E. and Bertha L. Teel, 1991.1071. Reproduced by permission from the Museum of Fine Arts, Boston. Photo credit: © 2006 Museum of Fine Arts, Boston.

Figure 27. Orlan, *Self-hybridations precolombiennes no. 1*, 1999. Cibachrome collé sur aluminium, cadre : boite américaine, cornières et plexiglas Aide technique au traitement numérique des images: Pierre Zovilé.

Figure 28. Alexandre Cabanel, *The Birth of Venus*, 1863, Musée d'Orsay, Paris, France. Reproduced by permission from Art Resource, NY. Photo credit: Réunion des Musées Nationaux.

Figure 29. Jean Auguste Dominique Ingres, *Vénus Anadyomene*, 1848, Musée Condé, Chantilly, France. Reproduced by permission from Art Resource, NY. Photo credit: Réunion des Musées Nationaux.

Figure 30. Jake and Dinos Chapman, *Zygotic acceleration, Biogenetic de-sublimated libidinal model (enlarged × 1000)*, 1995. Mixed Media, 58 13/16 × 70 9/16 × 54 14/16 in. (150 × 180 × 140 cm). © the artists. Reproduced by permission from Jay Jopling / White Cube, London, UK. Photo credit: Diane Bertrand.

Figure 31. Robert Morris, *Untitled* (*Ring with Light*), 1965–66. Reproduced by permission from Monika Sprueth Philomene Magers, Cologne, Munich, Germany.

Figure 32. Chaim Soutine, *Portrait of Man* (*Emile Lejeune*), c. 1922–23. Reproduced by permission from ARS, New York. Photo credit: J. G. Berizzi, Réunion des Musées Nationaux / Art Resource, NY.

Figure 33. Sandro Botticelli, *Annunciation*, c. 1489, Uffizi, Florence, Italy. Reproduced by permission from Art Resource, NY. Photo credit: Alinari.

Figure 34. Sandro Botticelli, *La Primavera*, c. 1478, Galleria degli Uffizi, Florence, Italy. Reproduced by permission from Art Resource, NY. Photo credit: Scala.

Figure 35. Edouard Manet, *Execution of Emperor Maximilian of Mexico*, 1867, Staedtische Kunsthalle, Mannheim, Germany. Reproduced by permission from Art Resource, NY. Photo credit: Erich Lessing.

Figure 36. Edouard Manet, *Execution of Emperor Maximilian of Mexico*, 1867–68. Reproduced by permission from National Gallery, London, UK. © The National Gallery, London, UK.

Figure 37. Edouard Manet, *Execution of Emperor Maximilian of Mexico* (detail), 1867, Staedtische Kunsthalle, Mannheim, Germany. Reproduced by permission from Art Resource, NY. Photo credit: Erich Lessing.

Figure 38. Sol LeWitt, *Schematic Drawing for Incomplete Open Cubes*, 1974. Reproduced by permission from the Wadsworth Athenaeum Museum of Art, Hartford, Connecticut. Sol Lewitt, born in Hartford, CT, 1928. Lives and works in Chester, CT. Ink and pencil on vellum; 12 × 12 inches. The Douglas Tracy Smith and Dorothy Potter Smith Fund, and partial gift of Carol and Sol LeWitt, 2001.8.139.

Figure 39. Stefano di Giovanni (Sassetta), *St. Francis Giving His Cloak to a Poor Soldier*, 1437–44. Reproduced by permission from the National Gallery, London, UK. Bought with contributions from the National Art Collections Fund, Benjamin Guinness and Lord Bearsted, 1934.

Figure 40. Yves Klein, *Vénus bleue* (*Blue Venus*), S 41, 1962 / Pure pigment and synthetic resin on plaster / 27 × 13 × 7 in. 1970. Copyright: Yves Klein, ADAGP, Paris. Reproduced by permission from the Yves Klein Archives, Paris, France.

Figure 41. Damien Hirst, *Alantolactone*, 1965. Gloss household paint on canvas 38 × 58 in. (96.5 × 147.3 cm) (10 × 15 spots). Copyright © the artist. Reproduced by permission from Jay Jopling, White Cube, London, UK.

Figure 42. Photograph of John Merrick. Reproduced by permission from St. Bartholomew's Hospital Archives and Royal London Hospital Archives. Copyright © St. Bartholomew's Hospital Archives and © Royal London Hospital Archives. Courtesy of St. Bartholomew's Hospital Archives and Royal London Hospital Archives.

Figure 43. Faces. Reproduced by permission from www.faceresesearch.org.

Figure 44. Peter Paul Rubens, *Holy Family with St. Elizabeth* (*Madonna of the Basket*), c. 1615, Galleria Palatina, Palazzo Pitti, Florence, Italy. Reproduced by permission from Art Resource, NY. Photo credit: Scala.

Figure 45. Titian, *Man with Bulging Eyes*, c. 1545, Galleria Palatina, Palazzo Pitti, Florence, Italy. Reproduced by permission from Art Resource, NY. Photo credit: Scala.

Figure 46. *Madonna and Child*, known as the "Pisa Madonna," Florentine School, mid-13th century, Galleria degli Uffizi, Florence, Italy. Reproduced by permission from The Bridgeman Art Library Nationality.

Figure 47. Nicholas Papas, *Virgin Hodegetria*. Contemporary, Byzantine style.

Figure 48. Duccio di Buoninsegna, Madonna and Child, c. 1300, Metropolitan Museum of Art, New York.. Reproduced by permission from The Metropolitan Museum of Art, New York. All rights reserved.

Figure 49. Jean Baptiste Siméon Chardin, *La Pourvoyeuse* (*The Cateress*), 1739, Louvre, Paris, France. Reproduced by permission from the Art Resource, NY. Photo credit: Erich Lessing.

Figure 50. Nicolas de Largillière, *Portrait of Marguerite de Sève*, 1729. Reproduced by permission from The Putnam Foundation, Timken Museum of Art, San Diego, California.

Figure 51. Johannes Vermeer, *View of Delft* (detail), 1662, Mauritshuis, The Hague, Netherlands. Reproduced by permission from Art Resource, NY. Photo credit: Scala.

Figure 52. Piero della Francesca, *The Baptism of Christ*, c. 1450–55, National Gallery, London, UK. Reproduced by permission from Art Resource, NY. Photo credit: Erich Lessing.

Figure 53. Norman Rockwell, *After the Prom*, 1957. Licensed by and reproduced by permission from Curtis Publishing Co., Indianapolis, Indiana. C 1957 SEPS: www.curtispublishing.com. All rights reserved.

Figure 54. Jacques Louis David, *Death of Marat*, 1793. Oil on canvas, 165 × 128 cm. Louvre, Paris, France. Reproduced by permission from Art Resource, NY. Photo credit: Erich Lessing.

Figure 55. Domenico Ghirlandaio, *Old Man with a Child*, c. 1489, Louvre, Paris, France. Reproduced by permission from Art Resource, NY. Photo credit: Harry Bréjat, Réunion des Musées Nationaux.

Figure 56. John Currin, *Heartless*, 1997. Reproduced by permission from Gagosian Gallery.

Figure 57. Robert Motherwell, *Elegy to the Spanish Republic No. 110*, Easter Day, 1971. Acrylic with pencil and charcoal on canvas, 82 × 144 inches (208.3 × 298.6 cm). Reproduced by permission

from the Solomon R. Guggenheim Museum, New York, gift, Agnes Gund, 1984, 84.3223.

Figure 58. Lucas Cranach the Elder, *Apollo and Diana in Wooded Landscape*, 1533, Gemaeldegalerie, Staatlich Museen zu Berlin, Germany. Reproduced by permission from Art Resource, NY. Photo credit: Bildarchiv Preussischer Kulturbesitz.

Figure 59. Edouard Manet, *Olympia*, 1863, Musée d'Orsay, Paris, France. Reproduced by permission from Art Resource, NY. Photo credit: Hervé Lewandowski, Réunion des Musées Nationaux.

Figure 60. Titian (Tiziano Vecellio), *Venus of Urbino*, c. 1538, Galleria degli Uffizi, Florence, Italy. Reproduced by permission from Art Resource, NY. Photo credit: Alinari.

Figure 61. Alexandre Cabanel, *The Birth of Venus*, 1863, Musée d'Orsay, Paris, France. Reproduced by permission from Art Resource, NY. Photo credit: Réunion des Musées Nationaux.

Figure 62. Edouard Manet, *The Negro Woman*, 1862–63, Pinacoteca Gianni e Marcella Agnelli, Turin, Italy. Reproduced by permission from Art Resource, NY. Photo credit: Gilles Mermet.

Figure 63. Jean-Léon Gérôme, *The Snake Charmer*, c. 1870. Reproduced by permission from Sterling and Francine Clark Art Institute, Williamstown, Massachusetts, USA.

Figure 64. Edouard Manet, *The Old Musician*, 1862, the National Gallery of Art, Washington, DC, USA. Reproduced by permission from Art Resource, NY. Photo credit: Erich Lessing.

Figure 65. François Boucher, *A Lady on Her Day Bed* (*Presumed Portrait of Mme. Boucher*), 1743. Reproduced by permission from The Frick Collection, New York.

Figure 66. François Boucher, *La Toilette*, 1742. Reproduced by permission from Museo Thyssen-Bornemisza, Madrid, Spain. Photo credit: akg-images, London.

Figure 67. Félix Jacques Moulin, *A Moorish Woman and Her Maid*, c. 1865. German. 18.1 × 22.8 cm (7 1/8 × 9 in.). Albumen silver. Reproduced by permission of The J. Paul Getty Museum, Los Angeles.

Figure 68. Nadar (Gaspard Félix Tournachon) (1820–1910), photograph of Charles Baudelaire (1821–67), c. 1843. French. Private collection; Archives Charmet, from the Bridgeman Art Library; out of copyright.

Figure 69. Edouard Manet, *Portrait of Baudelaire* [1820–67], etching. Copyright © Nationalmuseum, Stockholm, Sweden. Photo credit: The Bridgeman Art Library.

Figure 70. Edouard Manet, *Olympia* (detail), 1863, Musée d'Orsay, Paris, France. Reproduced by permission from Art Resource, NY. Photo credit: Hervé Lewandowski, Réunion des Musées Nationaux.

Figure 71. Félix Nadar, photograph of Edouard Manet, 1865, Musée d'Orsay, Paris, France. Reproduced by permission from Art Resource, NY. Photo credit: Réunion des Musées Nationaux.

Figure 72. Louis-Camille Olivier, nude photograph, untitled. Reproduced by permission from George Eastman House, Museum Collection, Rochester, NY.

Figure 73. Edouard Manet, *Olympia* (detail), 1863, Musée d'Orsay, Paris, France. Reproduced by permission from Art Resource, NY. Photo credit: Hervé Lewandowski, Réunion des Musées Nationaux.

Figure 74. *Christ Pantocrator*, 6th century, Monastery of Saint Catherine, Mount Sinai, Egypt. Reproduced by permission from © Monastery of Saint Catherine, Mount Sinai, Egypt / Ancient Art and Architecture Collection Ltd. / The Bridgeman Art Library Nationality / copyright status: out of copyright.

Figure 75. *Christ Pantocrator* (detail), 6th century. Reproduced by permission from © Monastery of Saint Catherine, Mount Sinai, Egypt / Ancient Art and Architecture Collection Ltd. / The Bridgeman Art Library Nationality / copyright status: out of copyright.

Figure 76. *Virgin Hodegetria* (known as "Glykophilousa"), 14th century, Byzantine Museum, Athens, Greece. Reproduced by permission from Art Resource, NY. Photo credit: Werner Forman.

Figure 77. Edouard Manet, *Music in the Tuileries Garden*, 1862. © The National Gallery, London, UK. Reproduced by permission from The National Gallery, London, UK.

Figure 78. Diego Velasquez, *The Little Cavaliers*, c. 1650, Louvre, Paris, France. Reproduced by permission from Réunion des Musées Nationaux. Photo credit: Hervé Lewandowski.

Figure 79. Edouard Manet, *The Little Cavaliers*, 1858–59. Gift of Walter P. Chrysler, Jr. 71.679. Oil on canvas, 18 × 19¾ inches. Reproduced by permission of the Chrysler Museum of Art, Norfolk, VA.

Index

Baptism of Christ, The (Piero della Francesca), 93

Bardac, Joseph, 162n.112/22

Barkan, Leonard, 141n.10/17

Baudelaire, Charles, vii, 34, 87, 107–8, 115–17

Baumgarten, Alexander, 139n.3/37

Baxandall, Michael, 90–91

Baywatch, 84

Beardsley, Monroe C., 15, 143n.15/20, 165n.123/32

beauty: abandonment of ancient/classical vision of (*see* abandonment of ancient/classical vision of beauty); aesthetic value as distinct from, 43–44; ancient/classical vision of, 2–3, 6–7, 132–33; appearance, manifested in, 16–22, 63–64, 70–71; as appearance, Modernism and, 23–29 (*see also* Modernism); attraction to/desire for another person (*see* desire); attractiveness and, 70–71; criticism and (*see* criticism); difference and distinction, as a matter of, 133–37; direct contact/experience/perception of, 94–101; the erotic and, 9–11, 18–19, 141n.10/17 (*see also* erōs); experience of as inseparable from interpretation of, 105; friendship and, 58–59; Hegel on, 94–95; immediacy of, 16–17, 22; inner and outer, love and, 59–63; interpretation of, 125–26, 131–32 (*see also* interpretation); as its own reward, 138; judgment of (*see* judgment of beauty); love and, 59–63, 72 (*see also* love); of Manet's *Olympia* (*see Olympia* (Manet)); morality/ goodness and, 2–4, 21–22, 127, 133, 137–38; perception of, implications of, 163–64n.121/5; Picasso's playing with,

25–28; standards of, 64–65 (*see also* appearance); as visual rhetoric, 20

Bell, Clive, 11–12, 25, 142n.12/18

Berenson, Bernard, 89

Berkeley, George, 42

Bertall (Albert Arnoux), 37

Beyle, Marie-Henri. *See* Stendhal

"Bijoux, Les" (Baudelaire), 115

Birth of Venus, The (Cabanel), 40, 107–8

Birth of Venus (Botticelli), 28

Black Square (Malevich), 23

Bloom, Harold, 42–43

blue, 16, 24, 51, 91, 150n.51/21

Blue Nude (Matisse), 23–24, Pl. 2

Blue Venus (Klein), 52, Pl. 8

Böhm, Karl, 157n.83/9

Botticelli, Sandro (Alessandro di Mariano Filipepi), 28, 47–48

Boucher, François, 112–15, Pl. 11–12

Bouguereau, William-Adolphe, 21–22, 25–28, Pl. 4

Bourdieu, Pierre, 144n.18/18

Bovary, Emma, 60

Brillo Box (Warhol), 38

Brombert, Beth Archer, 115, 162n.113/3, 163n.115/22

Browning, Robert, 34–35

Burial at Ornans, A (Courbet), 51

Cabanel, Alexandre, 40, 107–8

camp, 88–89

Cantaloube, Amédée, 147n.39/26

Caprichos (Goya), 48

Caravaggio, Michelangelo Merisi, 135, 138, 167n.138/7

Carey, John, 95

Carrier, David, 82, 156n.82/14

Castelli, Leo, 89

Cat's Tail or the Charcoal-seller of Batignoles, The (Bertall), 37

Cavafy, Constantine P., 75, 139n.2/24

Cézanne, Paul, 12, 162n.113/8

Chapman, Dinos, 46

Chapman, George, 33

Chapman, Jake, 46

Chardin, Jean Baptiste Siméon, 90–91

Charles Baudelaire (Manet), 117

Charles II, 11

Christ Pantocrator, 120

Church at Auvers-sur-Oise (van Gogh), 17–18, Pl. 1

Clark, T. J., 51, 107–11, 116, 162n.113/8, 163n.116/18

Clay, Jean, 118

Cohen, Ted, 80–82

Coleridge, Samuel, 128–29

Collingwood, R. G., 13, 73

Confrontational Vulnerability (Johnson), 112

Corbière, Tristan, 34

Correggio, Antonio Allegri, 138, 167n.138/7

Courbet, Gustave, 27, 51

Cranach, Lucas, the Elder, 98–99

criticism: aesthetic terms in, minor role of, 48; appearance vs. analysis, the issue of, 22; attitude towards the critic, 150n.48/15; beauty as immediately obvious, issue of, 16–17; conception of, modern impulse regarding beauty and, 13–15; connecting Modernism and the past through, 30–35; Eliot on the function of, 89; evaluation/judgment and, 14–16, 41–44, 143–44n.16/14, 148–49n.43/30; evaluation vs. description in, 142–43n.15/3; objectivity of, 42, 148n.42/30; of *Olympia,* 39–42 (see also *Olympia* [Manet]); reviews, 44–47, 52–53; significance and judgment of value,

inseparability of, 41; Wilde on the function of, 136. *See also* aesthetics; interpretation

Critique of the Power of Judgment (Kant), 15, 79

Currin, John, 96–97

Dada, 20–21, 25

Danto, Arthur: "aesthetic" and "artistic," usage of, 144n.17/3, 145n.24/6; aesthetic considerations cannot provide a definition of art, 96; beauty, ordinary and artistic distinguished, 16–17; beauty and good art, conceptual distinction between, 21; beauty as coordinate with other aesthetic features, 160n.99/16; beauty pushed aside by Modernism, 25; Matisse's *Blue Nude,* rejection of beauty in, 23–24; Motherwell's "Elegies for the Spanish Republic," reaction to, 97–98; on Sontag's argument regarding interpretation, 164n.121/33; terms of aesthetic vocabulary, 44–45

"Dark Lady" sonnets (Shakespeare), 61

Darwin, Charles, 65

David, Jacques-Louis, 51, 96–98

David, Larry, 128

Davoust, M., 162n.112/22

Death in Venice (Mann), 103–5

Death of Marat (David), 51, 96–98

Déjeuner sur l'herbe, Le (Luncheon on the grass) (Manet), 25–27, 107, 110, 115, 118

Delacroix, Eugène, 25

Demoiselles d'Avignon, Les (Picasso), 25

desire: appearance and, 59–63; of attraction and of love, distinction between, 63–64; beauty as the spark of, 53–55; Plato's celebration of, 6–7, 9; to possess beauty, 11, 55–57;

Schopenhauer's torture by, 5, 9; sexual (*see* sexual desire); social provoked by beauty, 77

Dickens, Charles, 138, 158n.90/7

Diderot, Denis, 14

Die Frau ohne Schatten (Strauss), 82–83

Disdéri, A. A., 115

Dissanayake, Ellen, 156n.82/7

Dogwood Chapel (Kinkade), 17–18

Donne, John, 33, 35

Donoghue, Denis, 151n.57/17

Dryden, John, 33

Duccio di Buoninsegna, 85

Duchamp, Marcel, 37

education, in Rome at the time of Cicero, 14

Elegy to the Spanish Republic No. 110 (Motherwell), 97–98

Elephant Man, The (Lynch), 59

Eliot, George (Mary Anne Evans), 127

Eliot, T. S., 30, 33–35, 89

Elkins, James, 142–43n.15/3

Elliot and Dominick (Mapplethorpe), 21

Eminem, 94

Encyclopedia of Aesthetics, 49, 51, 148–49n.43/30

erōs: beauty and, 9–10, 61, 68; as the desire to possess beauty, 55 (*see also* desire); Plato's exclusion of the arts from the objects of, 73. *See also* sexual desire

Euripides, 126

Evans, Mary Anne. *See* Eliot, George

evil, the dangers of beauty and, 10

evolution, features of appearance and, 65–68

Execution of Emperor Maximilian of Mexico (Manet), 49–50, 91, 116, Pl. 6–7

Fable, Jean, 38

Faces, 65

Fantin-Latour, Henri, 110, 162n.113/8

Farwell, Beatrice, 115

Femmes d'Alger (Delacroix), 25

Flaubert, Gustave, 76

"For Anne Gregory" (Yeats), 151n.58/28

Forster, E. M., 103

Fosse, Bob, 122

Foster, Hal, 35, 144n.19/26

Fountain (Stieglitz), 37

Frankfurt, Harry G., 158n.89/33

Frasier, 47, 80

Fried, Michael: Manet's paintings, influence of photography in, 115, 117–18; Minimalism, rejection of, 88, 166n.128/32; *Olympia,* interpretation of, 109–11, 117–18; streak of paint in *The Execution of Emperor Maximilian,* interpretation of, 49–50, 91–92

friendship: Aristotle on, 57–58; beauty and, 58–59; the desire to possess in, 57; the love of friends, 58

Fry, Roger, 12, 25

Frye, Northrop, 148n.42/30

Garbo, Greta, 88

Gass, William, 51

Gauguin, Paul, 12, 162n.113/8

Gautier, Théophile, 39

Gay Science, The (Nietzsche), 87

gender, attitudinal impact of, 139n.2/24

Gérôme, Jean-Léon, 109–10

Getty Provenance Index Databases, 162n.112/22

Ghirlandaio, Domenico, 96

Gilmore, Jonathan, 140n.5/15

di Giovanni, Stefano. *See* Sassetta

Goldman, Alan, 15

Goodman, Nelson, 43, 159n.93/13